Jacobus eventually got his own crack at the art for this book, when he designed the cover for the 2003 reprint. His version features Dr. Brewer's clone, appearing here as a monstrous tree-like person, standing in front of a lab table. He holds a beaker in one hand, and behind him are several mysterious vials filled with colorful liquids. The effect might be less frightening than the original, but it raises a question for the reader to answer, creating a sense of excitement.

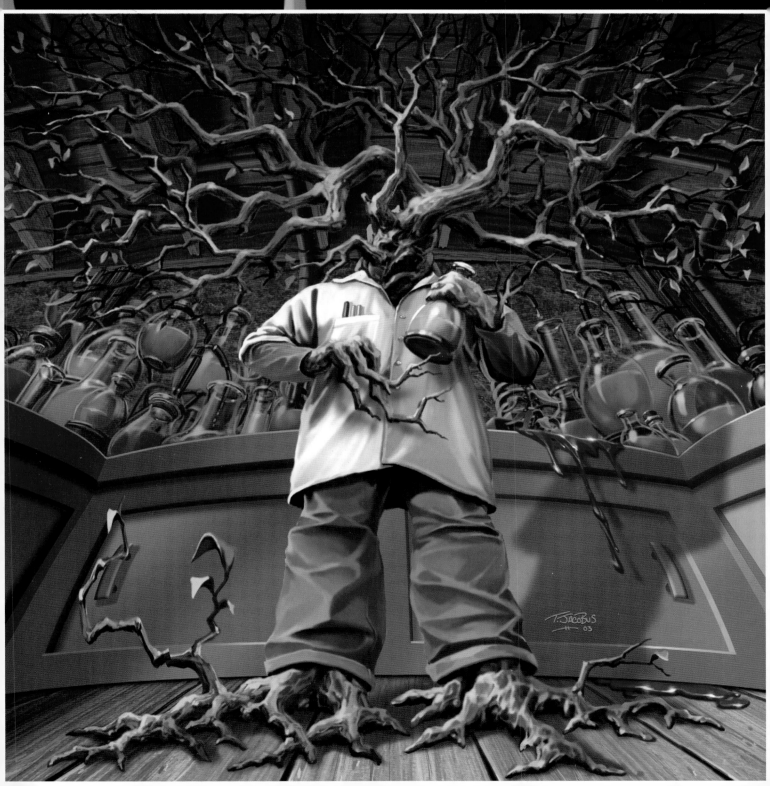

MONSTER BLOOD

REGULAR SERIES - BOOK #3 - JULY 1992

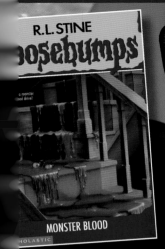

It's a monster blood drive!

"Blood, blood everywhere…While staying with his weird great-aunt Kath Evan visits a funky old toy store and buys a dusty can of monster blood fun to play with at first. And Evan's dog, Trigger, likes it so much, he some! But then Evan notices something weird about the green, slimy st it seems to be growing. And growing. And growing. And all that growin given the monster blood a monstrous appetite…"

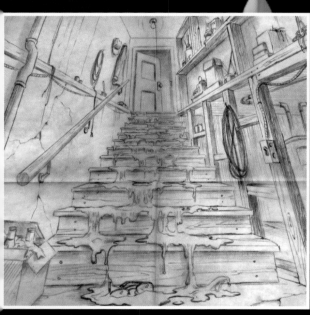

Pencil Sketch 1

Pencil Sketch 2

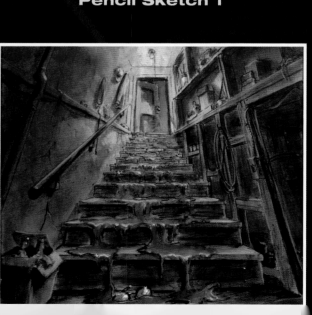

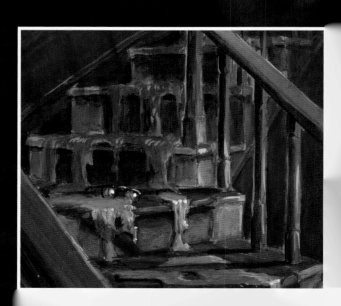

In what would become a hallmark of the style of the original series art, Jacobus never painted red blood. On this cover the titular blood is green and slime-like, and it pools down the stairs, giving the image an illusion of motion. Ominously, a pair of glasses sits in a puddle of the fluid, inviting the imagination to conjure up several possibilities about the whereabouts of the owner.

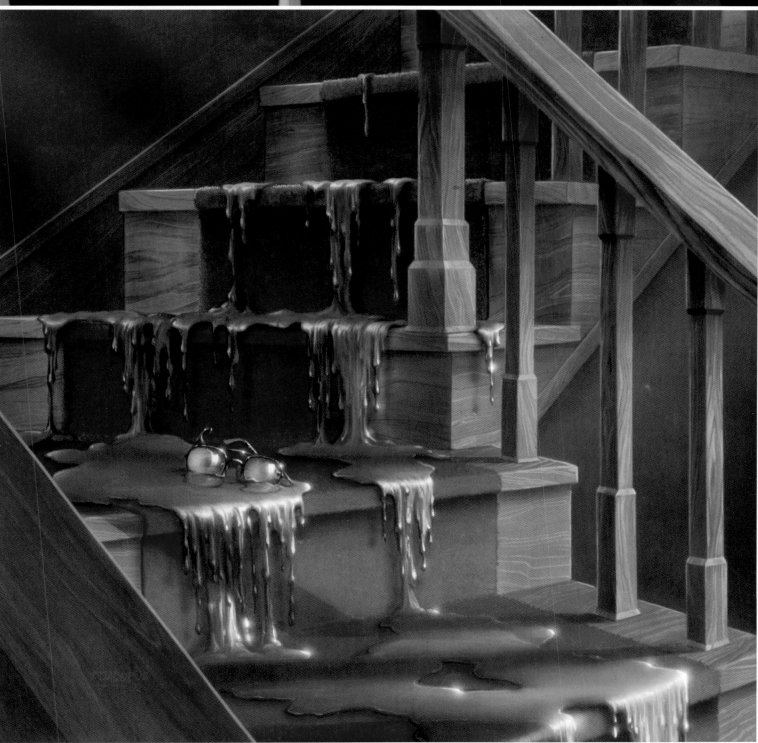

R.L. Stine said he was inspired to write this story by the toy slime his son used to play with. It is one of the few *Goosebumps* books written in third person, with all of the following *Monster Blood* books

SAY CHEESE AND DIE

REGULAR SERIES - BOOK #4 - NOVEMBER 1992

R.L. STINE
Goosebumps

One picture is worth a thousand screams.

SAY CHEESE AND DIE!

SCHOLASTIC

One picture is worth a thousand screams...

"Every picture tells a story...Greg thinks there is something wrong with the old camera he and his friends found. The photographs keep turning out wrong. Very wrong. Like the snapshot Greg took of his father's new car that shows it totaled. And then Greg's father is in a nasty wreck. But Greg's friends don't believe him. Shari even makes Greg bring the camera to her birthday party and take her picture. Only Shari's not in the photograph when it develops. Is Shari about to be taken out of the picture permanently? Who is going to take the next fall for...the evil camera?"

Curly Says:

The cover for this novel is the start of what would become an essential ingredient in most of the series' covers: the juxtaposition of a normal looking subject matter with a grotesque element. Jacobus said that the title of this book is what first made him realize that the series was humor mixed with horror.

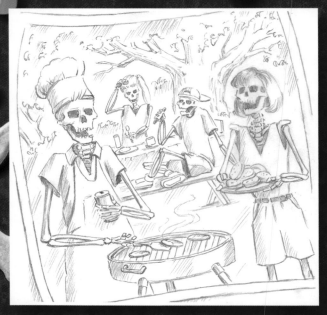

Pencil Sketch

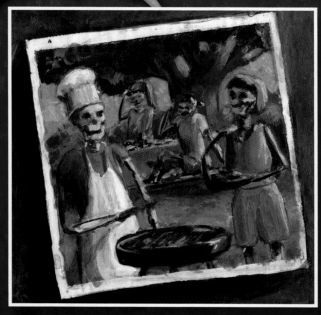

Color Mockup

In this case, the cover features a seemingly happy family enjoying a barbecue on a sunny day. The only catch is that they're all skeletons. This cover was so beloved by the Scholastic team that, when they realized there were no scenes in the book that resembled the art, they called R.L. Stine and asked him to add the moment into his story. Stine ingeniously added the scene as a dream sequence.

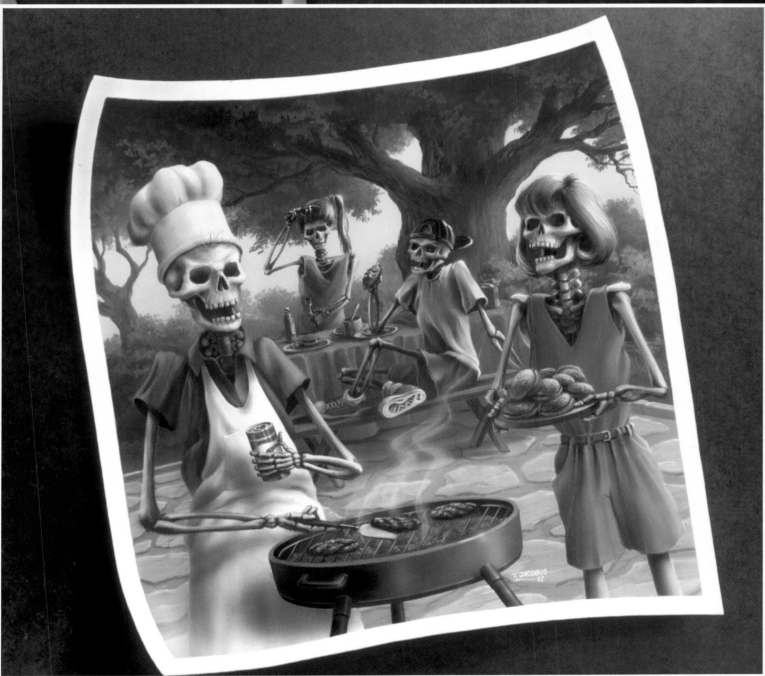

The cover is also noteworthy for being the first to feature what would become a bit of a running visual gag: Converse shoes. Jacobus loves Converse and almost every shoe featured on the covers of the

THE CURSE OF THE MUMMY'S TOMB

REGULAR SERIES - BOOK #5 - JANUARY 1993

R.L. STINE
Goosebumps

THE CURSE OF THE MUMMY'S TOMB

SCHOLASTIC

What will wake the dead?

"Something dead has been here…Gabe just got lost—in a pyramid. One minute, his crazy cousin Sari was right ahead of him in the pyramid tunnel. The next minute, she'd disappeared. But Gabe isn't alone. Someone else is in the pyramid, too. Someone. Or something. Gabe doesn't believe in the curse of the mummy's tomb. But that doesn't mean that the curse isn't real. Does it?"

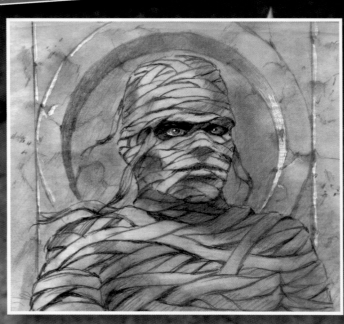

Pencil Sketch

Curly Says:

This book's title shares the same name as the 1964 horror film *The Curse of the Mummy's Tomb*.

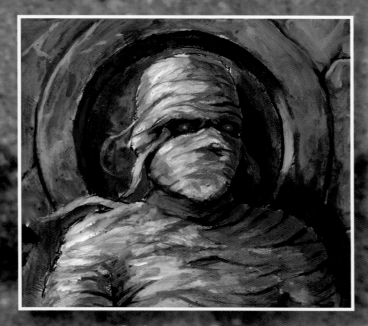

Color Mockup

Evoking a very traditional image of the classic tale, this cover features a mummy wrapped in white bandages with frightening, glowing, red eyes. Jacobus originally sketched the mummy with human eyes, but decided to use the glow instead to make the mummy's head seem more hollow. He used the round cut stonework around the mummy's head to create dramatic framing and added touches of pinks and purples to the dark shadows to help the monster pop out.

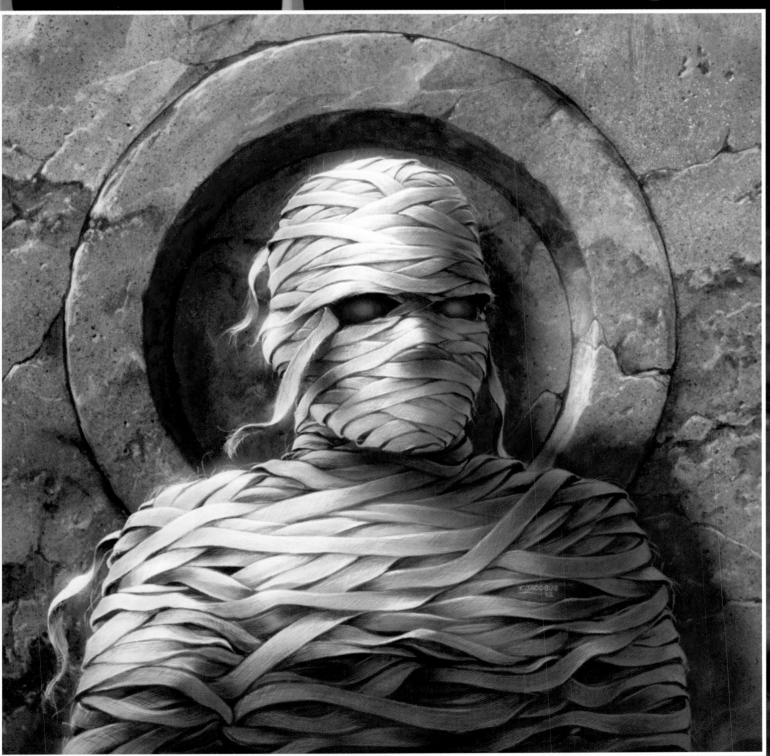

LET'S GET INVISIBLE!

REGULAR SERIES - BOOK #6 - MARCH 1993

R.L. STINE
Goosebumps

LET'S GET INVISIBLE!

SCHOLASTIC

Now you see him. Now you don't.
"Disappearances can be deadly. On Max's birthday, he finds a sort of magic mirror in the attic. It can make him become invisible. So Max and his friends start playing now you see me, now you don't. Until Max realizes that he's losing control. Staying invisible a little too long. Having a harder time coming back. Getting invisible is turning into a very dangerous game. The next time Max gets invisible, will it be...forever?"

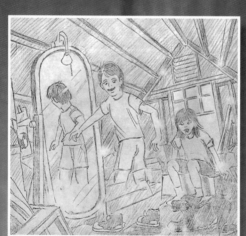

Pencil Sketch 1

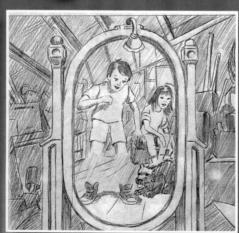

Pencil Sketch 2

Photo Shoot

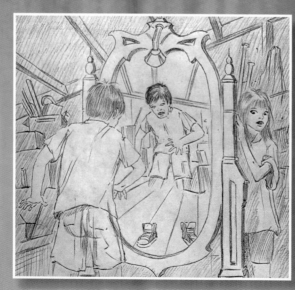

Pencil Sketch 3

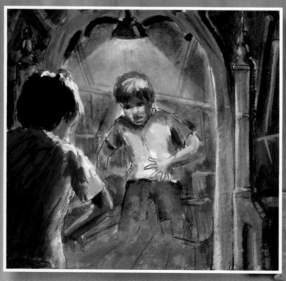

Color Mockup

Curly Says:

At 139 pages, this is the longest book in the original series.

24

A young boy in an orange sweater stands in front of a tall mirror. The light shining from a single bulb and the blue background are disquieting, suggesting stillness and loneliness. Through Max Thomspon's eye line, the reader's own eye is drawn to the image of the child in the mirror, where the lower half of his body is disappearing.

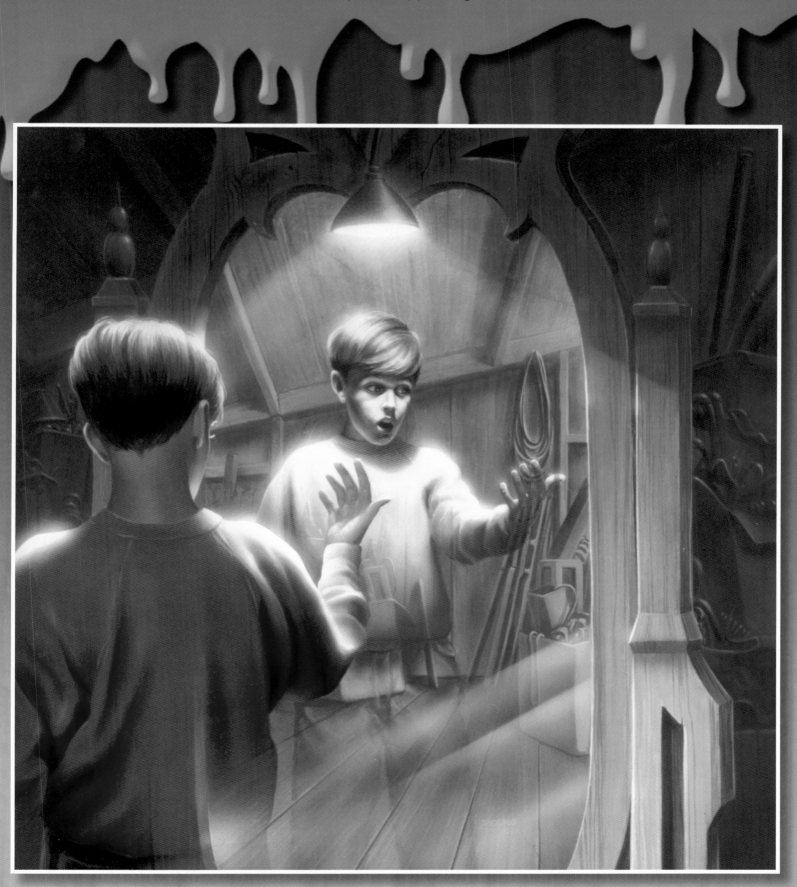

Interestingly, the cobwebs and spider visible on the original cover were not part of Jacobus' art. They were added by an unknown artist at Scholastic. The 2003 reprint did not include the spooky addition.

NIGHT OF THE LIVING DUMMY

REGULAR SERIES - BOOK #7 - MAY 1993

R.L. STINE
Goosebumps
He walks. He stalks...
NIGHT OF THE LIVING DUMMY
SCHOLASTIC

He walks. He stalks...

"He's no dummy! Lindy names the ventriloquist's dummy she finds Slappy. Slappy is kind of ugly, but he's a lot of fun. Lindy's having a great time learning to make Slappy move and talk. But Kris is jealous of all the attention her sister is getting. It's no fair. Why does Lindy always have all the luck? Kris decides to get a dummy of her own. She'll show Lindy. Then weird things begin to happen. Nasty things. Evil things. No way a dummy can be causing all the trouble. Or is there?"

Pencil Sketch 1

Pencil Sketch 2

Pencil Sketch 3

Pencil Sketch 4

Curly Says:

Slappy's eyes are described as blue in the book, but on both the original cover and the 2008 cover, he is depicted with green eyes.

Much like Jason in the original movie of the *Friday the 13th* franchise, Slappy is getting cover credit despite not being the main villain of the story. Mr. Wood is the actual antagonist dummy of this book, though Slappy becomes the central figure of the subsequent Living Dummy novels.

The use of shadow is what really draws the eye in this cover. Slappy's cheerful smile and tidy hair and outfit only add to the sinister insinuations caused by the glow of his green eyes from the shadows.

THE GIRL WHO CRIED MONSTER

REGULAR SERIES - BOOK #8 - MAY 1993

She's got the monster of all problems!

"She's telling the truth…but no one believes her! Lucy likes to tell monster stories. She's told so many that her friends and family are sick of it. Then one day, Lucy discovers a real, live monster: the librarian in charge of the summer reading program. Too bad Lucy's told so many monster tall tales. Too bad no one believes a word she says. Too bad the monster knows who she is…

…and is coming after her next."

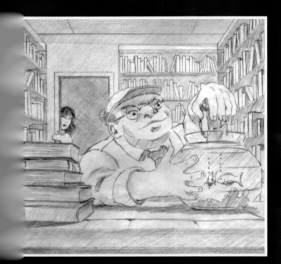

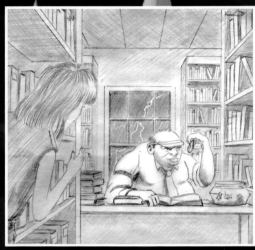

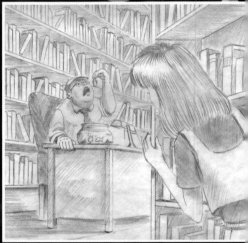

Pencil Sketch 1 **Pencil Sketch 2** **Pencil Sketch 3**

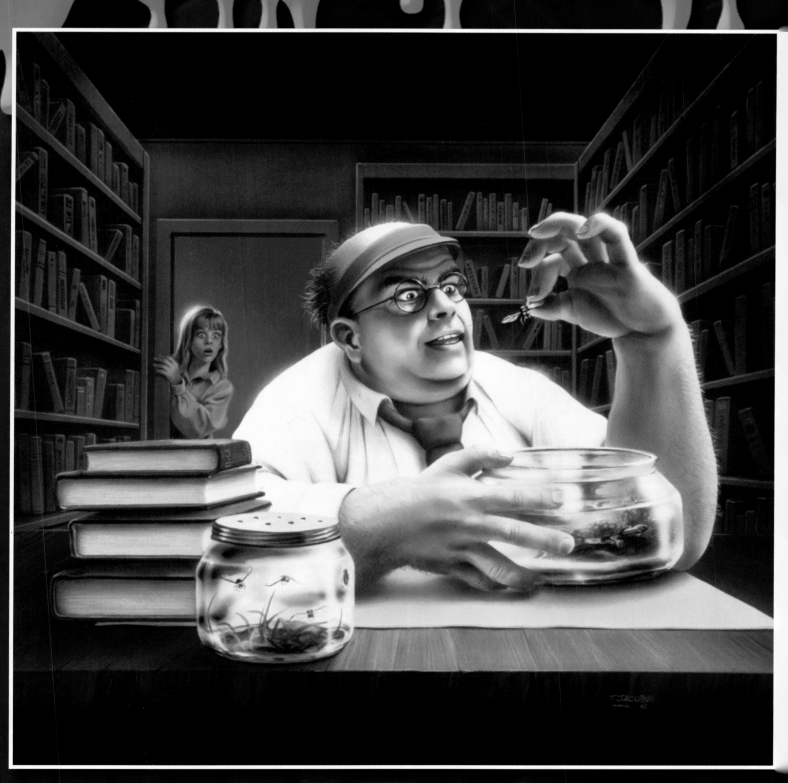

This is the first cover in the series to feature a human (on the outside at least) adult. Although the girl on the cover is a model, the librarian is actually Jacobus himself. He thought it would be funny to draw himself as bald, because at the time he had lots of hair. For some reason, now that he is actually bald, he

WELCOME TO CAMP NIGHTMARE

REGULAR SERIES - BOOK #9 - JULY 1993

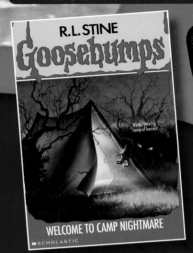

R.L. STINE
Goosebumps

WELCOME TO CAMP NIGHTMARE

SCHOLASTIC

It's the little camp of horrors!

"Those scary stories about camp are all coming true… The food isn't great. The counselors are a little strange. And the camp director, Uncle Al, seems sort of demented. Okay, so Billy can handle all that. But then his fellow campers start to disappear. What's going on? Why won't his parents answer his letters? What's lurking out there after dark? Camp Nightmoon is turning into Camp Nightmare. For real. And Billy might be next…"

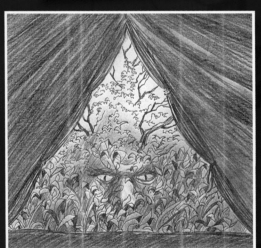

Pencil Sketch 1

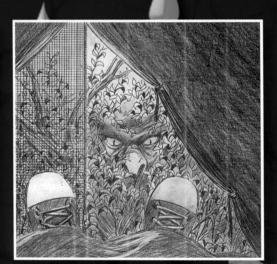

Pencil Sketch 2

Pencil Sketch 3

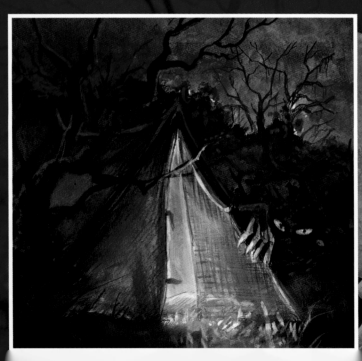

Stine Says:

The name of this novel was inspired by a visit to my son's sleepaway camp. The camp was infested with bugs and I hated visiting there.

The success of *Welcome to Camp Nightmare* inspired me to release camp-themed stories every Summer from 1995 to 1999, including *The Horror at Camp Jellyjam, Ghost Camp, The Curse of Camp Cold Lake, Fright Camp,*

The eerie glow of the green tent almost distracts from the dark creature peering into the open flap. However, the glowing eyes ensure that the monster is just visible enough to be mysterious and terrifying. In the background, the twisted, bare branches and roiling clouds add to the unsettling feel of the cover.

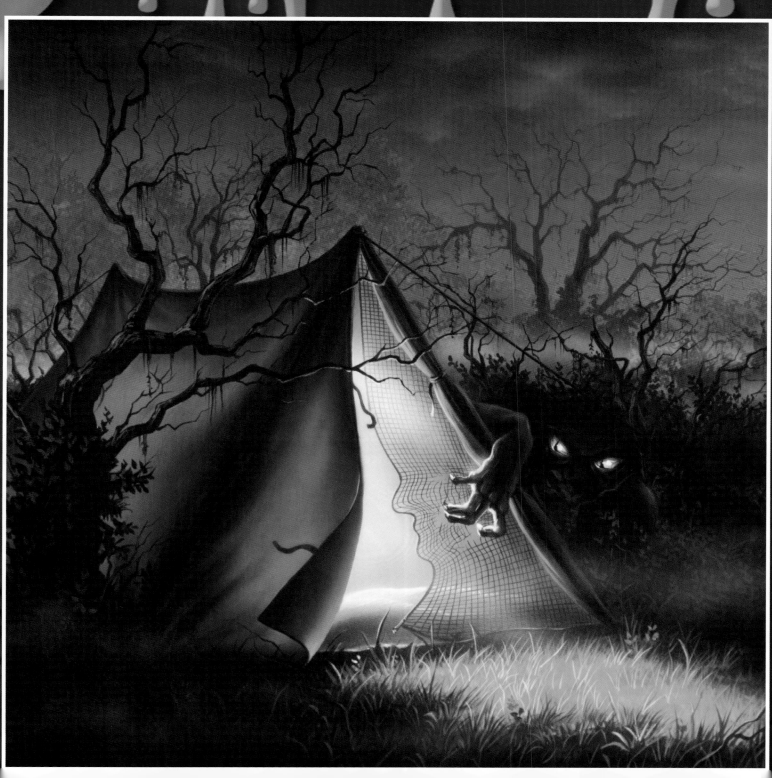

THE GHOST NEXT DOOR

REGULAR SERIES - BOOK #10 - AUGUST 1993

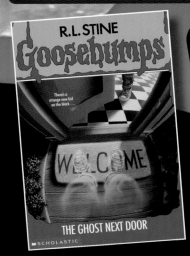

There's a strange new kid on the block...

"'How come I've never seen you before?' Hannah's neighborhood has just gotten a little—weird. Ever since that new boy moved in next door. But when did he move in? Wasn't the house empty when Hannah went to sleep the night before? Why does it still look deserted? She's not getting any answers from her new neighbor. He just keeps disappearing in the oddest ways. And he's so pale... Is Hannah being haunted by...

...the ghost next door???"

Pencil Sketch 1

Pencil Sketch 2

Pencil Sketch 3

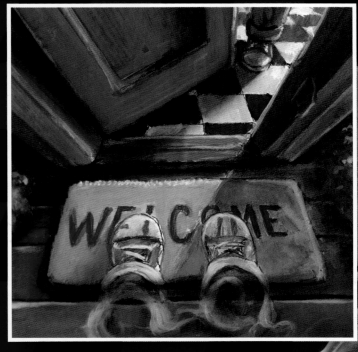

Color Mockup

Stine Says:

I've mentioned online that this book is one of my saddest, though it does have a happy ending.

Could Hannah Fairchild's appearance as the protagonist and adopted daughter of mine in the *Goosebumps* film hint at a deep connection with this novel?

Another cover that blends the normal with the supernatural, the pleasant, average "welcome" sign, and the familiar kitchen tiles contrast with the outline of a ghost standing at the door. Once again, we see the use of Converse shoes by Jacobus.

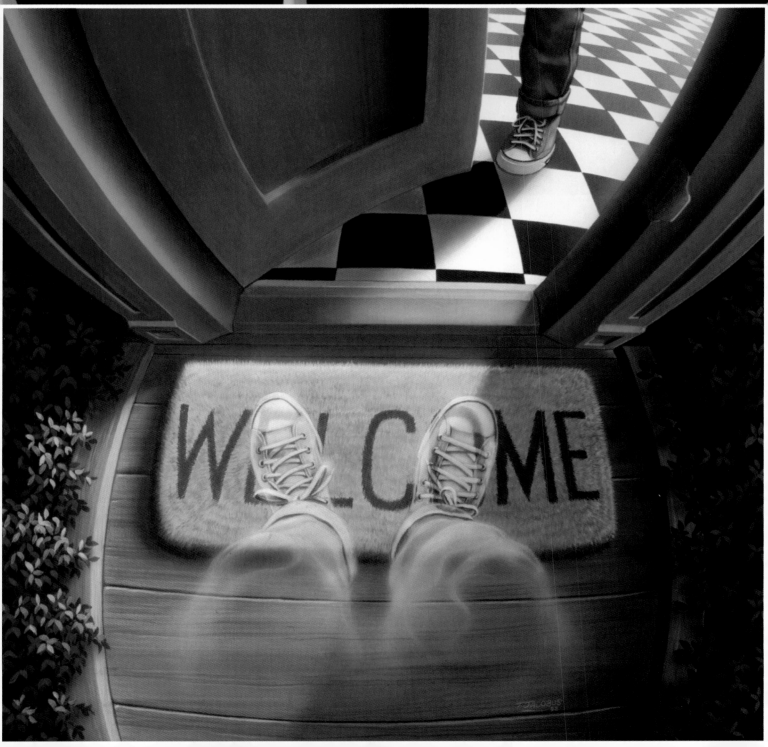

THE HAUNTED MASK

REGULAR SERIES - BOOK #11 - SEPTEMBER 1993

If looks could kill...

"Face to face with a nightmare… How ugly is Carly Beth's Halloween mask? It's so ugly that it almost scared her little brother to death. So terrifying that even her friends are totally freaked out by it. It's the best Halloween mask ever. It's everything Carly Beth hoped it would be. And more. Maybe too much more. Because Halloween is almost over. And Carly Beth is still wearing that special mask…"

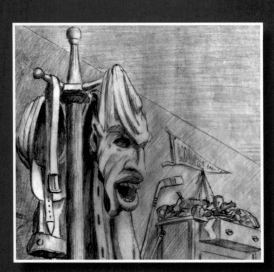

Pencil Sketch 1

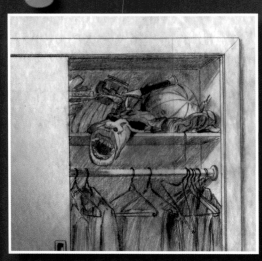

Pencil Sketch 2

Pencil Sketch 3

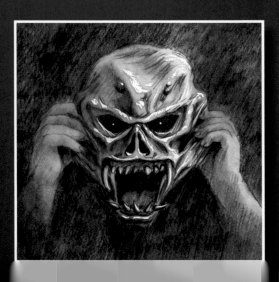

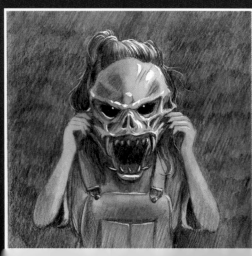

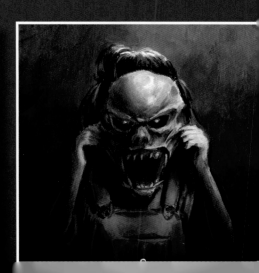

A quintessential *Goosebumps* cover, the disgusting, creepy, sickly-green mask is juxtaposed with the image of a sweet, young girl. The overalls suggest innocence, while the dripping sharp fangs suggest horror. This cover is perfectly mysterious and unsettling.

To create it, Jacobus enlisted the help of his niece, Jessie, to be the model. Jessie held up Jacobus' dad's old rubber mask, which had been used as the head of a scarecrow before its big debut on a book cover. Jacobus snapped a picture of the scene and used it to create the now iconic artwork.

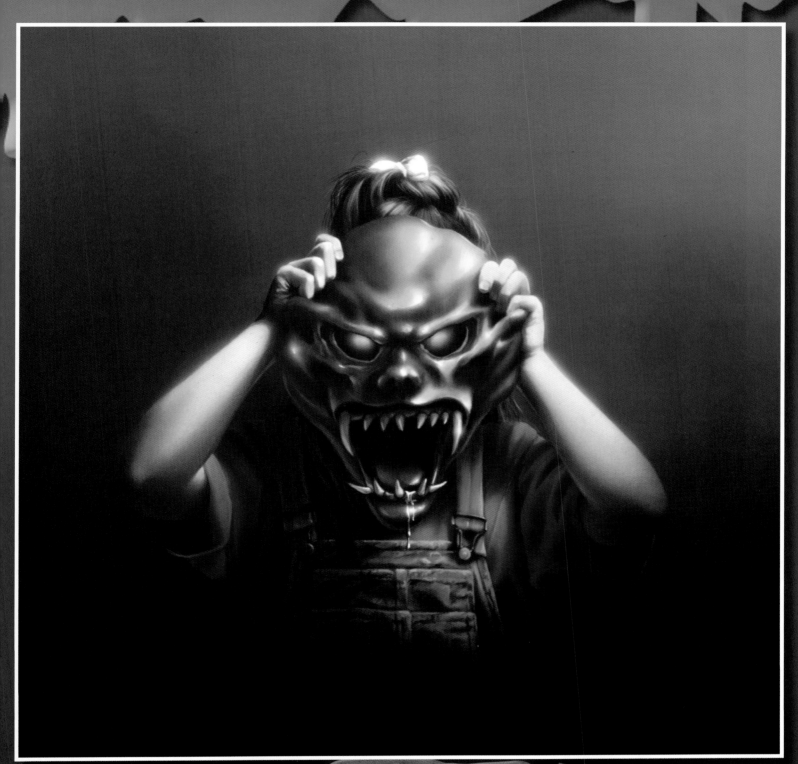

Stine Says:

This was one of my favorite books in the series and one that I'm most proud of. I was inspired to write it when my son, Matthew Stine, struggled to take off a mask he wore for Halloween. I thought the Halloween-themed book would make a great horror movie.

BE CAREFUL WHAT YOU WISH FOR...

REGULAR SERIES - BOOK #12 - OCTOBER 1993

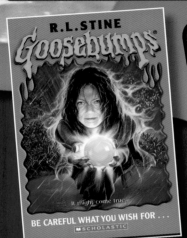

It might come true.

"Make a wish! Samantha Byrd is a klutz. An accident waiting to happen. She's the laughingstock of the girls' basketball team. And that mean, rotten Judith Bellwood is making her life miserable on and off the court. But everything's about to change. Sam's met someone who can grant her three wishes. For real. Too bad Sam wasn't careful what she wished for. Because her wishes are coming true. And they're turning her life into a living nightmare!"

Curly Says:

One of only two books in the initial *Goosebumps* run to feature cover art by an artist other than Jacobus, this cover was created by Stanislaw Fernandes. Fernandes brings his unique style, which utilizes a "flat" modern look to the *Goosebumps* aesthetic with his use of purples and shadows. The illustration shows Samantha Byrd with an expression of fear – or is it curiosity? – on her face. Clarissa's hands are visible over the crystal ball.

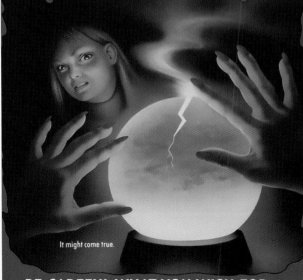

Original Cover by
Stanislaw Fernandes

Jacobus was on vacation, which is why he was unavailable to create the cover. He eventually designed the 2005 reprint, which shows Clarissa holding a crystal ball in the rain. Eerie smoke gathers around her and the strange perspective gives the cover a surreal feel.

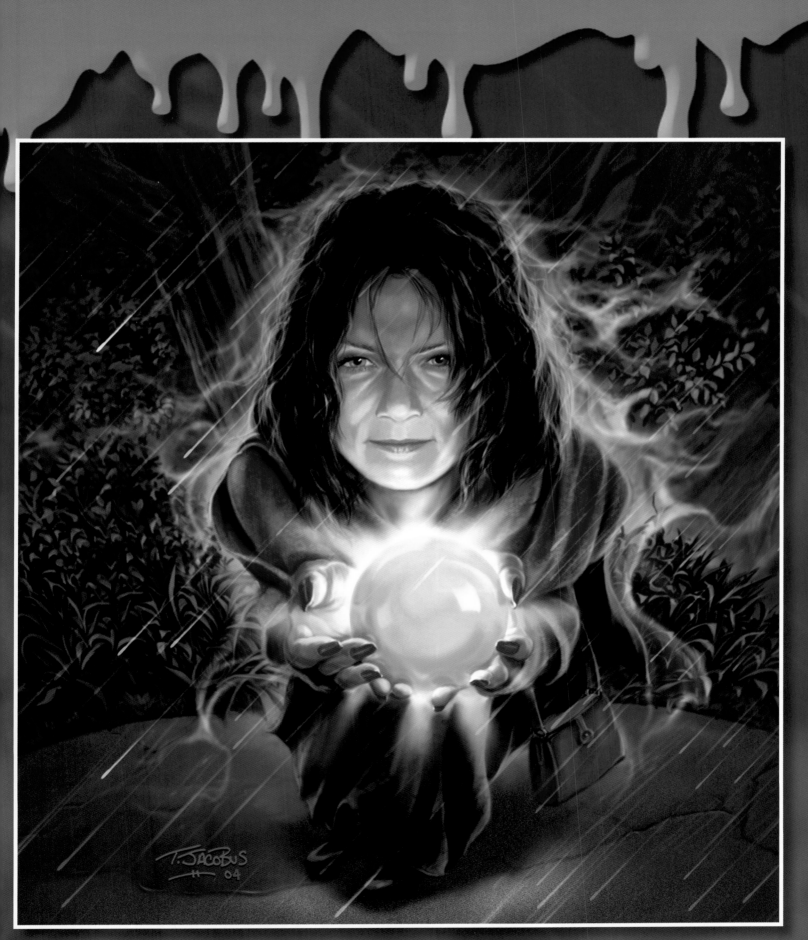

PIANO LESSONS CAN BE MURDER

REGULAR SERIES - BOOK #13 - NOVEMBER 1993

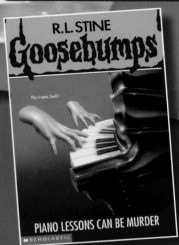

Play it again, hands!

"Practice till you drop... dead. When Jerry finds a dusty old piano in the attic of his new house, his parents offer to pay for lessons. At first, taking piano seems like a cool idea. But there's something creepy about Jerry's piano teacher, Dr. Shreek. Something really creepy. Something Jerry can't quite put his finger on. Then Jerry hears the stories. Terrifying stories. About the students at Dr. Shreek's music school. Students who went in for a lesson... and never came out."

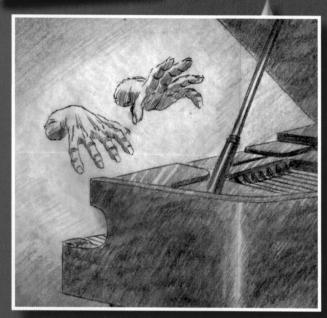

Pencil Sketch 1

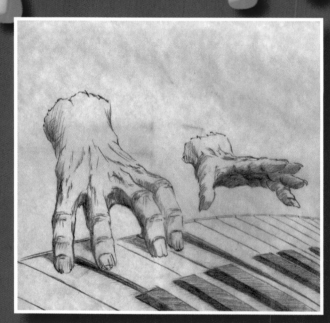

Pencil Sketch 2

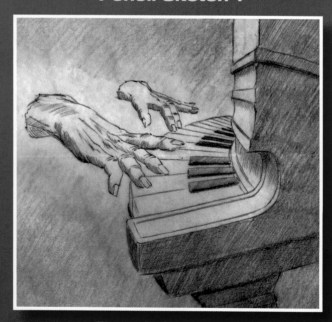

Pencil Sketch 3

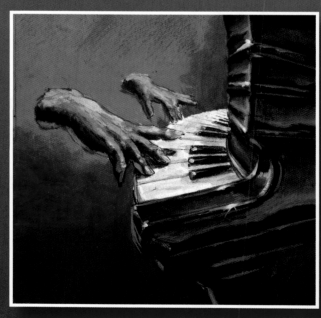

Color Mockup

Although technically the disembodied hands playing the piano are free of any gore, Jacobus' use of bright red for the background immediately brings to mind the idea of blood. This subtle technique raises the subconscious horror level of the cover, causing the reader to perhaps imagine a scene more gruesome than what is actually depicted.

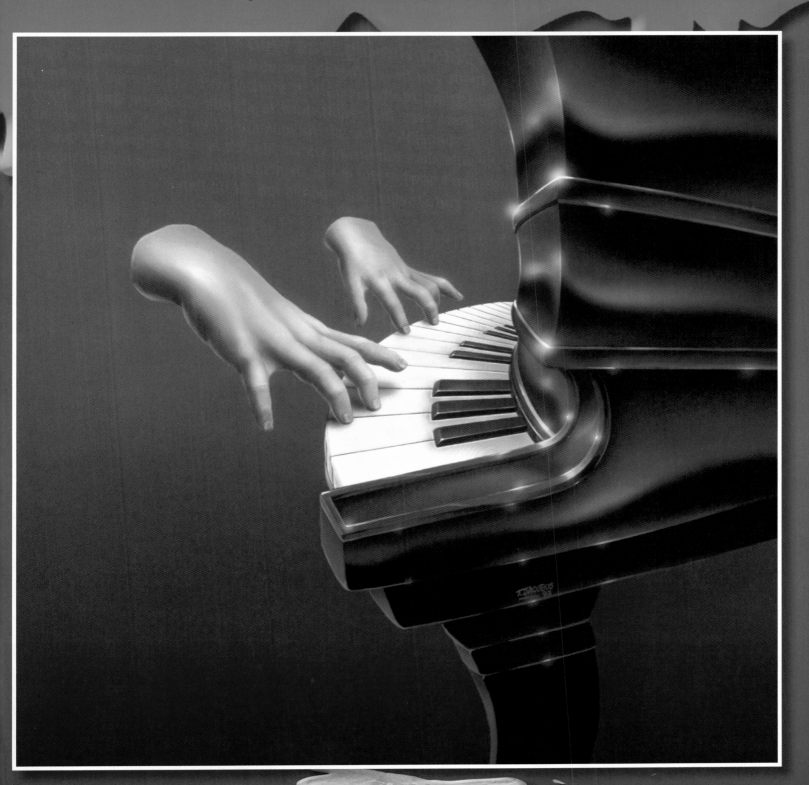

Stine Says:

This book was originally going to be called *Guitar Lessons Can be Murder*, inspired by my son's guitar lessons. However, I was apparently told by several people that guitars were not spooky enough for *Goosebumps*, so I chose the piano instead. I eventually got his ghastly guitar story in the book *More & More Tales to Give You Goosebumps*.

THE WEREWOLF OF FEVER SWAMP

REGULAR SERIES - BOOK #14 - DECEMBER 1993

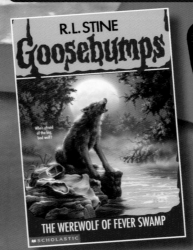

R.L. STINE
Goosebumps
Who's afraid of the big, bad wolf?
THE WEREWOLF OF FEVER SWAMP
SCHOLASTIC

Who's afraid of the big, bad wolf?

"What big teeth you have! There's something horrible happening in Fever Swamp. Something really horrible. It started with the strange howling at night. Then there was the rabbit, torn to shreds. Everyone thinks Grady's new dog is responsible. After all, he looks just like a wolf. And he seems a little on the wild side. But Grady knows his dog is just a regular old dog. And most dogs don't howl at the moon. Or disappear at midnight. Or change into terrifying creatures when the moon is full. Or do they?"

Pencil Sketch 1

Pencil Sketch 2

Pencil Sketch 3

Pencil Sketch 4

Pencil Sketch 5

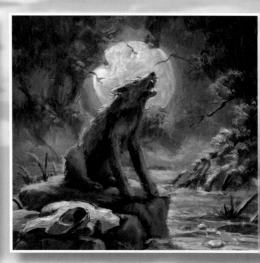

Color Mockup

The classic image of the wolf howling at the bright, full moon is given the *Goosebumps* treatment, as the realistic looking wolf is against a background of a neon green swamp and hazy purple sky. The other indication that this is not just an ordinary wolf is the pile of clothes, a tee shirt and a hat, on the rock next to the creature.

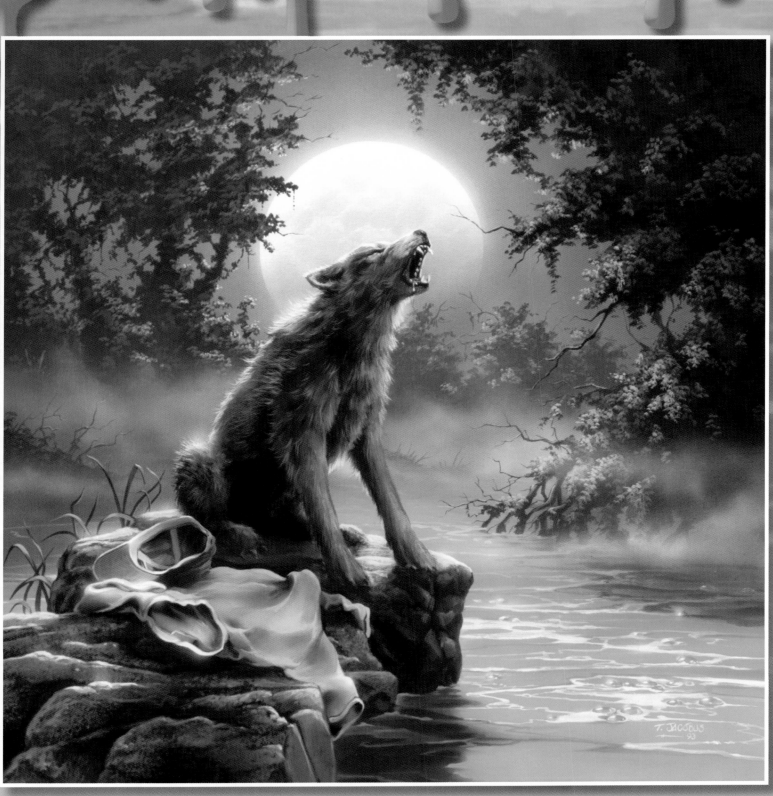

Further showing the evolution of the series, this was the first book to feature a page-long advertisement for the next *Goosebumps* novel.

YOU CAN'T SCARE ME!

REGULAR SERIES - BOOK #15 - JANUARY 1994

R.L. STINE
Goosebumps

They're coming for you...

YOU CAN'T SCARE ME!

■ SCHOLASTIC

They're coming for you...

" It's gonna be a scream! Courtney is a total show-off. She thinks she's so brave and she's always making Eddie and his friends look like wimps. But now Eddie's decided he's had enough. He's going to scare Courtney once and for all. And he's come up with the perfect plan. He's going to lure Courtney down to Muddy Creek. Because Eddie knows Courtney believes in that silly rumor about the monsters. Mud Monsters that live in the creek. Too bad Eddie doesn't believe the rumor. Because it just might be true..."

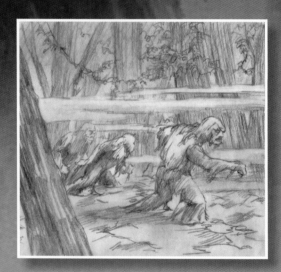

Pencil Sketch 1

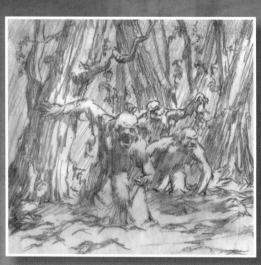

Pencil Sketch 2

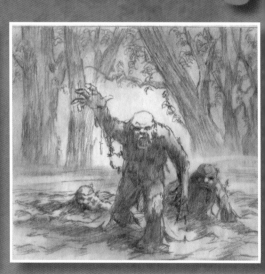

Pencil Sketch 3

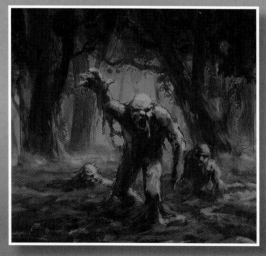

Color Mockup

Photo Shoot - Tim Jacobus

Given the main monsters of this book are called Mud Monsters, it only makes sense that this cover is one of the few to feature browns as the main color scheme. The disgusting Mud Monsters rise up from the stony creek bed, surrounded by a sickly, yellow-green haze. Jacobus added oranges, greens, and even a few tiny dashes of blue and purple to break up the neutral tone of the scene.

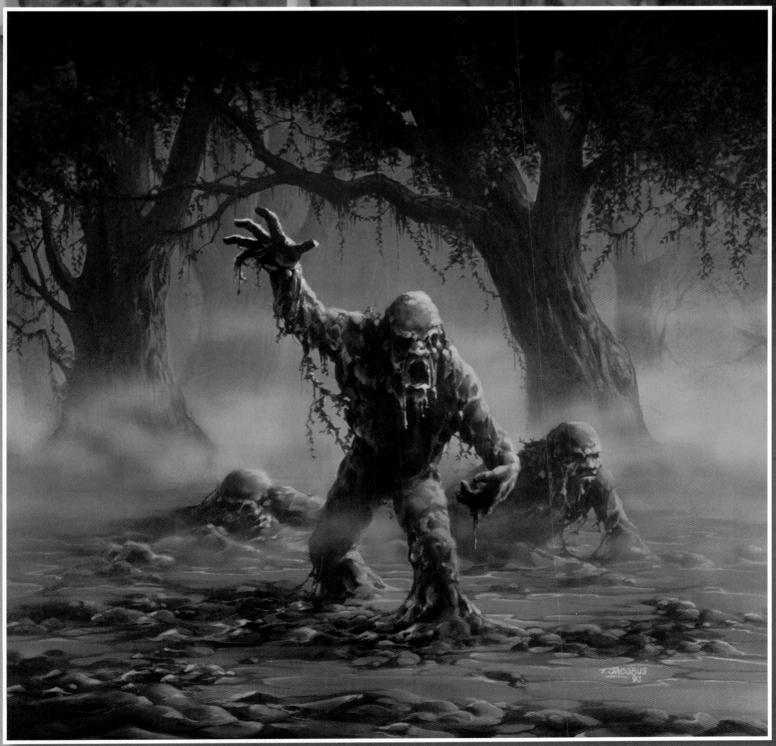

ONE DAY AT HORRORLAND

REGULAR SERIES - BOOK #16 - FEBRUARY 1994

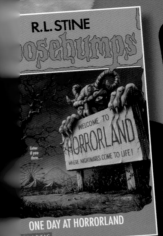

ONE DAY AT HORRORLAND

Enter if you dare...

"The next ride might be their last… The Morris family got lost trying to find Zoo Gardens Theme Park. But that's okay. They found another amusement park instead. It's called HorrorLand. In HorrorLand there are no crowds. No lines. And the admission is free. It seems like a pretty cool place. But that was before that heart-stopping ride on the deadly Doom Slide. And that terrifying experience in the House of Mirrors. Because there's something weird about the rides in HorrorLand. Something a little too creepy. A little too real…"

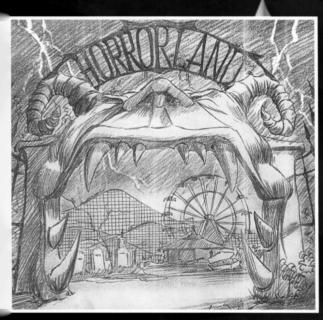

Pencil Sketch 1

Pencil Sketch 2

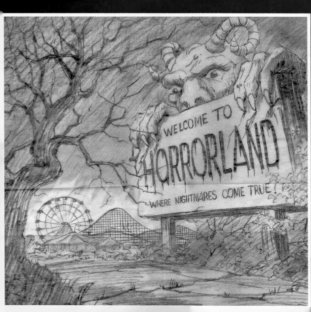

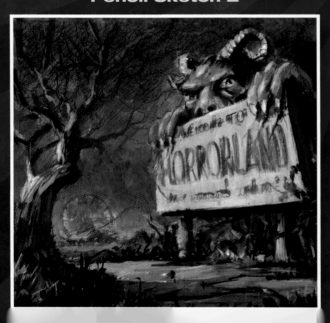

Another great example of blending a familiar scene with the unfamiliar, this cover features a giant horror, unable to fully hide behind the HorrorLand billboard. Jacobus used blues and muted greens to suggest loneliness and abandonment, with the amusement park lit slightly with orange to hint that night is falling. The red paint on the welcome sign drips ominously, like blood. The overall effect is creepy without being overtly so.

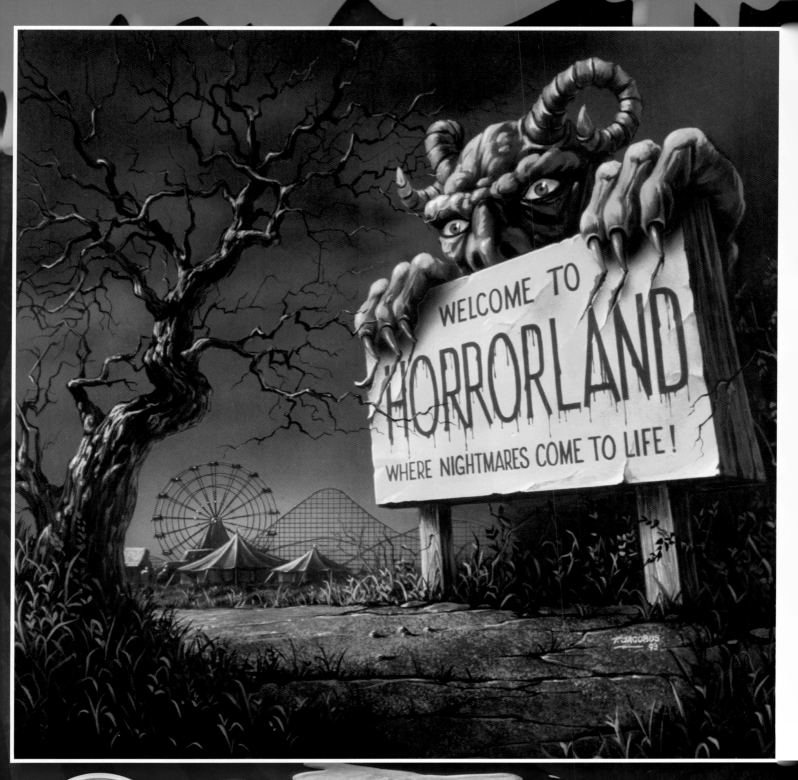

Stine Says:

This is one of my favorite books, and fans agree:
a 2015 poll on the official Scholastic Tumblr page resulted in
Welcome to HorrorLand winning favorite book of the
original series.

WHY I'M AFRAID OF BEES

REGULAR SERIES - BOOK #17 - MARCH 1994

He's no ordinary human bee-ing...

"Right brain. Wrong body. Gary Lutz needs a vacation... from himself. Bullies are constantly beating him up. His only friend is his computer. Even his little sister doesn't like him. But now Gary's dream is about to come true. He's going to exchange bodies with another kid for a whole week. Gary can't wait to get a new body. Until something horrible happens. And Gary finds out his new body isn't exactly human..."

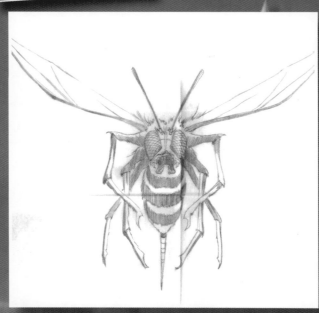

Pencil Sketch 1

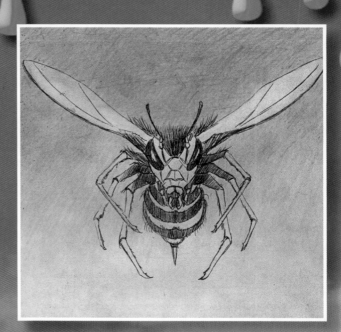

Pencil Sketch 2

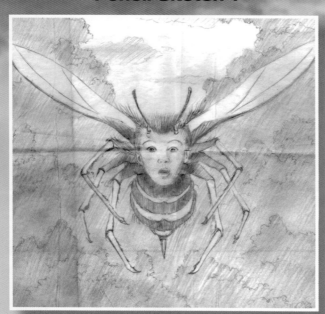

Pencil Sketch 3

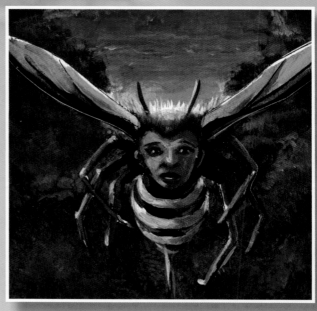

Color Mockup

This cover features gorgeous, green trees, a beautiful sunrise, and a bee with a terrified expression of a young boy. The flight over the trees and in the reader's direction gives more of a sense of adventure than the usual horror vibes of many of the covers. The use of Gary Lutz's head on the bee body is both metaphorical, because he only swaps minds with the bee, but also reminiscent of the classic horror film *The Fly* (1958).

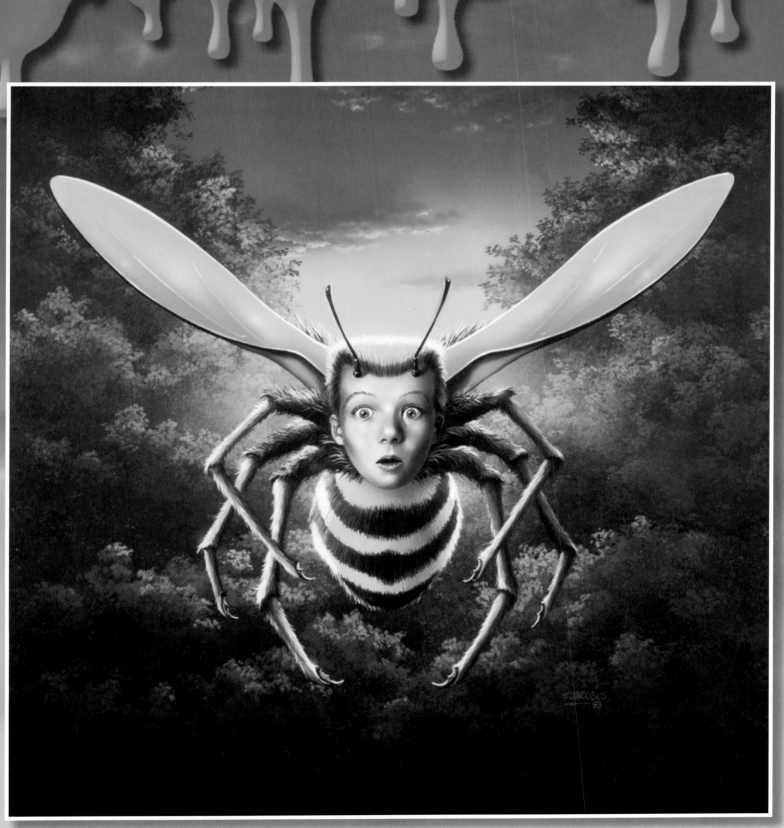

Interestingly, and possibly owing to the brightness of the colors used, this is the only original *Goosebumps* cover to use black text for the tagline.

MONSTER BLOOD II

REGULAR SERIES - BOOK #18 - APRIL 1994

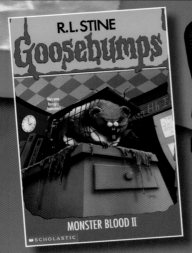

He's one hungry hamster!

"It's baaack... Evan Ross can't stop thinking about Monster Blood and what happened last summer. It was so horrible. So terrifying. Too bad Evan's science teacher doesn't believe him. Now he's stuck cleaning out the hamster's cage as punishment for making up stories. Then Evan's friend Andy comes to town, and things go from bad to worse. Because Andy's got a present for Evan. It's green and slimy and it's starting to grow..."

Pencil Sketch 1

Pencil Sketch 2

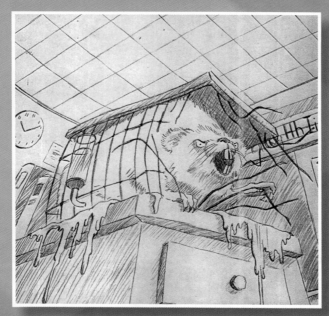

Pencil Sketch 3

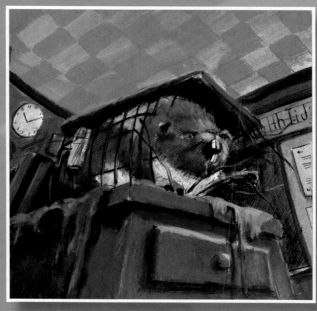

Color Mockup

Another quintessential Jacobus cover, *Monster Blood II* depicts Cuddles the hamster breaking through his cage. Monster Blood drips down from the top of the desk and the ripped cage and Cuddles' ferocious teeth suggest that this is no ordinary class hamster. Looking at the alphabet and tiled ceiling, it becomes clear that curved perspective, almost like a fisheye lens, is being utilized, invoking the feeling of a waking nightmare.

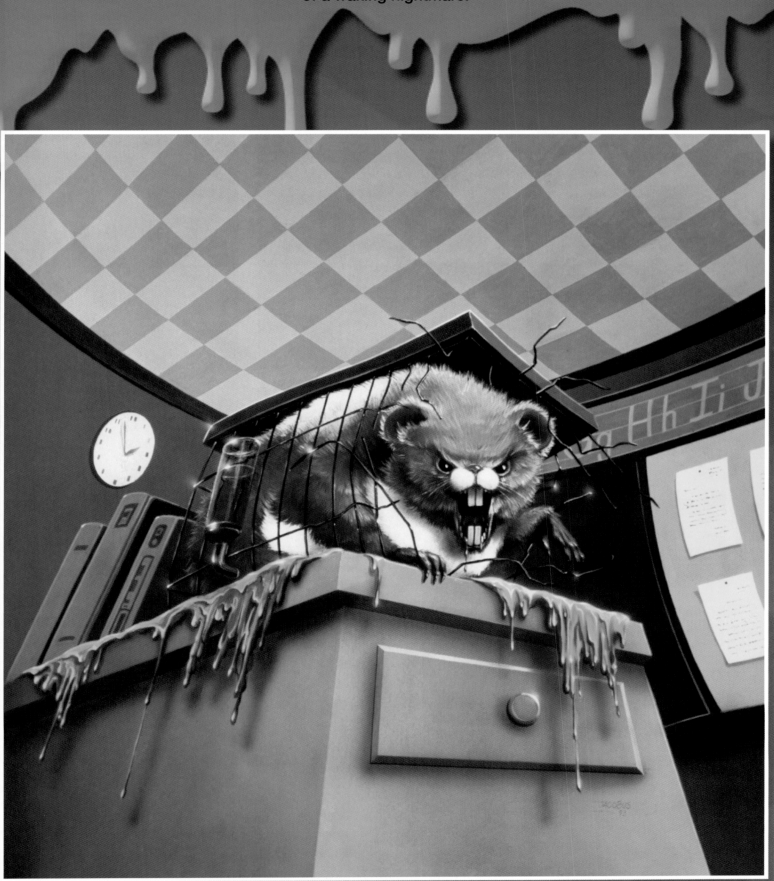

This is the first of many sequels in the original *Goosebumps* series. The only similarity between the covers of the first and second books in the *Monster Blood* series is the green, viscous blood.

DEEP TROUBLE

REGULAR SERIES - BOOK #19 - MAY 1994

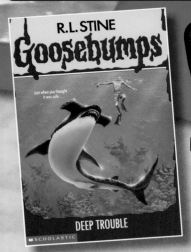

R.L. STINE
Goosebumps

Just when you thought it was safe.

DEEP TROUBLE

Ⓜ Scholastic

Just when you thought it was safe...

"Don't go in the water! Billy and his sister, Sheena, are visiting their uncle Dr. Deep on a tiny Caribbean island. It's the perfect place to go exploring underwater...and Billy's ready for an adventure. There's only one rule to remember: Stay away from the coral reefs. Still, the reefs are so beautiful. So peaceful. Billy can't resist. But he's not alone in the water. Something's lurking deep below the surface. Something dark and scaly. Something's half-human, half-fish..."

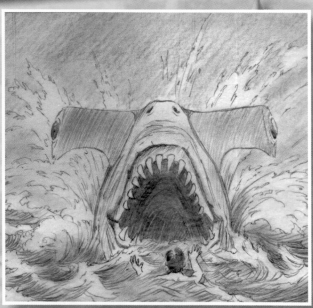

Pencil Sketch 1

Pencil Sketch 2

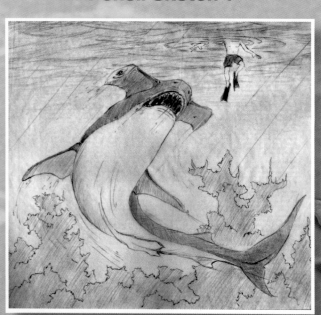

Pencil Sketch 3

Curly Says:

This is the final book of the original series to use the basic font *Goosebumps* title on the spine. It would be changed to the *Goosebumps* slime logo on the next book.

50

Inspired by the movie *Jaws* (1975), this cover plays on a common fear: what lies waiting for us beneath deep water? To create the realistic look of weightless limbs dangling in the water, Jacobus had his friend, Donny, sit on a stool in his backyard. He used cuts of light green into the blue to show the sun shining down into the water, and his trademark purple shows up in the underwater foliage. For the hammerhead shark, Jacobus used pictures from the encyclopedia.

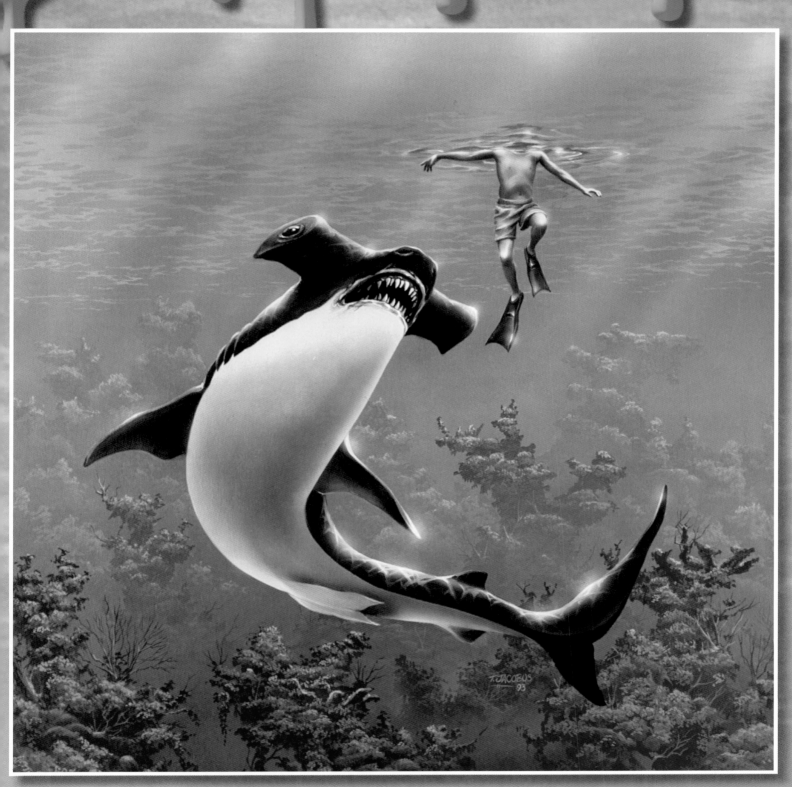

In 1995, *Deep Trouble* became the first of three *Goosebumps* books to win a Nickelodeon Kids' Choice Award.

THE SCARECROW WALKS AT MIDNIGHT

REGULAR SERIES - BOOK #20 - MAY 1994

It's a field of screams!

"They're alive! Jodie loves visiting her grandparents' farm. Okay, so it's not the most exciting place in the world. Still, Grandpa tells great scary stories. And Grandma's chocolate chip pancakes are the best. But this summer the farm has really changed. The cornfields are sparse. Grandma and Grandpa seem worn out. And the single scarecrow has been replaced by twelve evil-looking ones. Then one night Jodie sees something really odd. The scarecrows seem to be moving. Twitching on their stakes. Coming alive..."

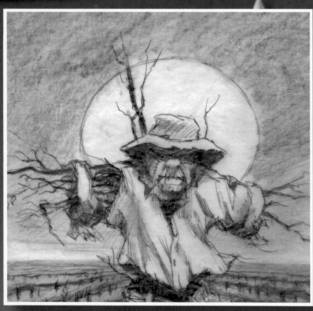

Pencil Sketch 1

Pencil Sketch 2

Pencil Sketch 3

Color Mockup

Scarecrows are already generally a creepy subject. The cover depicts a seemingly average scarecrow in a cornfield, with a bright, full moon and stars overhead in the purple sky. Only two things suggest this is not an ordinary sack of straw and sticks. First, the alarming, ruddy light shining in from the bottom of the illustration suggests fire. Secondly, the eyes of the scarecrow look startlingly realistic…and alive.

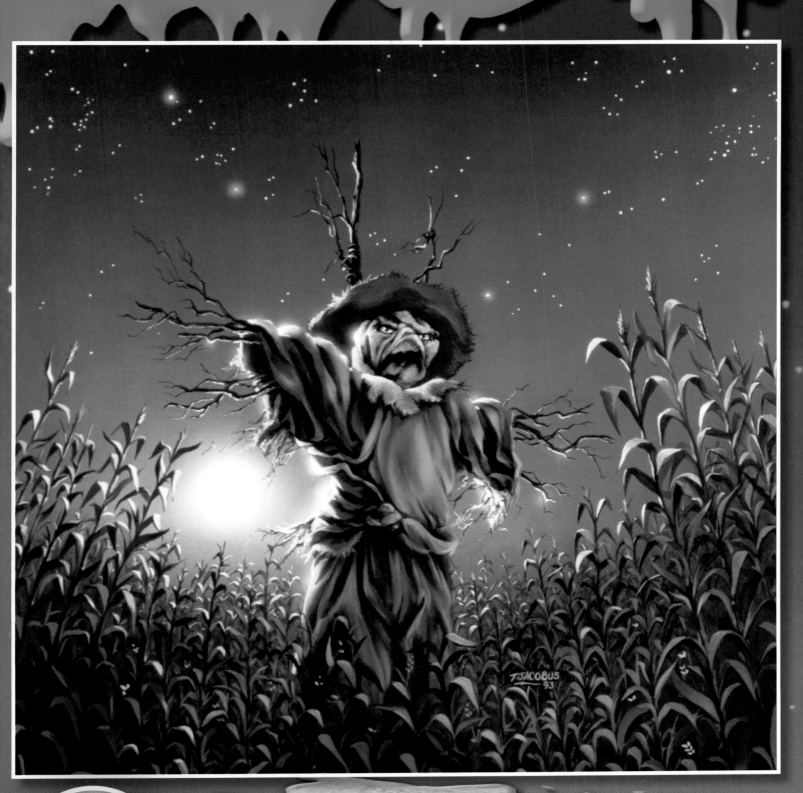

Stine Says:

This is one of my scarier works.
The tagline "It's a field of screams!" is a reference to the
1989 film, *Field of Dreams*.

53

GO EAT WORMS!

REGULAR SERIES - BOOK #21 - JULY 1994

Homework was never this gross before!

"They're creepy and they're crawly — they're totally disgusting! Obsessed with worms? That's putting it mildly. Todd is so fascinated with worms, he keeps a worm farm in his basement! Most of all, Todd loves torturing his sister and her best friend with worms. Dropping them into their hair. Down their backs. Until one day, after cutting a worm in half, Todd notices something strange. The rest of the worms seem to be staring at him! Suddenly worms start showing up in the worst places for Todd. In his bed. In his homework. Even in his spaghetti! What's a worm lover to do when his own worms are starting to gross him out?"

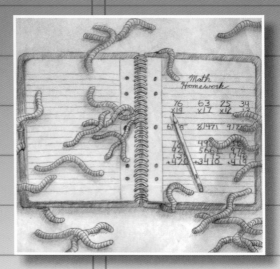

Pencil Sketch 1

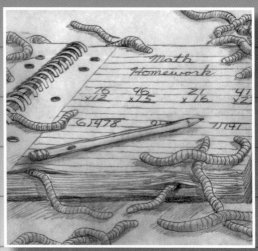

Pencil Sketch 2

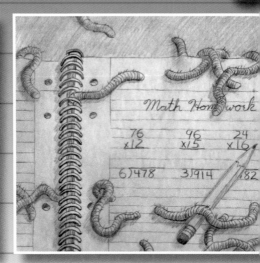

Pencil Sketch 3

Pencil Sketch 4

Color Mockup

Many *Goosebumps* cover illustrations mix something mundane with something horrifying, but this cover is instead a combination of two scary things: math homework and worms. The segmented purple worms burst through the yellow pages of the notebook, showing the reader exactly what they're getting into.

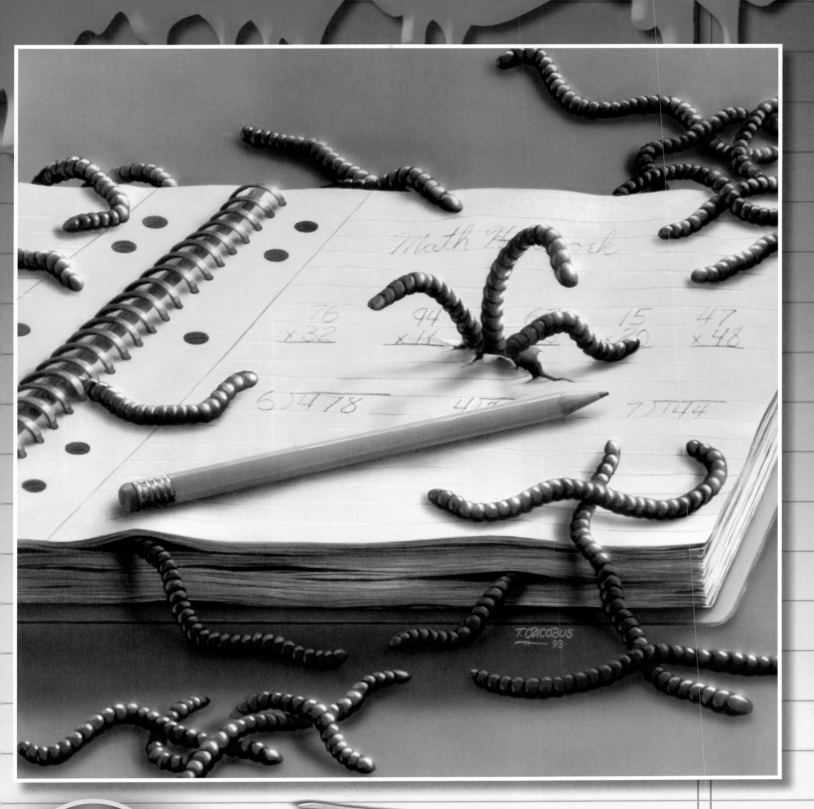

Stine Says:

This is one of my least favorite *Goosebumps* books, I was not happy with the story itself.

GHOST BEACH

REGULAR SERIES - BOOK #22 - AUGUST 1994

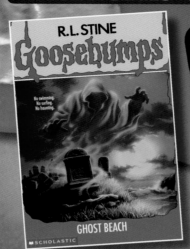

R.L. STINE
Goosebumps

No swimming
No surfing.
No haunting

GHOST BEACH

SCHOLASTIC

No swimming. No surfing. No haunting

"Do you believe in ghosts? Jerry can't wait to explore the dark, spooky old cave he found down by the beach. Then the other kids tell him a story. A story about a ghost who lives deep inside a cave. A ghost who is three hundred years old. A ghost who comes out when the moon is full. A ghost who is haunting the beach. Just another stupid ghost story. Right?"

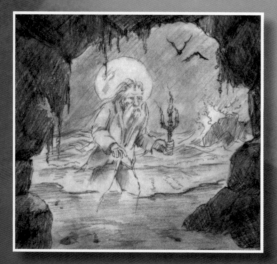

Pencil Sketch 1

Pencil Sketch 2

Pencil Sketch 3

Pencil Sketch 4

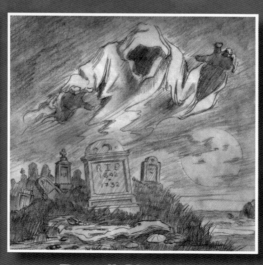

Pencil Sketch 5

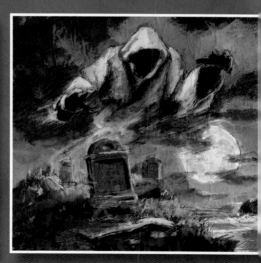

Color Mockup

In his autobiography, Jacobus suggests using different colors to elicit responses and to make the viewer feel something. He suggests black, gray, and deep blue for dark and gloomy moods, red and orange for fiery feelings and soft blues and greens for calm and peaceful moods. The blues and greens of this illustration are calming, despite the enormous ghost, making the overall effect an eerie, quiet vibe. You can practically hear the ocean. The mood is completed with the trademark Jacobus full moon, an ominous swirling of clouds and the hooded figure rising from the tombstone.

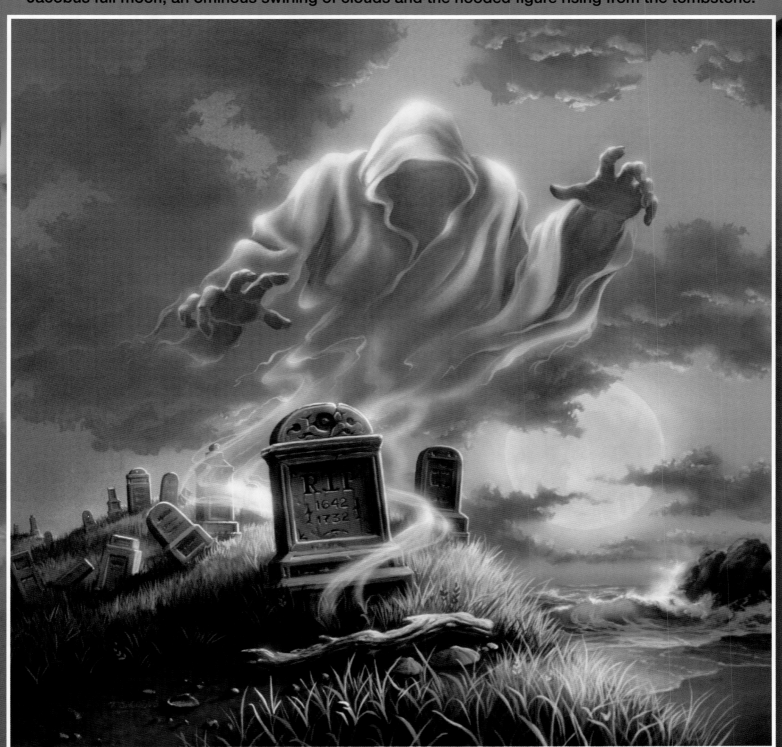

Curly Says:

The dates of the grave on the cover are interesting because the person buried would have been born a year after the great storm that nearly wiped out the Sadler ancestors, and lived to be ninety years old. Coincidence? Another bit of trivia is that this is currently the only *Goosebumps* book wherein every human character in the story shares the same last name.

The next wave of *Goosebumps* books set a precedent for several series within the series with the release of *Return of the Mummy, Monster Blood III, Night of the Living Dummy II, The Haunted Mask II, Night of the Living Dummy III,* and *Say Cheese and Die - Again!* The covers for these continuing stories often contained callbacks to the first books, whether through motif, color, or returning characters.

By the start of the school year, in September 1994, *Goosebumps* was enormously popular with both boys and girls, a unique achievement in children's publishing. Demand for the series increased, leading to the books being published bi-monthly by the ninth book.

This next series of books starts with a number of covers that evoke several classic characters, including the mummy, the Phantom of the Opera, the wolf boy, the executioner, and even Batman. These archetypal images help convey immediately to a potential reader a sense of familiarity and curiosity.

Slappy Says:

After graduating art school, Tim Jacobus worked many jobs, including painting bread and chicken for local grocery store ads. He also cleaned fish at a salmon cannery in Alaska and was a construction worker in New Jersey. His first cover painting job was for a *Star Trek* book. He illustrated several more sci-fi covers before landing the gig he would become best known for: *Goosebumps*.

R.L. STINE

Goosebumps

He's back... from the dead!

RETURN OF THE MUMMY

REGULAR SERIES - BOOK #23 - SEPTEMBER 1994

He's back...from the dead!

"Dead... or alive! After last year's scary adventure, Gabe's a little nervous about being back in Egypt. Back near the ancient pyramids. Back where he saw all those creepy mummies. Then he learns about an Egyptian superstition. A secret chant that is supposed to bring mummies to life. Gabe's uncle says it's just a hoax. But now it sounds like something's moving in the mummy's tomb. No way a couple of dumb words can wake the dead. Can they?"

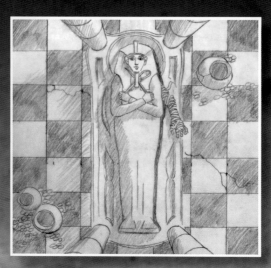

Pencil Sketch 1

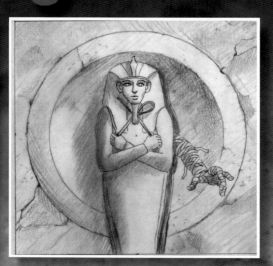

Pencil Sketch 2

Pencil Sketch 3

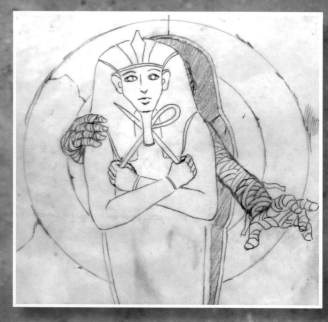

Pencil Sketch 4

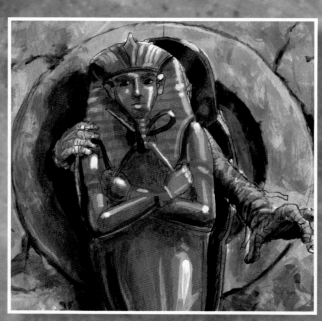

Color Mockup

The second sequel in the *Goosebumps* series, this cover is a direct callback to *The Curse of the Mummy's Tomb*, featuring a repeat of the blue stone circle motif. This version of the stone circle is a bit larger, and we see more of the mummy, this time with a beautiful gold and blue sarcophagus covering Prince Khor-Ru's face.

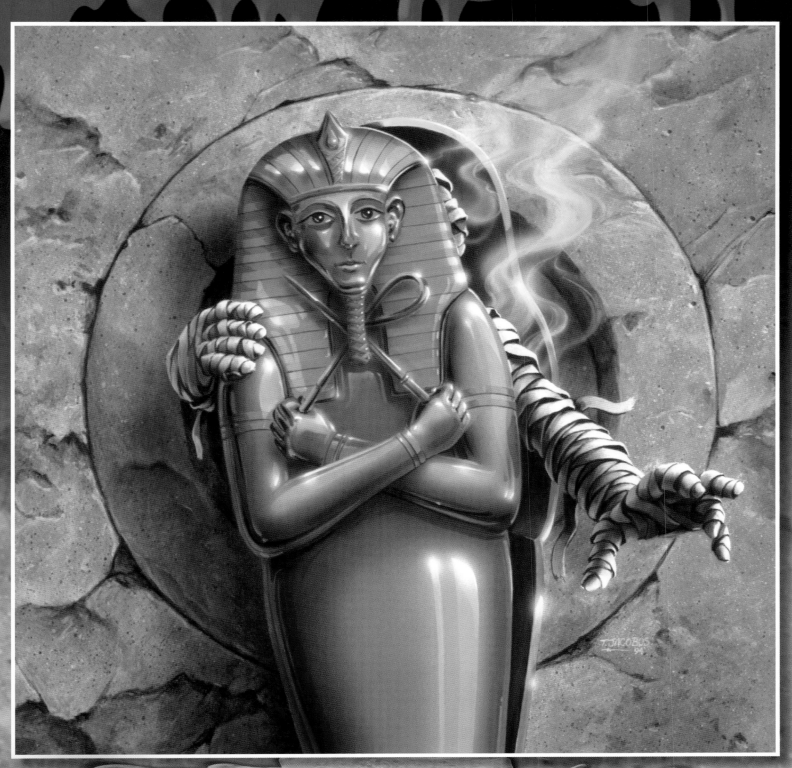

Stine Says:

Despite the title, the mummy from the first book does not actually return in this sequel. This is also the first sequel to feature a different title, rather than just a numeral after the name.

PHANTOM OF THE AUDITORIUM

REGULAR SERIES - BOOK #24 - OCTOBER 1994

He's out to stop the show... for good!

"Lights… curtain… phantom? Brooke's best friend, Zeke, has been given the lead role in the school play, the Phantom. Zeke's totally into it. He loves dressing up in the grotesque phantom costume. And scaring the other members of the cast. Brooke thinks Zeke's getting a little too into it. But then really scary things start happening. A message appears on a piece of scenery: "The Phantom Strikes!" A stage light comes crashing down. Is someone trying to ruin the play? Or is there really a phantom living under the stage?"

Pencil Sketch 1

Pencil Sketch 2

Pencil Sketch 3

Pencil Sketch 4

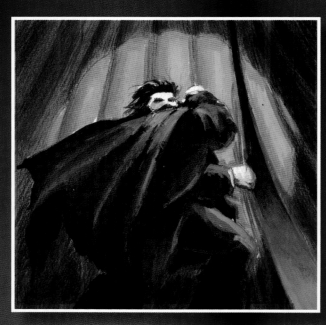

Color Mockup

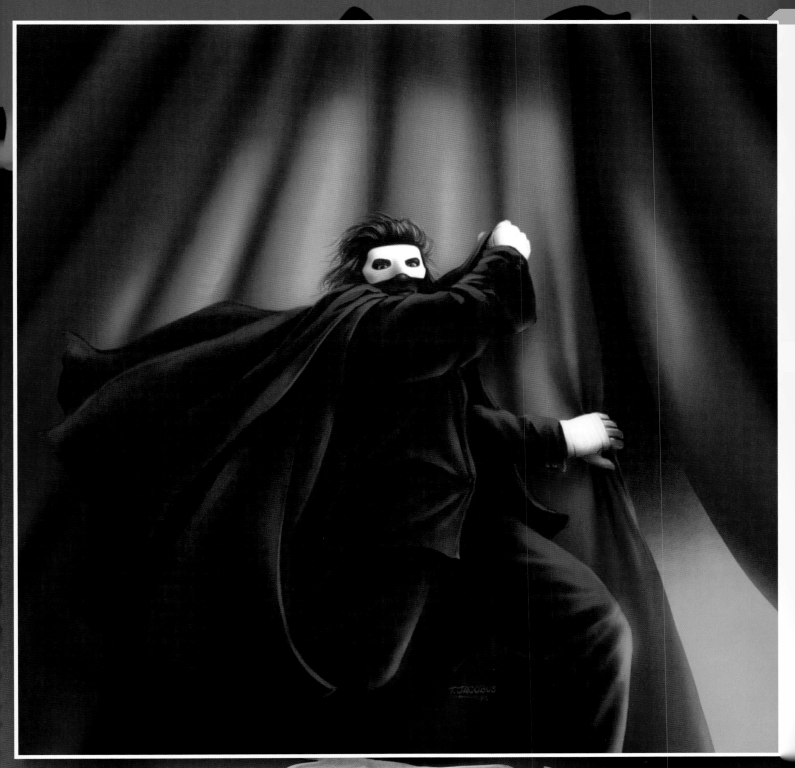

With all the drama of a classic movie poster, this book cover depicts the easily recognizable *Phantom of the Opera* character that inspired this story. The use of highlights on the magenta curtains creates the feeling of movement, and the glowing green light shining from behind the curtains sets an ominous tone.

Stine Says:

Appropriately enough, this book spawned a musical play entitled *Goosebumps The Musical: Phantom Of the Auditorium*. The script was written by John Maclay and the music was by Danny Abosch. The musical debuted in the Fall of 2016 in Wisconsin and Oregon before being produced in other theaters throughout the United States.

ATTACK OF THE MUTANT

REGULAR SERIES - BOOK #25 - NOVEMBER 1994

He's no superhero. He's a supervillain!

"Read at your own risk… Skipper Matthews has an awesome comic book collection. His favorite one is called The Masked Mutant. It's about an evil supervillain who's out to rule the universe! Skipper can't get enough of The Mutant. Until one day he gets lost in a strange part of town. And finds a building that looks exactly like The Mutant's secret headquarters. A building that appears and disappears. Has Skipper read one too many comic books? Or does The Masked Mutant really live in Riverview Falls?"

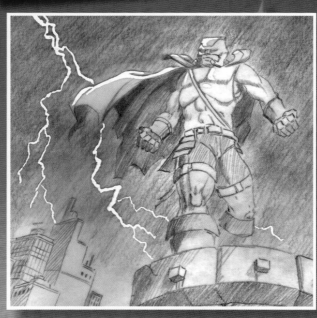

Pencil Sketch 1

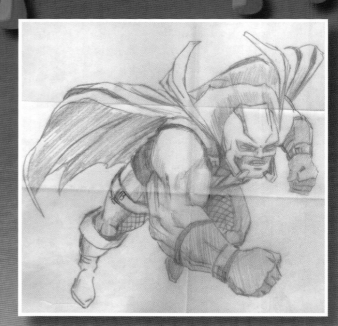

Pencil Sketch 2

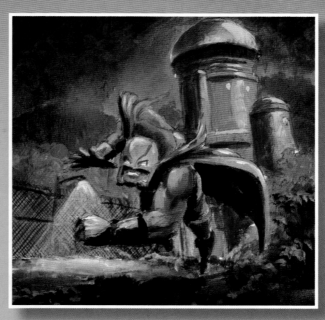

Color Mockup

In an homage to comic book heroes, the Masked Mutant springs forward on this cover in a traditional superhero pose, complete with flaring cape and bulging muscles. Behind him rises the secret lair, set in the woods near an imposing fence. The use of white color to recreate lens flare on the sides of the buildings creates a metallic look that's perfect for a villain's hideout. The purple sky lightens to pink near the tree lines, hinting at sunrise -- or sunset.

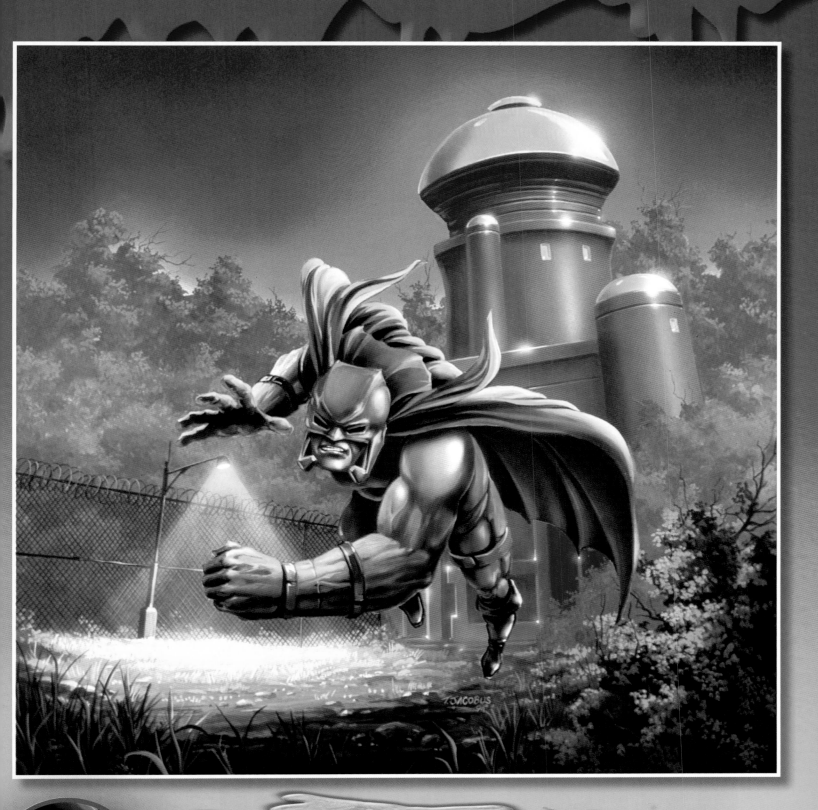

Slappy Says:

Keeping with the classic vibe, the television episode of this novel features a cameo from the original television Batman himself, Adam West, as the Galloping Gazelle.

MY HAIRIEST ADVENTURE

REGULAR SERIES - BOOK #26 - DECEMBER 1994

It keeps growing... and growing... and growing...

"He's having a really, really bad hair day... Larry Boyd just found the coolest thing in the trash. It's an old bottle of INSTA-TAN. 'Rub on a dark suntan in minutes'-- that's what the label says. So Larry and his friends do. But nothing much happens. Until Larry notices the hair. Dark, spikey hair growing on his hands and face. Really gross shiny hair. Hair that keeps growing back even after he shaves it off..."

Pencil Sketch 1

Pencil Sketch 2

Color Mockup

Photo Shoot

Aclassic *Goosebumps* cover, the tousle haired child in a quintessentially '90s sweater is placed in a surreal situation. Larry's face shows shock at his hairy hands, and the blues used in the bathroom and bright whites from the lighting juxtaposes the thick, dark hair. The image calls to mind scenes from a werewolf movie: the moment the character realizes their nightmare is coming true.

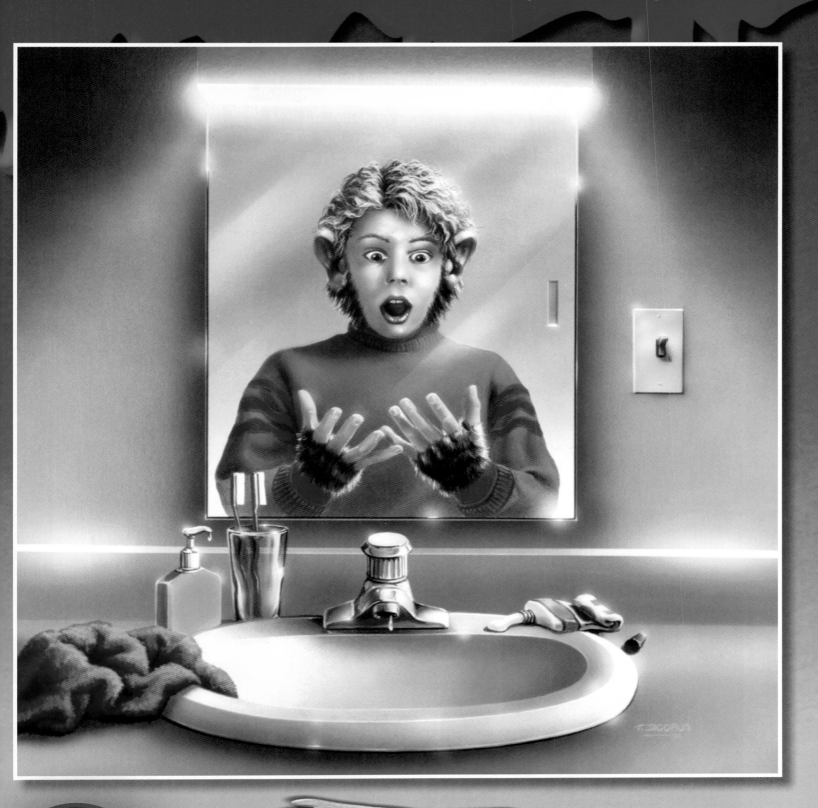

Slappy Says:

Jacobus' signature, along with a crumpled, red towel, are hidden by the slime on the final cover. They are, however, visible on the reprint edition.

NIGHT IN TERROR TOWER

REGULAR SERIES - BOOK #27 - JANUARY 1995

A NIGHT IN TERROR TOWER

It's gonna be a L-O-N-G night!

"All locked up and no place to go! Sue and her brother, Eddie, are visiting London when they run into a little problem. They can't find their tour group. Still, there's no reason to panic. No way their tour guide would just leave them. All alone. In a gloomy old prison tower. No way they'd get locked inside. After dark. With those eerie sounds. And a strange dark figure who wants them... dead."

Pencil Sketch 1

Pencil Sketch 2

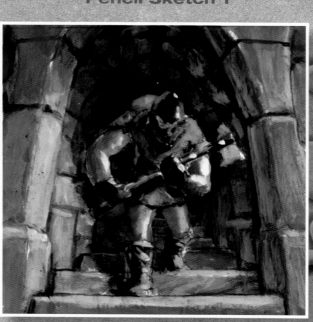

Color Mockup

Slappy Says:

This cover was one of Jacobus' least favorites of the series and the hardest he has ever had to paint. Jacobus ran into deadline issues and did not have the normal amount of time he uses to work on book covers. He completed the illustration in a thirty-hour marathon as quickly as he could, though he doesn't think anyone else could tell it was rushed.

The stone archway on this cover serves both to highlight and shadow the central figure, the Lord High Executioner. It accomplishes this through the diagonal that cuts across him, separating the warm brown stone from the cool blue stone, giving the character the impression of stepping forward from the shadow towards the reader. The green clothes, ax and black executioner's mask immediately suggest the figure is a villain, and Jacobus added lines of white to the ax to imitate the glint of metal.

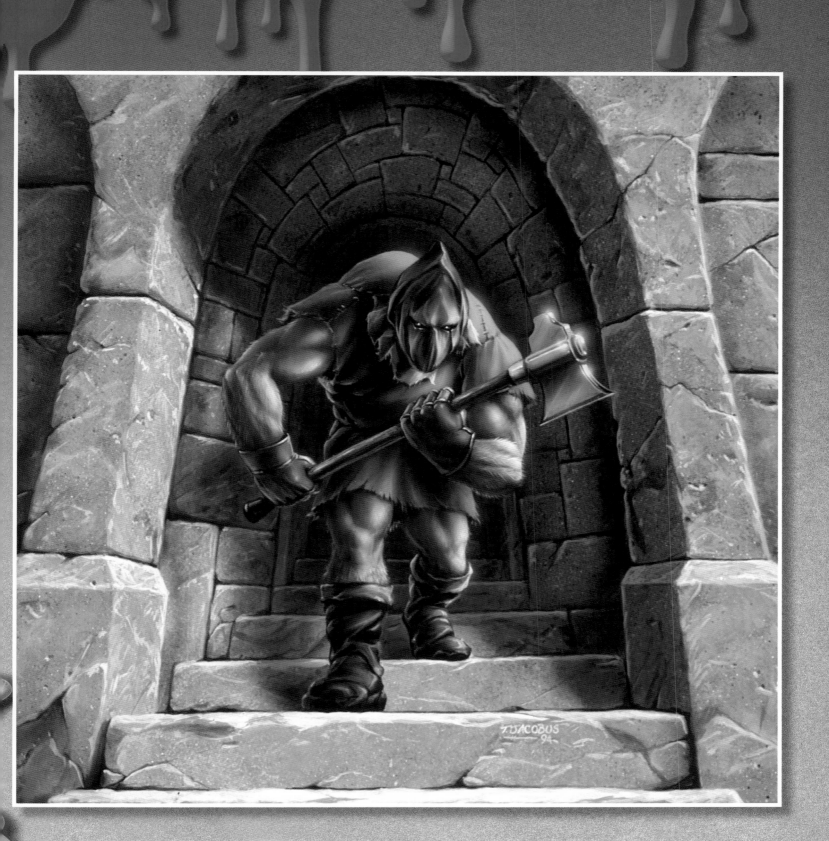

THE CUCKOO CLOCK OF DOOM

REGULAR SERIES - BOOK #28 - FEBRUARY 1995

Keep your eye on the birdie

"Don't beat the clock! Tara the Terrible. That's what Michael Webster calls his bratty little sister. She loves getting Michael in trouble. Making his life miserable. Things couldn't get any worse. Then Mr. Webster brings home the antique cuckoo clock. It's old. It's expensive. And Mr. Webster won't let anyone touch it. Poor Michael. He should have listened to his dad. Because someone put a spell on the clock. A strange spell. A dangerous spell. And now Michael's life will never be the same again…"

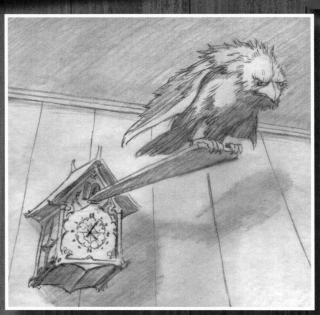

Pencil Sketch 1

Pencil Sketch 2

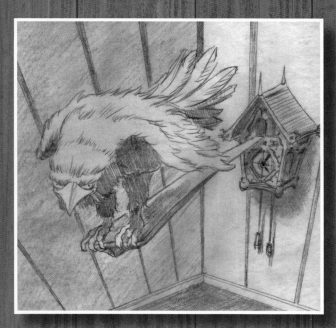

Pencil Sketch 3

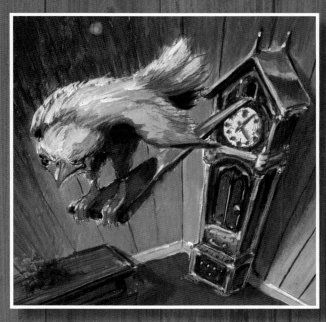

Color Mockup

According to Jacobus, this was one of the titles he was sent that made him laugh. It does sound a bit ridiculous, as cuckoo clocks are normally associated with old and gentle things. Perhaps playing on that idea, the cuckoo featured in this illustration is incredibly unsettling. It almost looks like a Tweety Bird, or a smaller version of Big Bird, but the flat-looking blue eyes and slightly lifted wings suggest a predatory fowl, such as a hawk. Jacobus uses the strange perspective to create movement: the bird appears to leap out from the clock in the background. The colors and lines on the wall leading up from the single tone red floor helps to heighten this feeling of movement within the illustration.

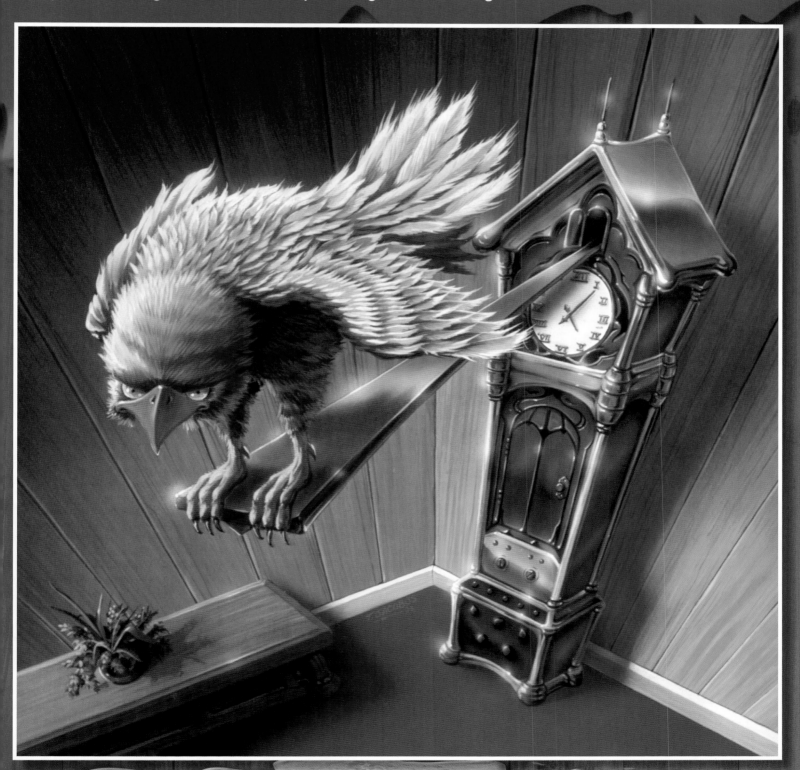

Stine Says:

This is the second book in the *Goosebumps* series to feature time travel as a central plot point, with the first book being its immediate predecessor, *A Night in Terror Tower*.

MONSTER BLOOD III

REGULAR SERIES - BOOK #29 - MARCH 1995

Evan's growing up way too fast!

"It's the slime that never dies! Evan can't stand baby-sitting his genius cousin, Kermit. Kermit refuses to play video games. He won't even play Frisbee! All he likes to do is hang out in the basement doing strange experiments and playing mean practical jokes on Evan and his friend Andy. But now Andy's found something that will teach Kermit a lesson once and for all. It's green. It's slimy. And it comes in a can marked... Monster Blood!"

Pencil Sketch 1

Pencil Sketch 2

Pencil Sketch 3

Photo Shoot

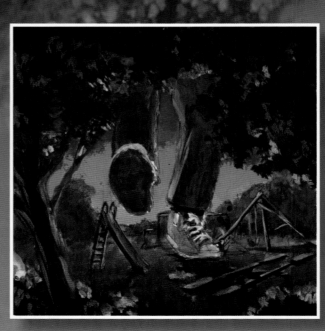

Color Mockup

Jacobus' color choices for the skies in his illustrations often give the impression of an in-between time, either dusk or dawn. The yellow-green leaves closest to the subject of the illustration serve to pull the sunlight towards the reader, with the purple leaves subtly giving the impression of shadow to highlight this effect.

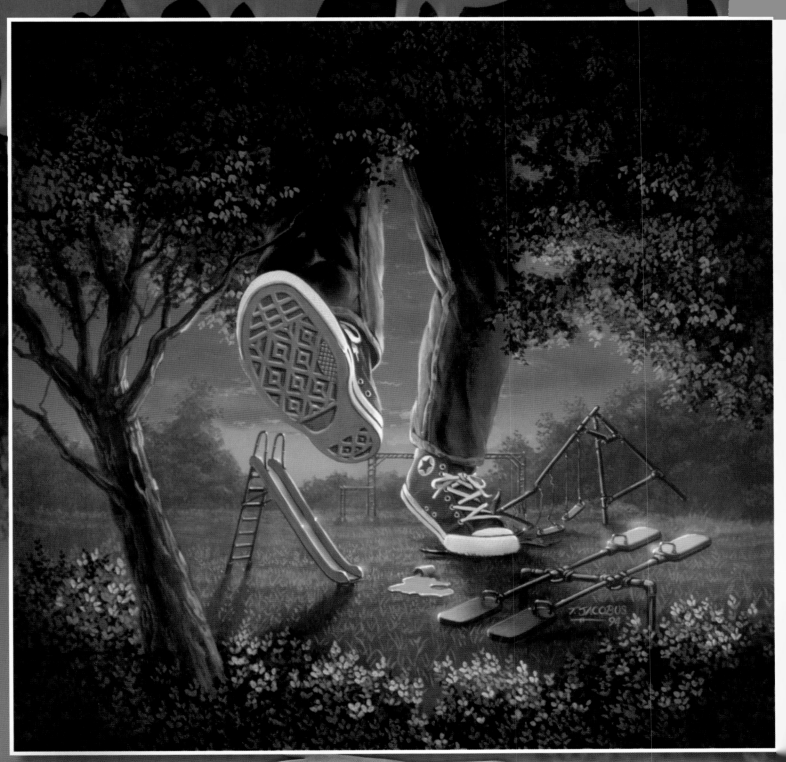

Slappy Says:

The first "threequel" in the series, this cover continues the tradition of featuring the titular monster blood as green slime. It also once again features Jacobus' use of Converse shoes, this time in enormous form.

IT CAME FROM BENEATH THE SINK!

REGULAR SERIES - BOOK #30 - APRIL 1995

R.L. STINE
Goosebumps

It's warm! It's breathing!
And it doesn't do dishes!

IT CAME FROM BENEATH THE SINK!

SCHOLASTIC

It's warm! It's breathing! And it doesn't do dishes!
"Their luck's about to go down the drain… Kat and her brother, Daniel, are so lucky. They just moved to a new house with tons of rooms, two balconies, and a lawn the size of a football field! But all that good luck is about to run out. Because there's something really evil living in their new house. Something that's moving. Watching. Waiting. Something that comes from beneath the kitchen sink…"

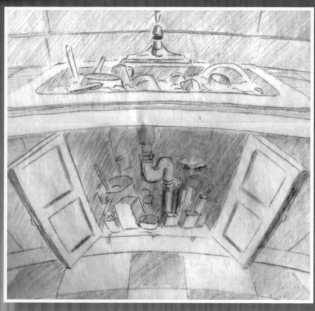

Pencil Sketch 1

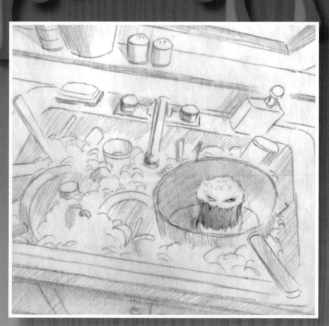

Pencil Sketch 2

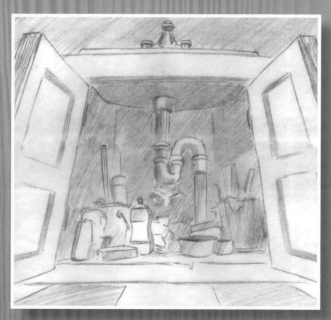

Pencil Sketch 3

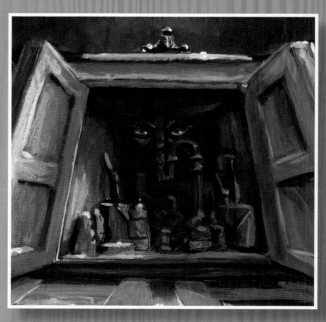

Color Mockup

An ordinary scene of a kitchen sink — and all of the junk people tend to put under their sinks — is marred by the unsettling reptilian green eyes of the Grool. In this cover, Jacobus uses color to give the impression of shadow and light. The tiles on the floor are blue and red in the shadow, but blue and orange in the light. Likewise, the area under the sink is purple in the shadows and orange in the light. The blues and purples above the sink do not actually follow a light source. Instead, the blue halo serves to draw the reader's eyes down the center of the image.

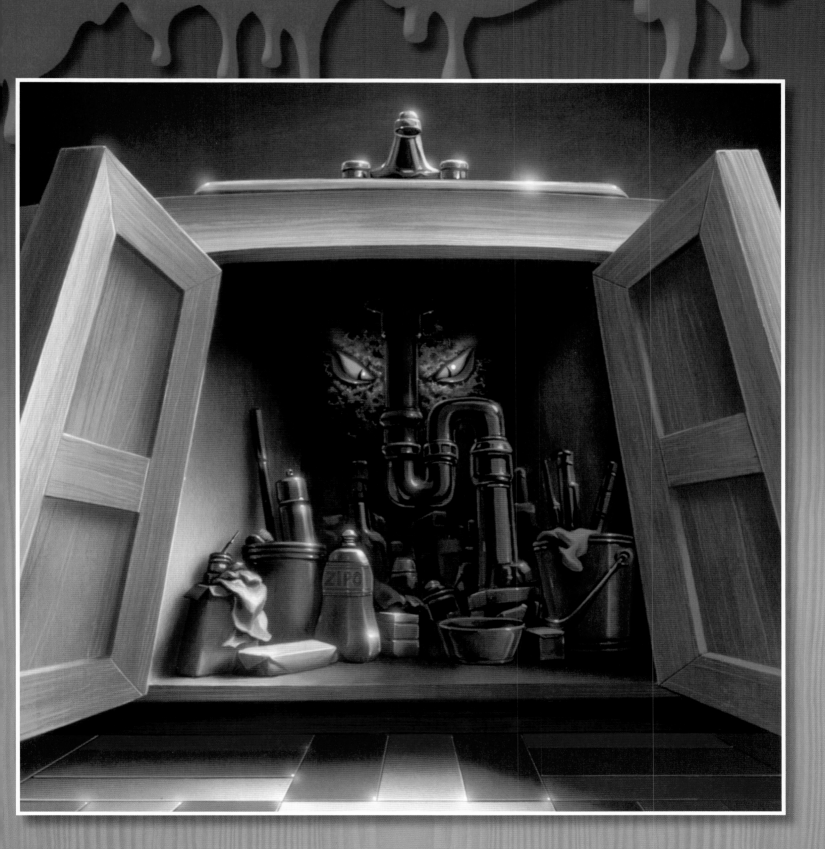

NIGHT OF THE LIVING DUMMY II

REGULAR SERIES - BOOK #31 - MAY 1995

R.L. STINE
Goosebumps

He's still walking.
He's still stalking.

NIGHT OF THE LIVING DUMMY II

SCHOLASTIC

He's still walking. He's still stalking.

"You can't teach an old dummy new tricks! Amy's ventriloquist dummy, Dennis, keeps losing his head...for real. So Amy begs her family for a new dummy. That's when her dad finds Slappy in a local pawnshop. Slappy's kind of ugly, but Amy's having fun practicing her new routine. Then terrible things start happening. Horrible, nasty things. Just like what happened the first time. Because there's something odd about Slappy. Something not quite right. Something evil..."

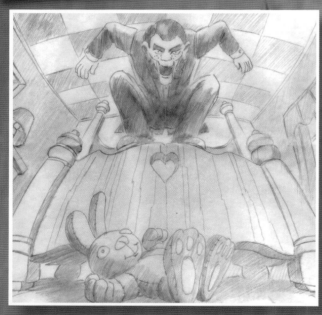

Pencil Sketch 1

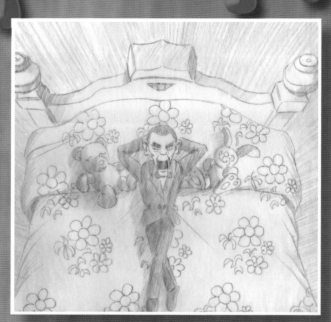

Pencil Sketch 2

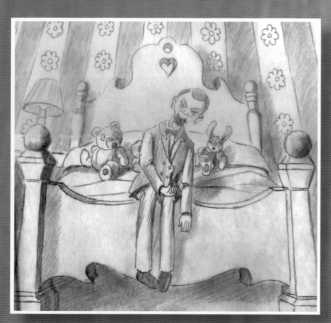

Pencil Sketch 3

Color Mockup

Perhaps the prettiest cover ever created for a horror book, *Night of the Living Dummy II* features a little girl's dream room, with a fancy pink bed and flowery wallpaper. The green and blue lines of the wallpaper are used to distort the image slightly, giving it a dream-like quality. The illusion of a beautiful scene is ruined by the terror on the stuffed animals' faces and by Slappy himself. The rumpled clothes and red mouth of the creepy dummy are dramatically out of place with the rest of the room.

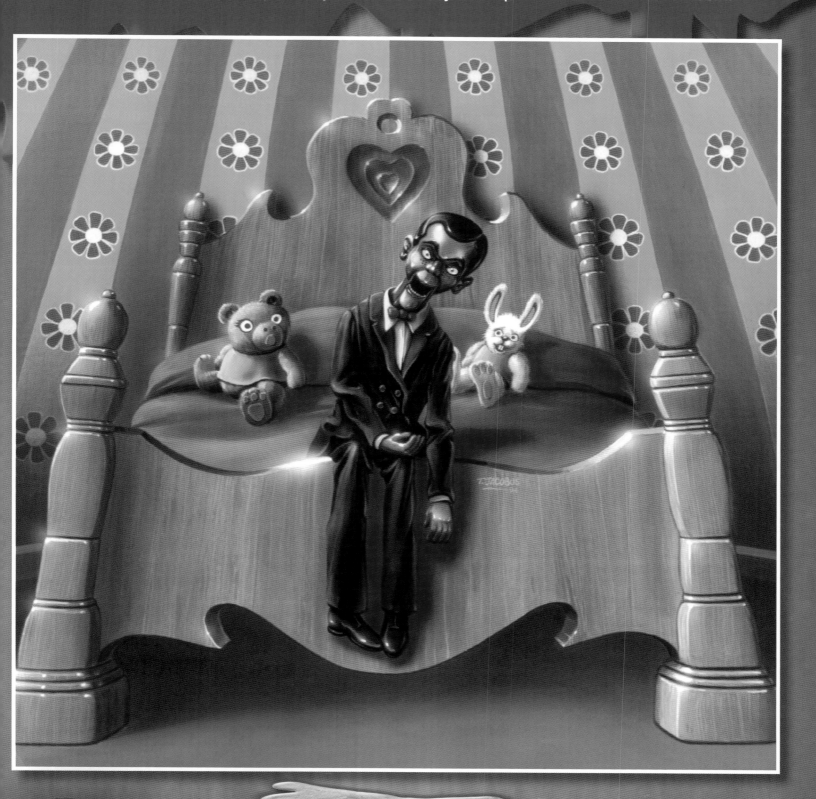

Slappy Says:

Exceptionally astute readers may notice that my eyes are blue on this cover, matching the description of the book, as opposed to the green eyes displayed on the first cover of the series. This is the first book in the Living Dummy series to feature me as the lead villain.

THE BARKING GHOST

REGULAR SERIES - BOOK #32 - JUNE 1995

R.L. STINE
Goosebumps

Bad dog. Really BAD dog

THE BARKING GHOST

SCHOLASTIC

Bad Dog. Really BAD Dog.

"It's a dog-gone nightmare! Scared of his own shadow. That's what everyone says about Cooper Holmes. But when the Holmeses move into a new house deep in the woods, scary things really do start happening. Problem is, no one believes a scaredy-cat like Cooper. But then no one else heard the bone-chilling barking late at night. Or ran into two evil-looking dogs who disappeared into thin air..."

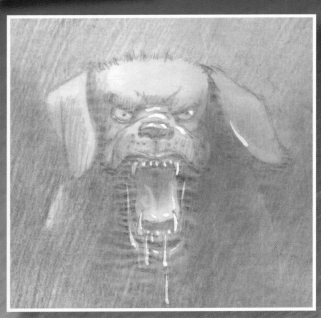

Pencil Sketch 1

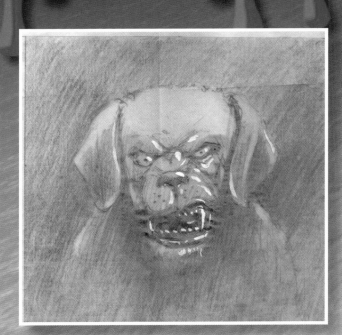

Pencil Sketch 2

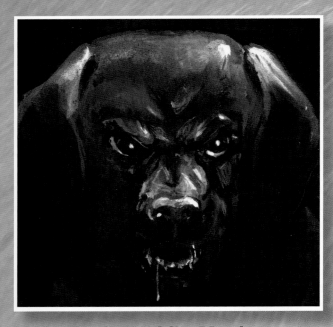

Black & White Mockup

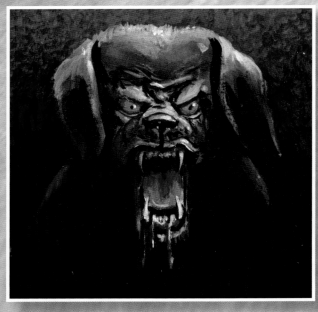

Color Mockup

Featuring a truly terrifying looking dog, at first glance this appears to be one of the simplest *Goosebumps* covers. On closer inspection, the gorgeous color blending can be seen in the background, and the hues used for the titular ghost range from red to blue to white. The tiny pupils used for the red eyes give the impression of evil orbs, telling the reader this is no ordinary dog. *The Barking Ghost* is the last of the *Goosebumps* books to get an original cover in the UK line. It only took thirty books for Jacobus to win them over!

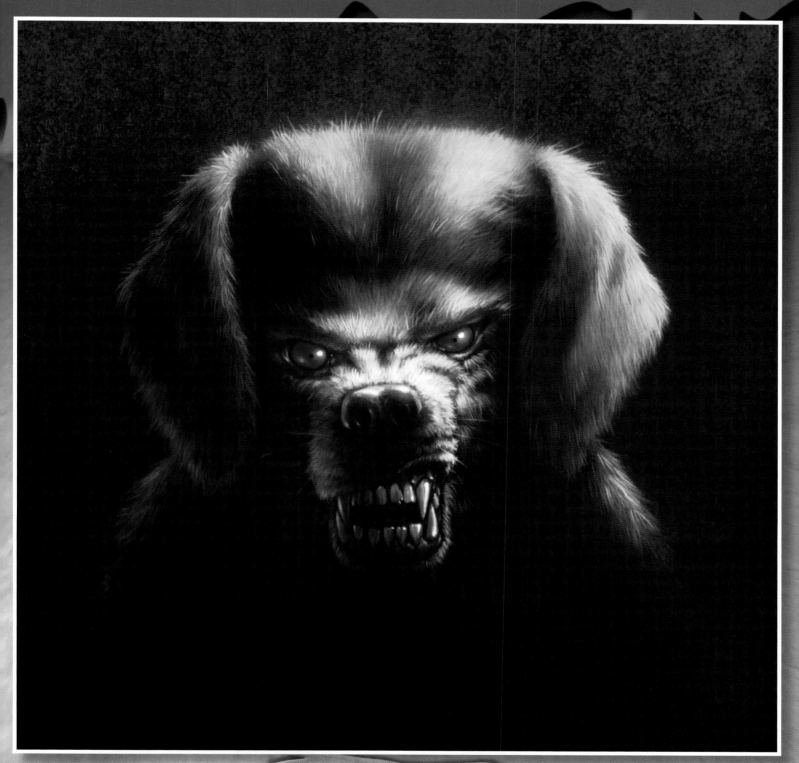

Stine Says:

I've stated that this novel was one of my least favorite in the series. The first printing of the book came with a fold-out poster with information about the 1995 summer release schedule for the next few books in the series. Later copies of the books came with a *Goosebumps* temporary tattoo.

THE HORROR AT CAMP JELLYJAM

REGULAR SERIES - BOOK #33 - JULY 1995

R.L. STINE
Goosebumps

THE HORROR AT CAMP JELLYJAM

SCHOLASTIC

Tennis... Ping-Pong... Monsters, anyone?

"It's not whether you win or lose – it's how you stay alive! Swimming, basketball, archery. King Jellyjam's sports camp has it all. Too bad Wendy isn't a total sports freak like her brother, Elliot. But how excited can you get over a game of softball. It's just a game, right? WRONG! Because Camp Jellyjam is no ordinary sports camp. And Wendy's about to find out why. Why the counselors seem a little too happy. A little too obsessed with winning. And why the ground is always rumbling late at night..."

Pencil Sketch 1

Pencil Sketch 2

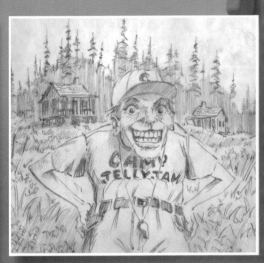

Pencil Sketch 3

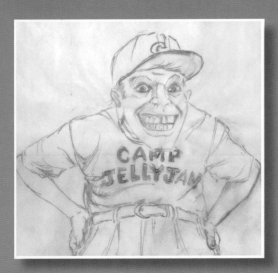

Pencil Sketch 4

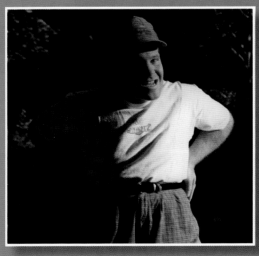

Photo Shoot - Tim Jacobus

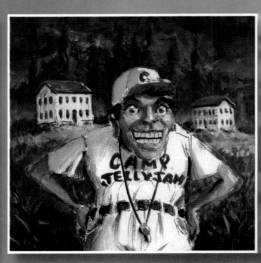

Color Mock-up

Notice anything familiar about the creepy, grinning figure of the camp counselor? This was yet another character modeled after Jacobus himself, who wore high-waisted pants and a baseball cap to create the image. The too-large mouth and wide eyes of the character are unsettling, as is the storm-darkened sky in the background. The touches of orange above the tree line lend an ominous feeling to the image. A light mist in the background near the boarding room style houses completes the picture of an unappealing campsite.

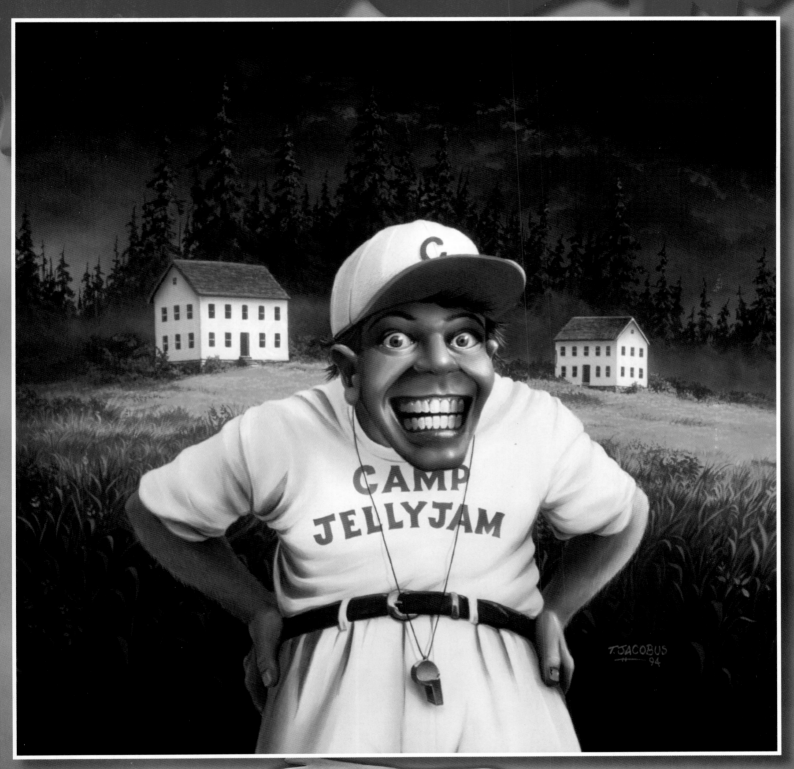

Stine Says:

The lead villain of this novel, King Jellyjam, is one of my favorite monsters. I enjoyed that the king died of his own foul odor. In fact, the original title for the book was going to be *Smelly Summer*.

REVENGE OF THE LAWN GNOMES

REGULAR SERIES - BOOK #34 - AUGUST 1995

Keep off their grass!

"Someone's been stalking in my garden! Two pink flamingos. A whole family of plaster skunks. Joe Burton's dad loves those tacky lawn ornaments. But then he brings home two ugly lawn gnomes. And that's when the trouble starts. Late at night. When everyone's asleep. Someone's creeping in the garden. Whispering nasty things. Smashing melons. Squashing tomatoes. No way two dumb old lawn ornaments could be causing all the trouble. Is there?"

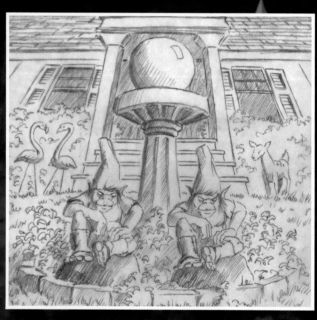

Pencil Sketch 1

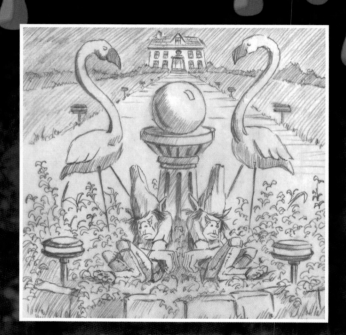

Pencil Sketch 2

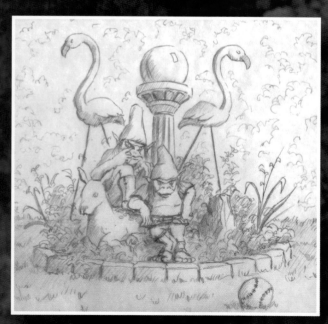

Pencil Sketch 3

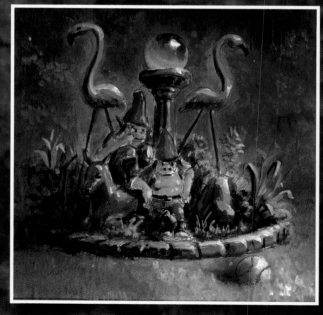

Color Mockup

Unlike the normal, smiling gnomes of well-manicured lawns, the gnomes on this cover have a serious attitude problem. However, Chip and Hap originally had even more sass. When Jacobus first turned in the art for *Revenge of the Lawn Gnomes*, the gnome on the left was picking his nose. Scholastic decided that was just a bit much, so Jacobus redrew the gnome scratching his head instead.

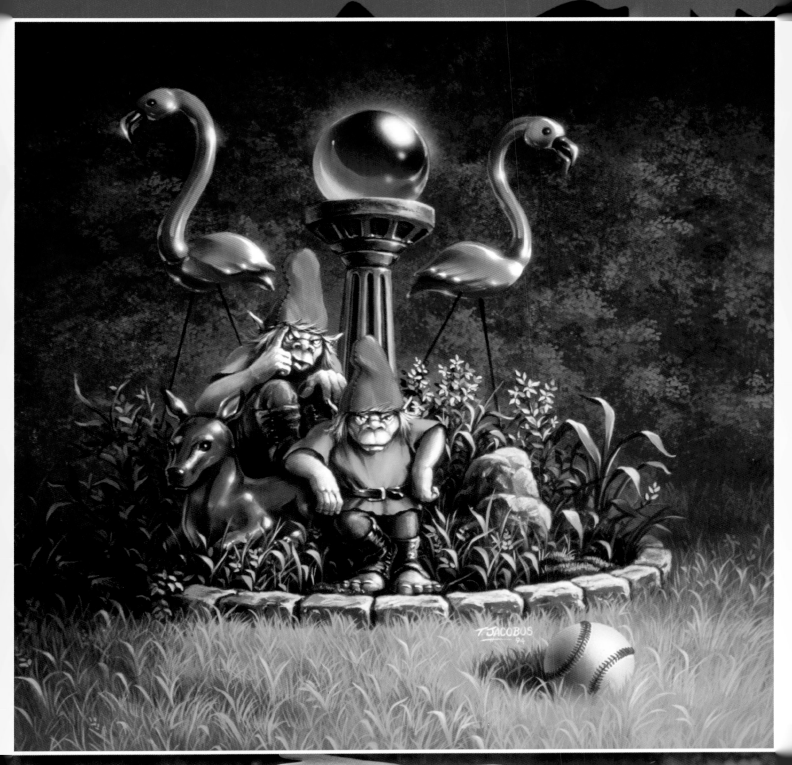

Slappy Says:

The two bright-pink flamingos serve to draw the eye down to the center of the image, where the orange and green of the gnome outfits contrast with the multitude of shades of blue used for the bushes in the background. The secret star of the cover is the beautifully painted crystal ball, in which Jacobus used light and dark colors to create the illusion of a clear, shining orb.

A SHOCKER ON SHOCK STREET

REGULAR SERIES - BOOK #35 - SEPTEMBER 1995

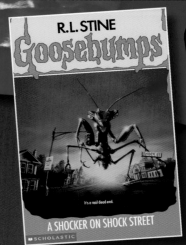

R.L. STINE
Goosebumps

It's a real dead end.

A SHOCKER ON SHOCK STREET

SCHOLASTIC

It's a real dead end.

"Talk about shock treatment! Erin Wright and her best friend, Marty, love horror movies. Especially Shocker on Shock Street movies. All kinds of scary creatures live on Shock Street. The Toadinator. Ape Face. The Mad Mangler. But when Erin and Marty visit the new Shocker Studio Theme Park, they get the scare of their lives. First their tram gets stuck in The Cave of the Living Creeps. Then they're attacked by a group of enormous praying mantises! Real life is a whole lot scarier than the movies. But Shock Street isn't really real. Is it?"

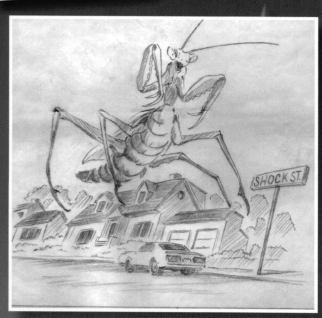

Pencil Sketch 1

Pencil Sketch 2

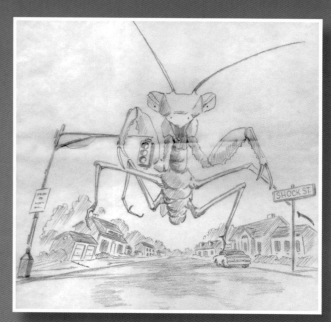

Pencil Sketch 3

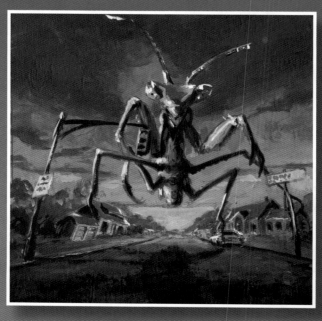

Color Mockup

At first glance, the enormous praying mantis on the cover of this book looks to be just that. Closer inspection reveals the metallic gleam and reflective surface of a robot. Again, Jacobus paints a time in-between: the sun shines bright on the horizon as flaming oranges and hot pink clouds cover the top of the sky. Shock Street itself is interesting, as the houses in the background suggest a very wealthy neighborhood, adding a hint of humor to the illustration.

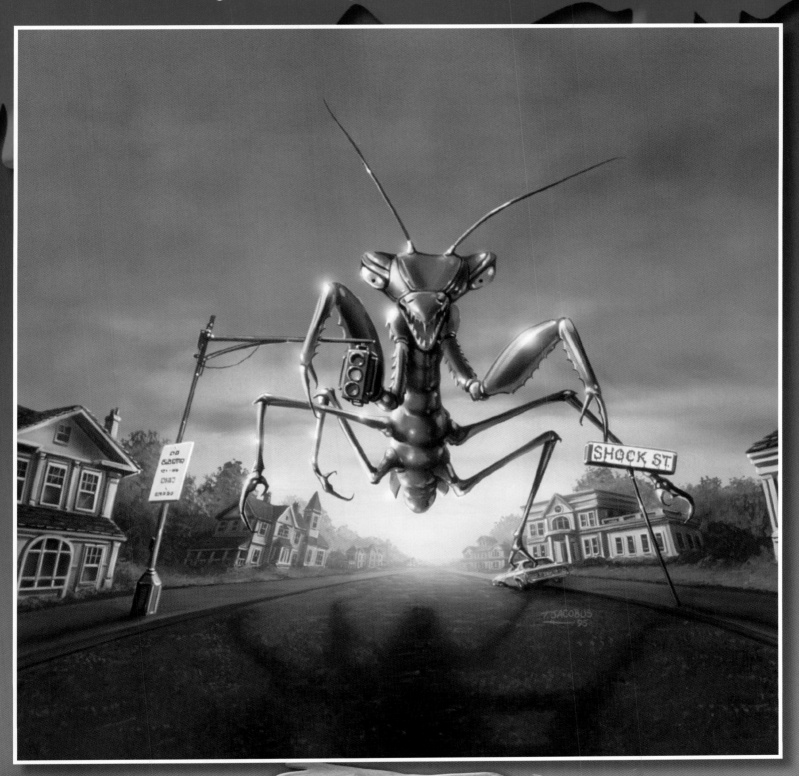

Stine Says:

I got the idea for *A Shocker on Shock Street* when I visited Universal Studios, a theme park, and wondered what would happen if the robotic attractions came alive.

THE HAUNTED MASK II

REGULAR SERIES - BOOK #36 - OCTOBER 1995

R.L. STINE
Goosebumps

THE HAUNTED MASK II

New face. Old nightmare.

"Just call him prune face! Steve Boswell will never forget Carly Beth's Halloween mask. It was so gross. So terrifying. But this year Steve wants to have the scariest costume on the block. So he gets a mask from the same store where Carly Beth got hers. It looks like a creepy old man. With stringy hair. A wrinkled face. And spiders crawling out of the ears! Steve's definitely got the scariest mask around. Too bad he's starting to feel so old. And so tired. And so evil…"

Thumbnails

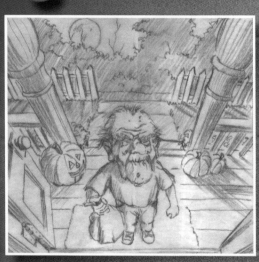
Pencil Sketch 1

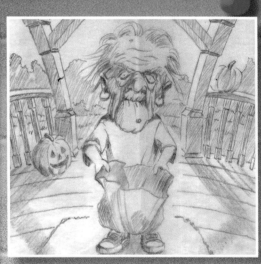
Pencil Sketch 2

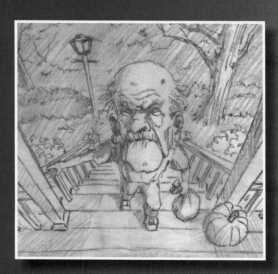
Pencil Sketch 3

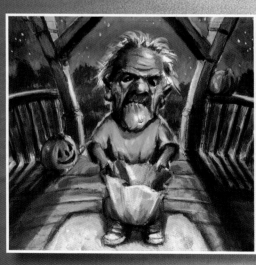
Color Mock-up 1

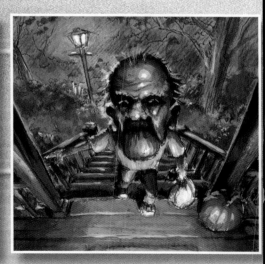
Color Mock-up 2

The cover for *The Haunted Mask* juxtaposed a monstrous face with the image of a young girl. Similarly, *The Haunted Mask II* juxtaposes an incredibly old-looking face with a young boy. The jack-o'-lanterns and bag in the child's hand indicates that the book takes place during Halloween, like its predecessor. In trademark fashion, Jacobus plays with perspective, giving the illusion of the masked figure leaning forward. Mist floats up the stairs behind the child.

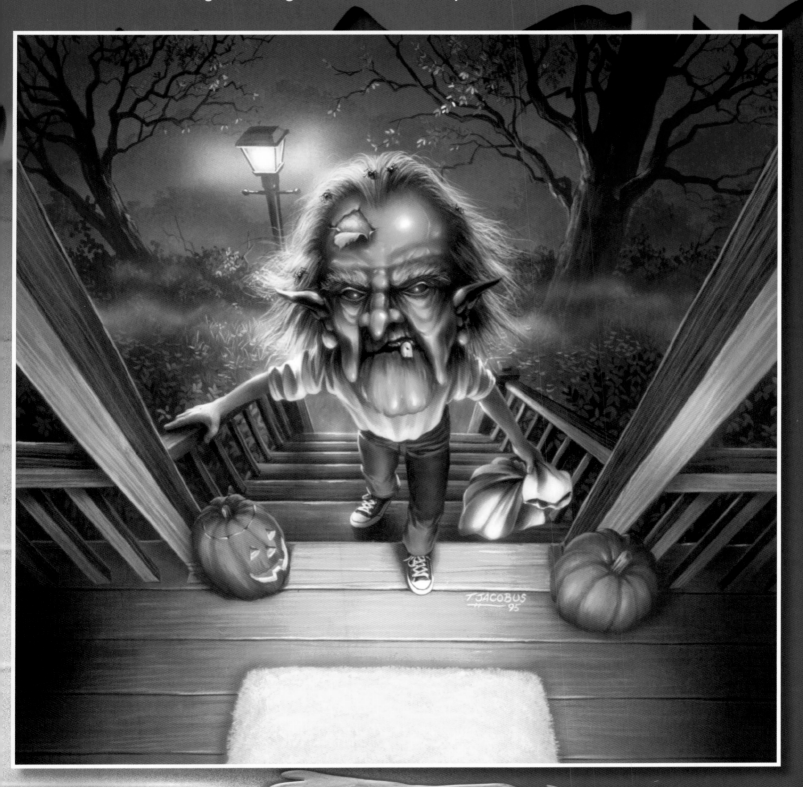

Slappy Says:

Jacobus' next Halloween-themed cover illustration also features white sacks for Halloween bags, which might look strange to modern readers in a time of store-bought trick-or-treat buckets.

THE HEADLESS GHOST

REGULAR SERIES - BOOK #37 - NOVEMBER 1995

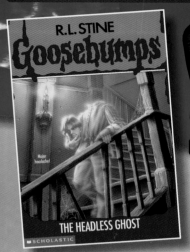

R.L. STINE
Goosebumps

Major headache!

THE HEADLESS GHOST

Scholastic

Major headache!

"They've got a real head start... Everyone knows about Hill House. It's the biggest tourist attraction in town. That's because it's haunted. Haunted by the ghost of a thirteen-year-old boy. A boy with no head! Duane and Stephanie love Hill House. It's dark. And creepy. And totally scary. Still, they've never actually seen the ghost. Until the night they decide to go on a search. A search for his head..."

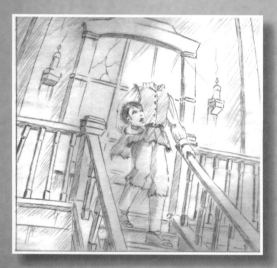

Pencil Sketch 1

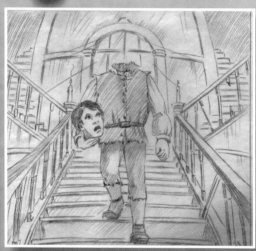

Pencil Sketch 2

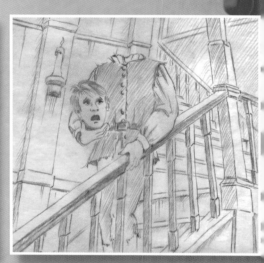

Pencil Sketch 3

Pencil Sketch 4

Photo Shoot

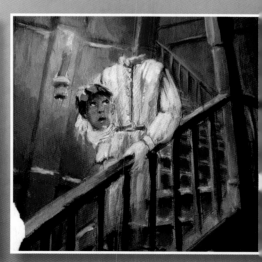

Color Mock-up 1

For this cover, Jacobus used silver and white tones to create the illusion of a transparent and glowing human coming down the stairs. With solid browns and wooden textures, the stairs, wall, and candle serve as a strong contrast to the ephemeral spirit. There is no strange perspective used in this illustration and the colors are very realistic. Even the purple used on the banner is a subtle tone compared to Jacobus' often bright palette. In this case, the realism of the background actually enhances the scariness of the supernatural aspect of the image.

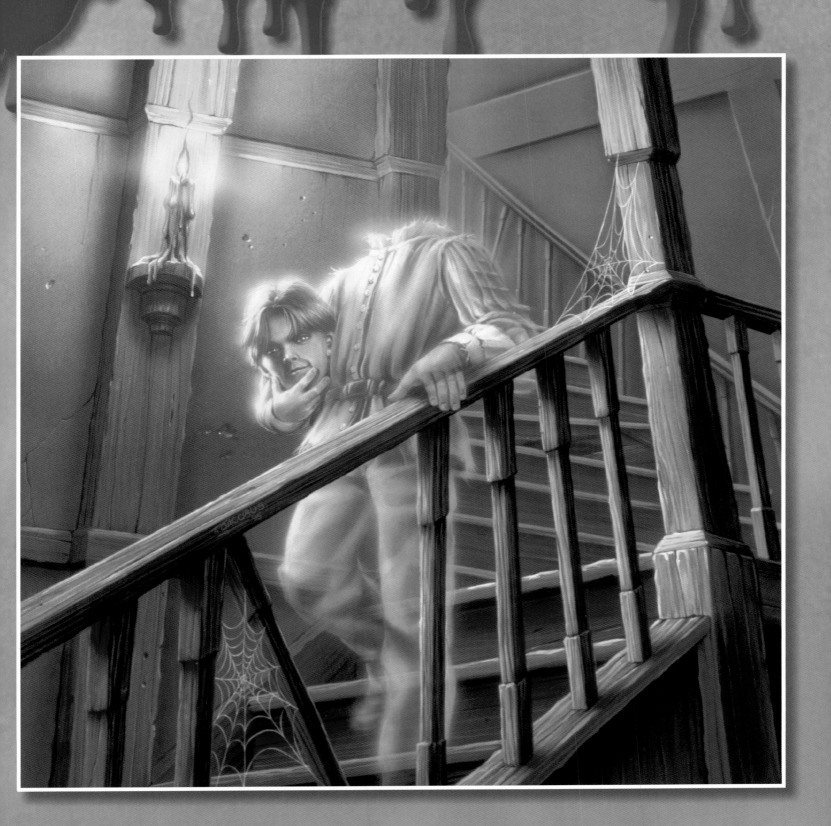

THE ABOMINABLE SNOWMAN OF PASADENA

REGULAR SERIES - BOOK #38 - DECEMBER 1995

He's no fun in the sun!

"Forget frosty! Jordan Blake and his sister, Nicole, are sick of the hot weather in Pasadena. Just once they'd like to have a real winter. A real winter with real snow. And then it happens. The Blakes are off to Alaska! Seems that Mr. Blake has been asked to photograph a mysterious snow creature there. Poor Jordan and Nicole. They just wanted to see snow. But now they're being chased by a monstrous creature. A big furry-faced creature... known as the Abominable Snowman."

Thumbnails

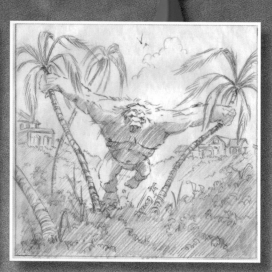

Pencil Sketch 1

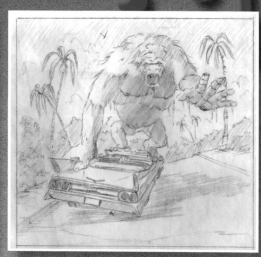

Pencil Sketch 2

Pencil Sketch 3

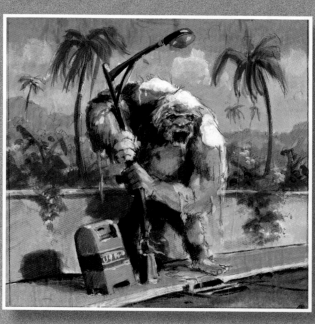

Color Mockup

Only in the *Goosebumps* series are the iconic hills, palm trees, and blue sky of southern California the perfect backdrop for a snow-covered yeti. Jacobus said the title of this book made him laugh, but the drooling, pink and yellow-brown yeti doesn't look very amused. The tilted mailbox and ripped up light post indicate a rampage on an otherwise normal Pasadena street.

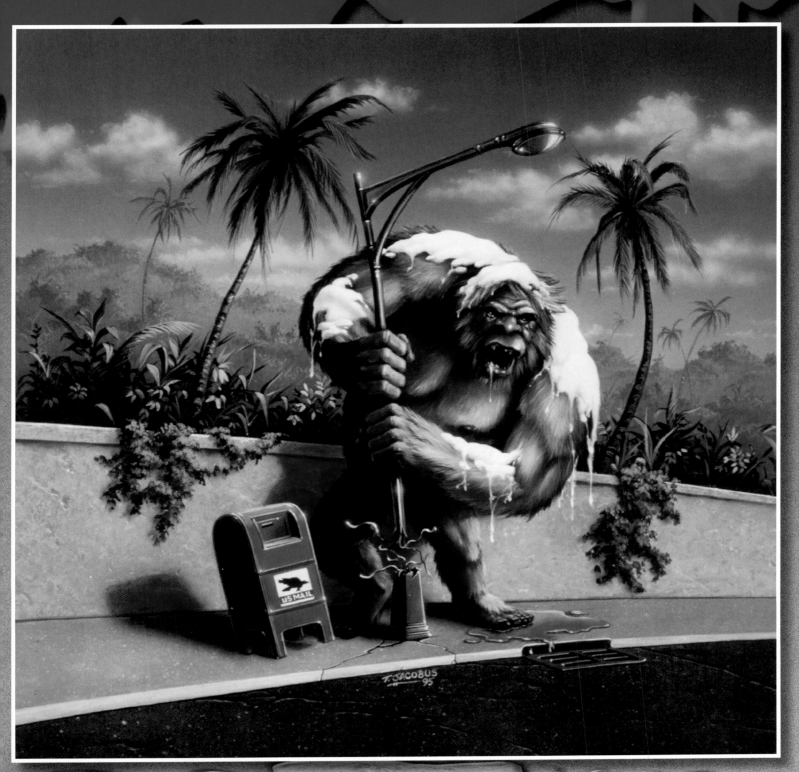

Slappy Says:

More than a decade after it was originally published, in September 2006, this story was adapted into a *Goosebumps Graphix* story by Scott Morse.

HOW I GOT MY SHRUNKEN HEAD

REGULAR SERIES - BOOK #39 - JANUARY 1996

Heads up!

"Two heads are better than one! What has two eyes, a mouth, and wrinkly green skin? Mark's shrunken head. It's a present from his Aunt Benna. A gift from the jungle island of Baladora. Mark can't wait to show the kids at school his shrunken head. It's so ugly. So gross. So awesome. But late one night the head starts to glow. Because it's no ordinary head. It gives Mark a strange power. A magical power. A dangerous power…"

Pencil Sketch 1

Pencil Sketch 2

Pencil Sketch 3

Pencil Sketch 4

Pencil Sketch 5

Color Mock-up

When creating book covers, Jacobus often uses models or existing images to depict the figures. However, in the case of the titular shrunken head, he had to create the image from his imagination. He drew several different heads to pick the best one for the job. Then he drew a typical, messy kid's room, leaving space on the top of a dresser for the head. He cut out the various heads and placed them in the space until he found one that he felt looked perfect in the spot. And that's how Jacobus got his shrunken head.

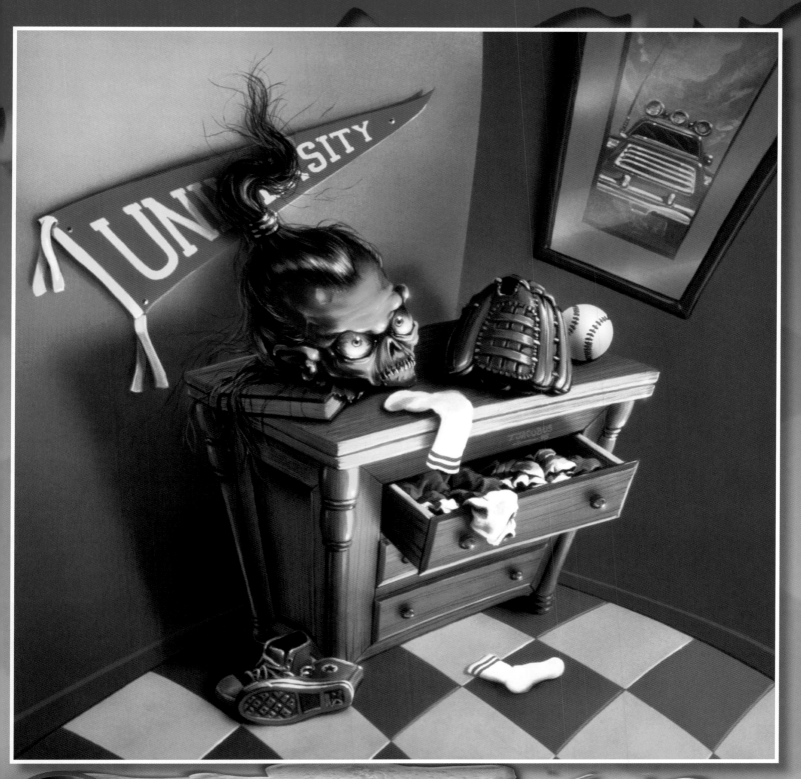

Slappy Says:

Several common Jacobus touchstones are depicted, including
a tiled floor, warped perspective and, of course,
a pair of Converse.

NIGHT OF THE LIVING DUMMY III

REGULAR SERIES - BOOK #40 - FEBRUARY 1996

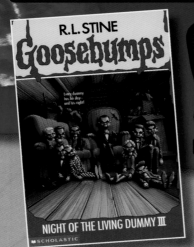

Every dummy has his day - and his night

"When dummies speak… everybody listens! Trina O'Dell's dad used to have a ventriloquist act. That's why he has all those dummies in the attic. He calls it his Dummy Museum. There's a dummy with freckles. And one with a sneer just like Rocky. Trina and her brother, Dan, think the dummies are pretty cool. But now there are voices in the attic. And dummies keep showing up in the strangest places. No way those dummies could be alive! Right?"

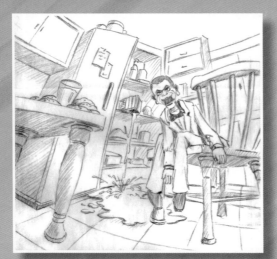

Pencil Sketch 1

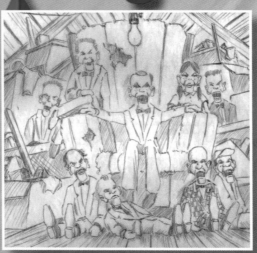

Pencil Sketch 2

Pencil Sketch 3

Pencil Sketch 4

Pencil Sketch 5

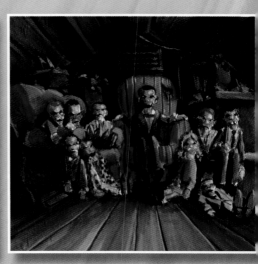

Color Mock-up

When asked about his favorite *Goosebumps* covers, Jacobus mentions *The Night of the Living Dummy III*. He loved drawing all of the dummies together on the cover. The lines of the floorboard are used to create the feeling of movement towards the subject matter, the family portrait of dummies. The background of junk is kept in two main colors: brown for items in the light and purple for items in shadow. The orange chairs stand out from the purples of the background, and draw the eye to the dolls, who are each creepy in their own special way.

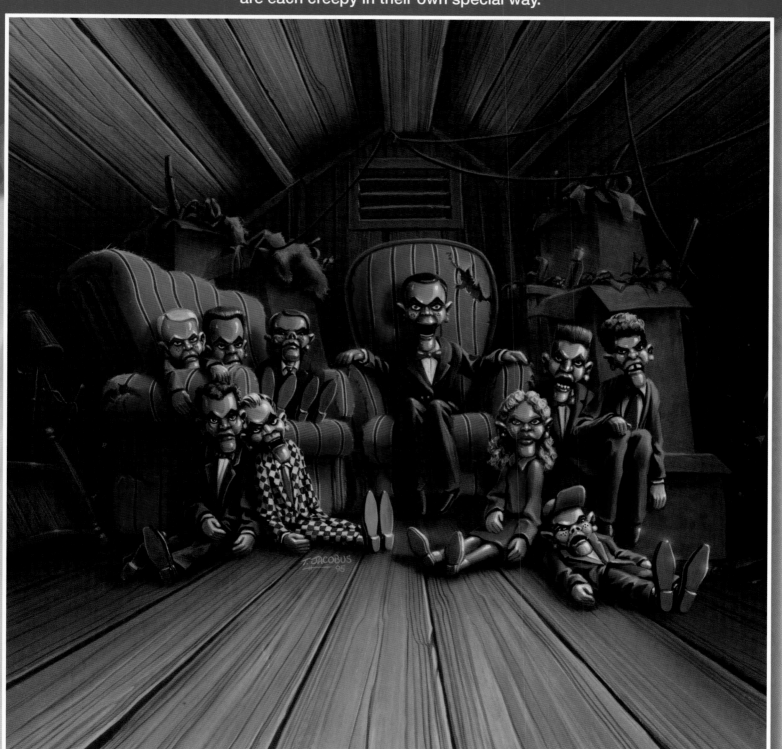

Slappy Says:

Night of the Living Dummy III was the first *Goosebumps* book to feature special tear-out trading cards and bookmarks inside, which would become a staple of future books in the original series. Another bit of trivia: this novel marks the shortest time between sequels in the original series, with only nine months separating *Night of the Living Dummy II* and *Night of the Living Dummy III*.

BAD HARE DAY

REGULAR SERIES - BOOK #41 - MARCH 1996

He's no Easter bunny!

"Pick a scare. Any scare. Trick cards, floating scarves, disappearing doves. Tim Swanson loves magic tricks. Someday he wants to be a real magician. Just like his all-time favorite hero, Amaz-O. But then Tim goes to Amaz-O's show. And he finds out his idol is a total grump. That's when Tim decides to steal the bag of tricks. Amaz-O's bag of secret tricks. Scary tricks. The one with the multiplying red balls. And all those hissing snakes…"

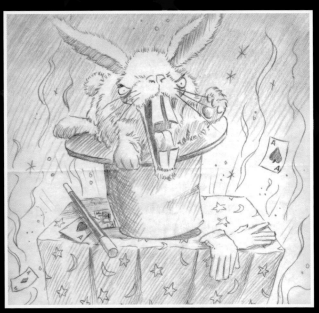

Pencil Sketch 1

Pencil Sketch 2

Stine Says:

I originally titled this book *The Hand Is Quicker Than The… AIII!*.

Readers might never look at a white rabbit the same way again. Jacobus exaggerated the rabbit's mouth and tilted the perspective down towards it, creating the illusion of being sucked down to the creature. Again, we see Jacobus use a flat color and small pupils to give an animal a crazed expression, the same technique he used on *The Barking Ghost*.

Similar to the cover of another *Goosebumps* book, *Phantom of the Auditorium*, the magenta curtains in the background are paired with a bright glow. The glow behind the curtains might conjure thoughts of the bright lights of the stage, or even of stage fright.

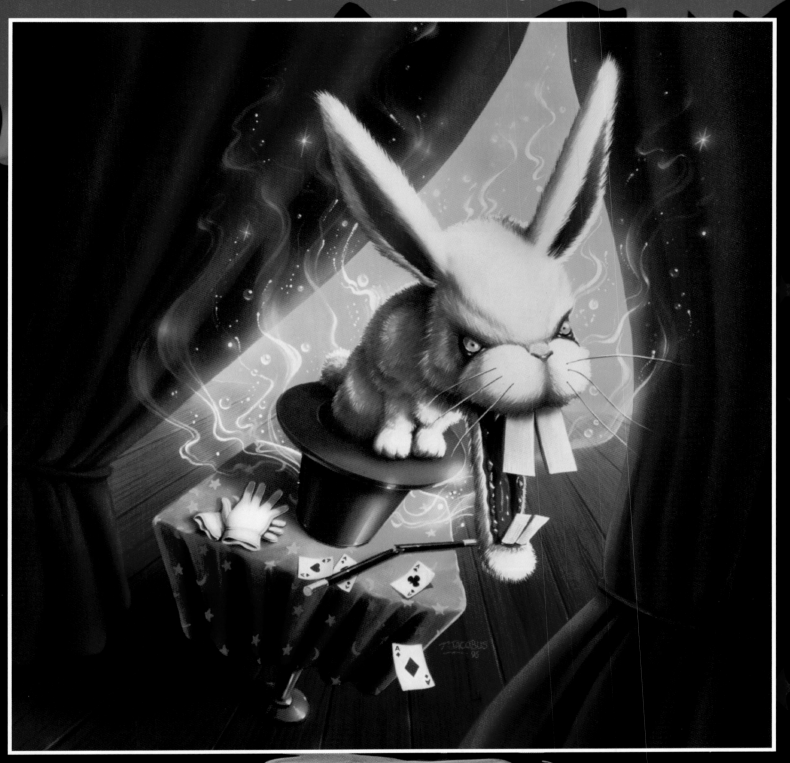

Slappy Says:

A magic act is conveyed through several items in the illustration, including the rabbit in the hat, cards, a mystic white steam coming off of the rabbit, and a magician's wand. But look closely: the wand is broken in half.

EGG MONSTERS FROM MARS

REGULAR SERIES - BOOK #42 - APRIL 1996

R.L. STINE
Goosebumps

They're no yolk!

EGG MONSTERS FROM MARS

SCHOLASTIC

They're no yolk!

"Which came first, the monster or the egg? An egg hunt. That's what Dana Johnson's bratty little sister, Brandy, wants to have at her birthday party. And whatever Brandy wants, Brandy gets. Dana's not big on egg hunts. But that was before he found The Egg. It's not like a normal egg. It's about the size of a softball. It's covered with ugly blue and purple veins. And it's starting to hatch…"

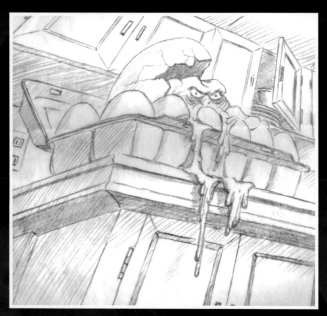

Pencil Sketch 1

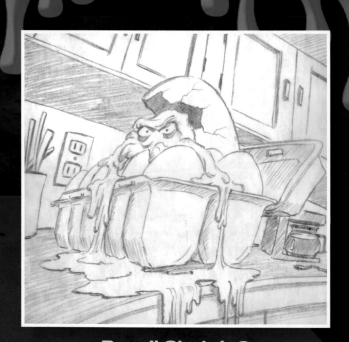

Pencil Sketch 2

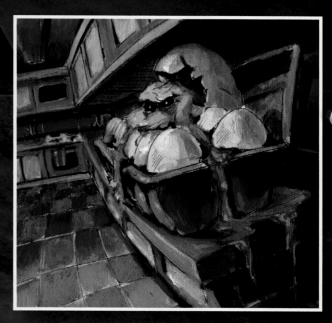

Color Mockup

Stine Says:

This book was also one of my favorite books to write, making it a hit with both Tim Jacobus and myself.

Egg Monsters from Mars is another one of Jacobus' favorite *Goosebumps* covers. In his autobiography, Jacobus said that it is scary to mix something ordinary, like a carton of eggs, with something creepy, such as the slime monster. He suggested that the unexpected inclusion of something frightening into an ordinary situation adds an element of surprise. Jacobus heightens the surrealism of the image with a strange perspective, again enhanced by his use of orange, red and yellow tiles, and with the curve of the kitchen counter. The color and texture of the monster are particularly disgusting looking, and the black eyes add an element of evil.

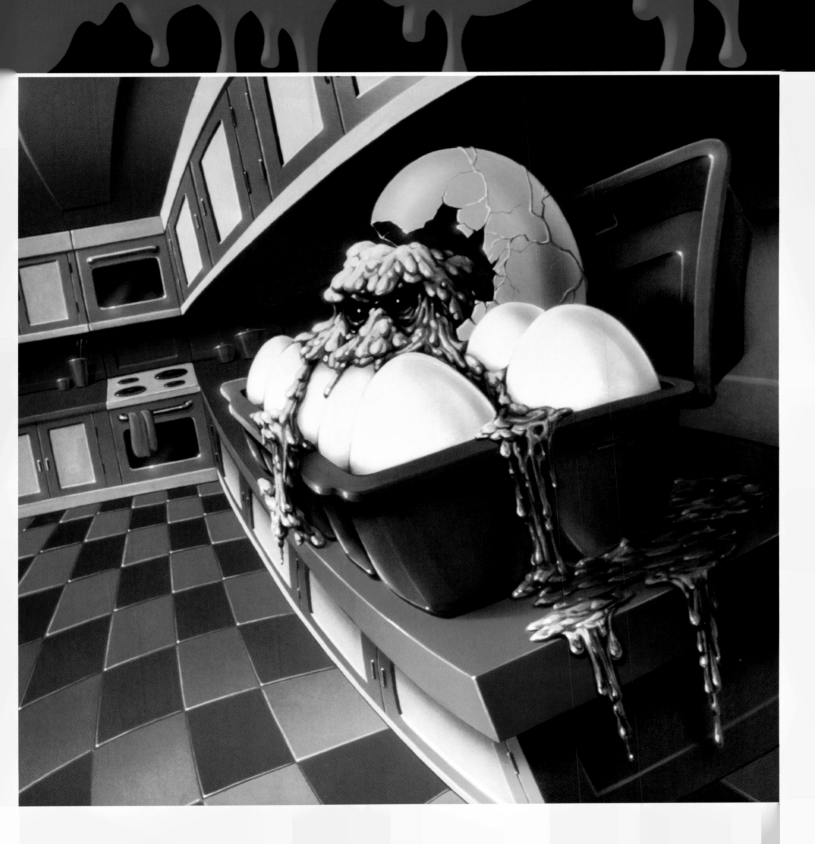

THE BEAST FROM THE EAST

REGULAR SERIES - BOOK #43 - MAY 1996

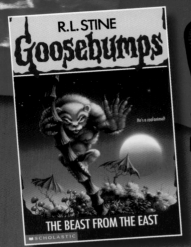

He's a real animal!

"Every beast for himself! Ginger Wald and her identical twin brothers, Nat and Pat, are lost in the woods. No problem. After all, Ginger did go to that stupid nature camp. Still, there's something odd about this part of the woods. The grass is yellow. The bushes are purple. And the trees are like skyscrapers. Then Ginger and her brothers meet the beasts. They're big blue furry creatures. And they want to play a game. The winners get to live. The losers get eaten…"

Pencil Sketch 1

Pencil Sketch 2

Pencil Sketch 3

Color Mockup

Perhaps the most fantastical *Goosebumps* cover of the original series, there is no hint of the real world or juxtaposition of a relatable setting in this illustration. The beast is blue and purple, somehow adorable and unsettling at the same time, but certainly not a normal animal. The background is full of strange, alien plants and the sky is made up of gorgeous layers of yellow, pink, and purple. The moon reflects the striated light, adding to the sense of otherworldliness.

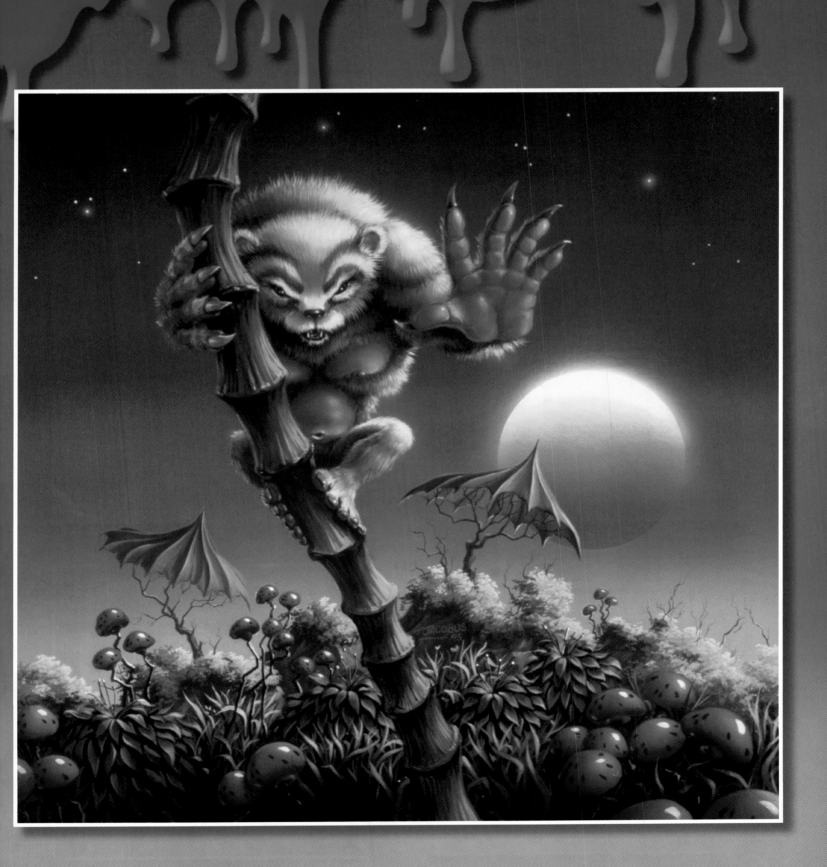

SAY CHEESE AND DIE-AGAIN!

REGULAR SERIES - BOOK #44 - JUNE 1996

Think negative. Real negative

"Picture-perfect nightmare! Sourball. That's what Greg calls his English teacher, Mr. Saur. He's a real grouch. And now he just gave Greg a big fat 'F' on his oral report. He didn't believe Greg's story. About the camera Greg found last summer. About the pictures it took. About the evil things that happened. Poor Greg. He just wanted to prove old Sourball wrong. But now that he's dug up the camera, bad things are happening. Really bad things. Just like the first time…"

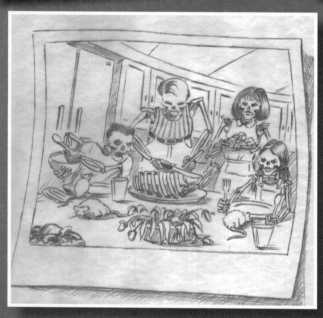

Pencil Sketch 1

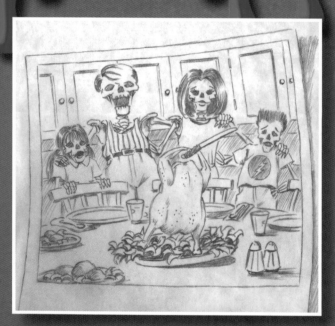

Pencil Sketch 2

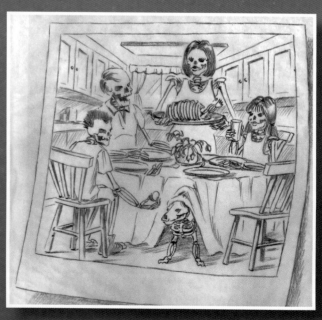

Pencil Sketch 3

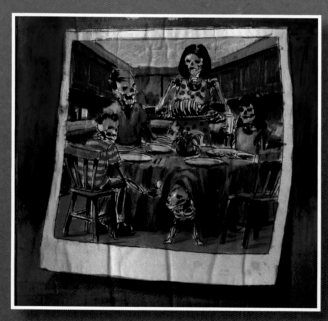

Color Mockup

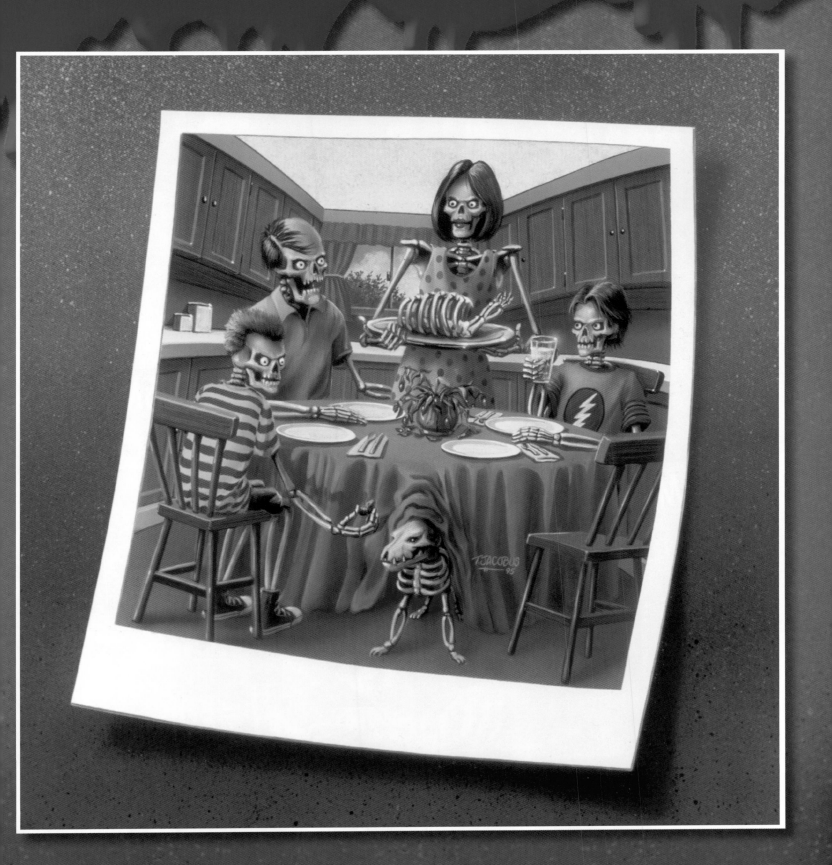

Despite boasting the longest time between sequels (three years and seven months, or about forty books), *Say Cheese and Die—Again!* has perhaps the most consistent imagery between the two book covers. Again, a skeleton family is depicted in a polaroid image sharing a meal. This time, the scene depicted is a family dinner in the kitchen—complete with a skeleton turkey and dead plants in the centerpiece. Jacobus uses orange as the main color scheme of this illustration, pairing it with the blue tablecloth and the purple accents on the walls of the kitchen to "pop" the figures out to the reader.

He's got a heart of cold!

Goosebumps®
SERIES 3

Be all that you can't see!

BEWARE, THE SNOWMAN

SCHOLASTIC

GHOST CAMP

VAMPIRE BREATH

ATTACK OF THE JA

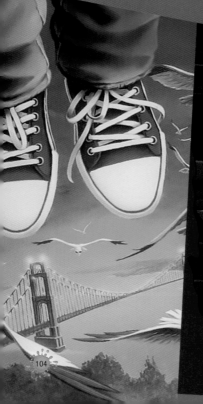

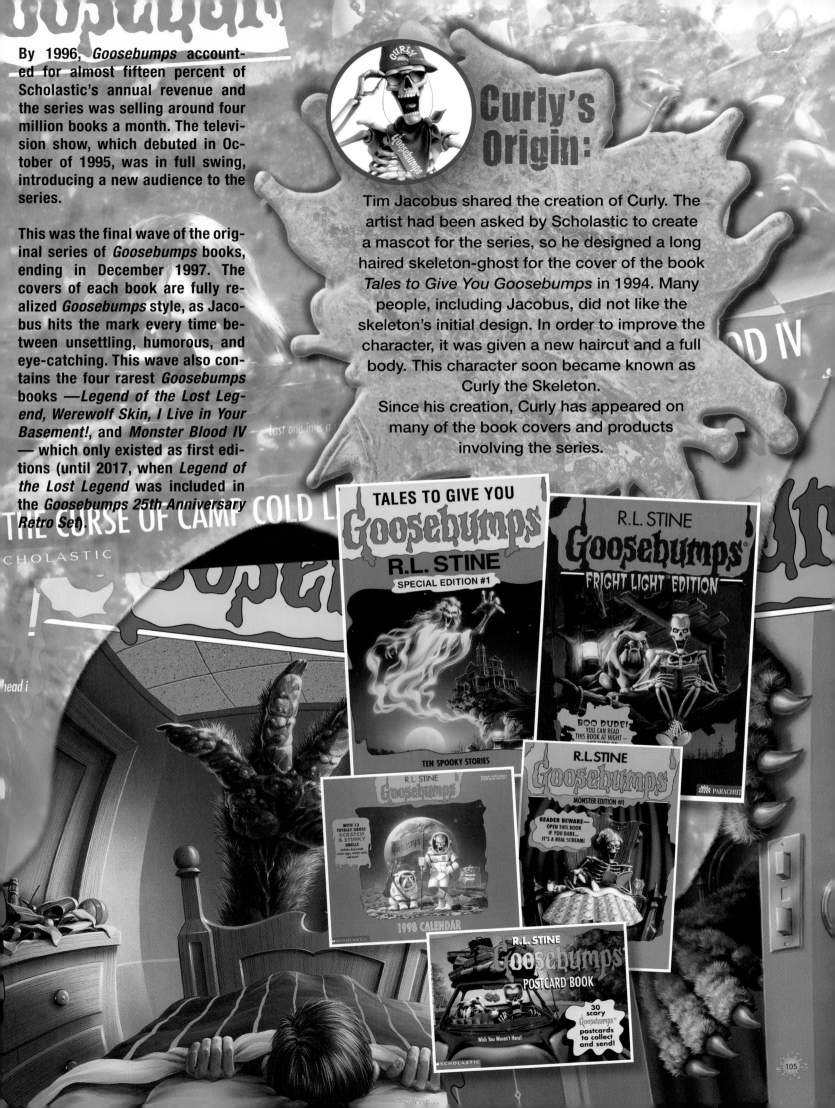

By 1996, *Goosebumps* accounted for almost fifteen percent of Scholastic's annual revenue and the series was selling around four million books a month. The television show, which debuted in October of 1995, was in full swing, introducing a new audience to the series.

This was the final wave of the original series of *Goosebumps* books, ending in December 1997. The covers of each book are fully realized *Goosebumps* style, as Jacobus hits the mark every time between unsettling, humorous, and eye-catching. This wave also contains the four rarest *Goosebumps* books —*Legend of the Lost Legend, Werewolf Skin, I Live in Your Basement!*, and *Monster Blood IV* — which only existed as first editions (until 2017, when *Legend of the Lost Legend* was included in the *Goosebumps 25th Anniversary Retro Set*).

Curly's Origin:

Tim Jacobus shared the creation of Curly. The artist had been asked by Scholastic to create a mascot for the series, so he designed a long haired skeleton-ghost for the cover of the book *Tales to Give You Goosebumps* in 1994. Many people, including Jacobus, did not like the skeleton's initial design. In order to improve the character, it was given a new haircut and a full body. This character soon became known as Curly the Skeleton.

Since his creation, Curly has appeared on many of the book covers and products involving the series.

GHOST CAMP

REGULAR SERIES - BOOK #45 - JULY 1996

Be all that you can't see!

"The joke's on them! Harry and his brother, Alex, are dying to fit in at Camp Spirit Moon. But the camp has so many weird traditions. Like the goody camp salute. The odd camp greeting. And the way the old campers love to play jokes on the new campers. Then the jokes start to get really serious. Really creepy. Really scary. First a girl sticks her arm in the campfire. Then a boy jams a pole through his foot. Still, they're just jokes… right?"

Pencil Sketch 1

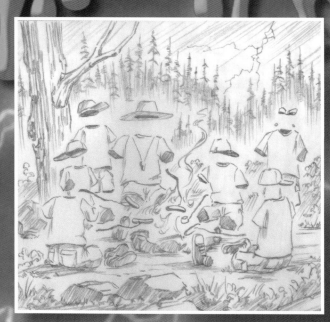

Pencil Sketch 2

Pencil Sketch 3

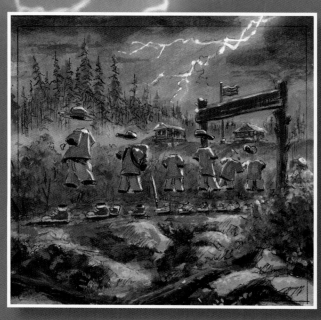

Color Mockup

onjuring images of the phrase "it was a dark and stormy night," the *Ghost Camp* illustration is a suitably frightening cover for a book that Stine considers one of the scariest of the series. The overgrown foliage of the foreground and background of the painting hint at a derelict camp, and the invisible ghost children certainly don't help with that image. As usual, Jacobus did not get to read the story before creating the cover, and thus the focus is on a human girl, whereas the protagonists of the book are two boys. On that subject, especially astute readers might notice an interesting detail about the Converse sneakers in this illustration: one pair of the ghost shoes are pink, like the living girl, suggesting at least one of the ghosts is also a girl.

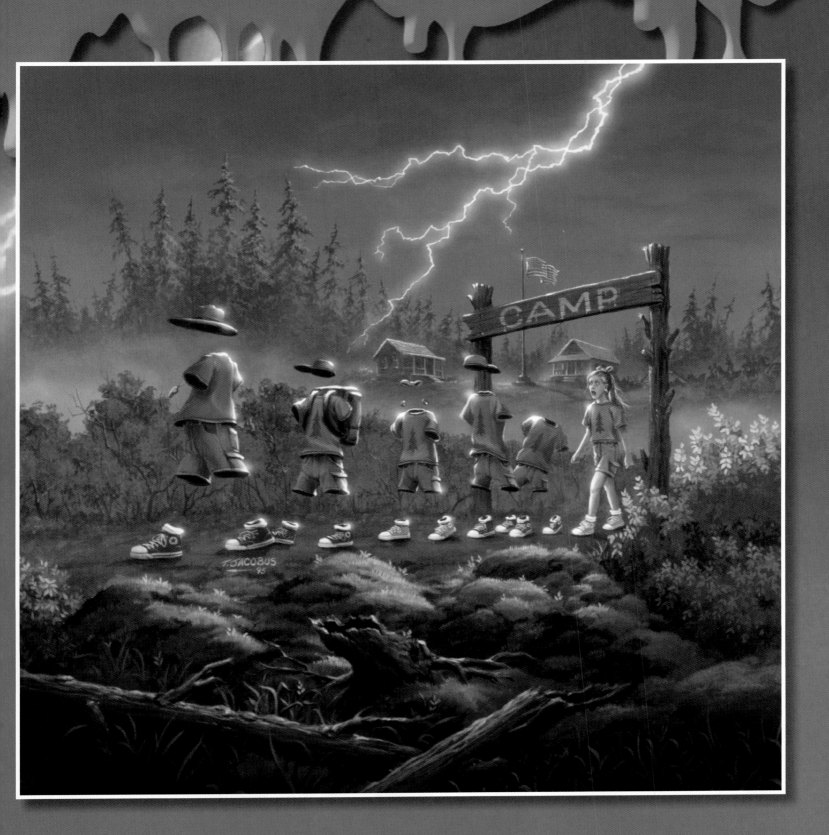

HOW TO KILL A MONSTER

REGULAR SERIES - BOOK #46 - AUGUST 1996

R.L. STINE
Goosebumps

Step 1: Run.
Step 2: Run faster.

HOW TO KILL A MONSTER

SCHOLASTIC

Step 1: Run. Step 2: Run faster.

"Home alone… with a monster? Gretchen and her stepbrother, Clark, hate staying at their grandparents' house. Grandpa Eddie is totally deaf. And Grandma Rose is obsessed with baking. Plus, they live in the middle of a dark, muddy swamp. Things couldn't get any worse, right? WRONG. Because there's something really weird about Grandma and Grandpa's house. Something odd about that room upstairs. The one that's locked. The one with the strange noises coming from it. Strange growling noises…"

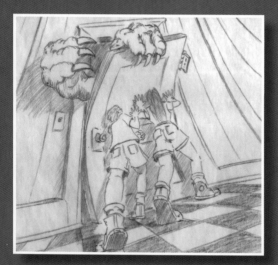

Pencil Sketch 1

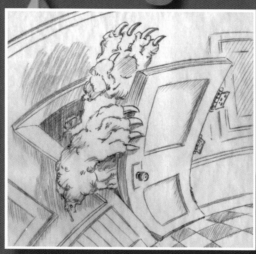

Pencil Sketch 2

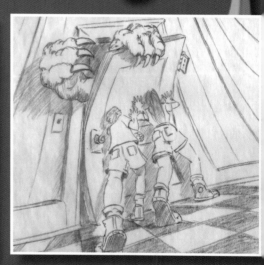

Pencil Sketch 3

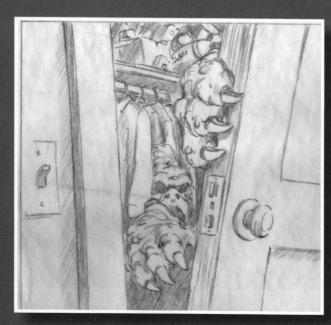

Pencil Sketch 4

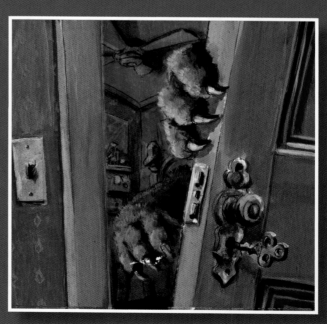

Color Mockup

108

The green monster hands that are the focus of the cover are so captivating that readers might not notice the lovely pink, vibrant orange, and deep blues making up the rest of the image. Instead of mixing colors together, which Jacobus often does for foliage or the sky, these colors are each in their own section. The wall on the left is curved, as is the door, creating the sense of a portal opening into the other room, which includes a trademark Jacobus tile floor.

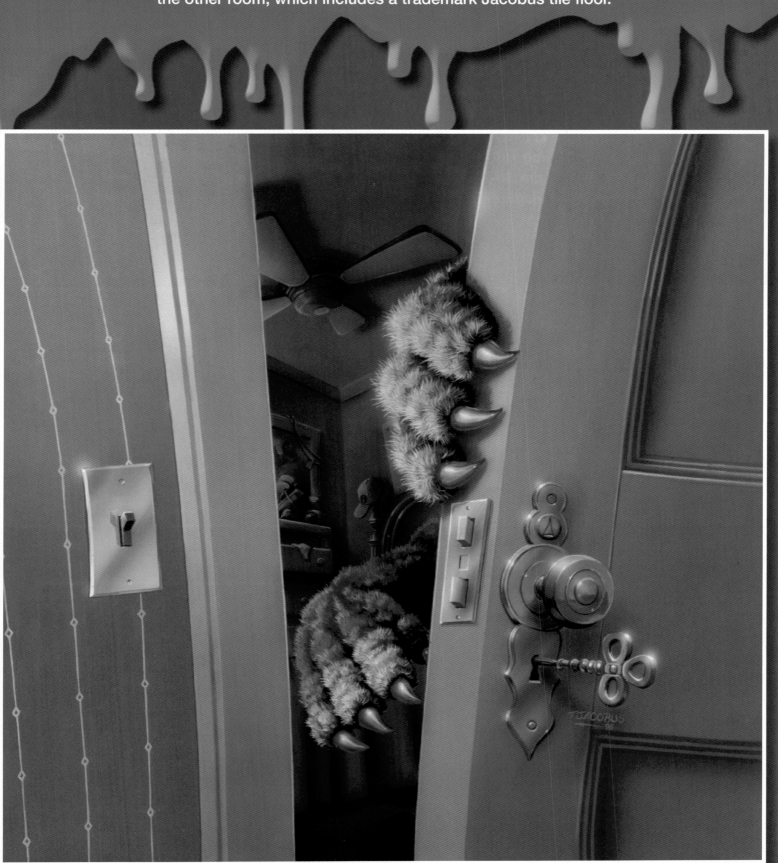

LEGEND OF THE LOST LEGEND

REGULAR SERIES - BOOK #47 - SEPTEMBER 1996

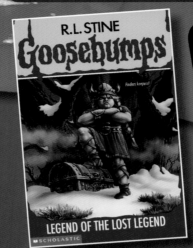

Finders keepers!

"Talk about a horror story! Nobody loves a good story like Justin's dad. He's a famous writer and story collector. That's how Justin and his sister, Marissa, ended up in Brovania. Their dad is searching for an ancient manuscript called The Lost Legend. Justin and Marissa want to help. But instead of finding The Lost Legend, they get lost. And the woods of Brovania are filled with the strangest creatures. Like hundreds of squealing mice. Silver-colored dogs. And terrifying Vikings from long ago..."

Pencil Sketch 1

Pencil Sketch 2

Pencil Sketch 3

Pencil Sketch 4

Color Mockup

Ivanna the Viking stands imposingly over the ancient silver treasure chest on this cover, commanding the reader's attention with her green eyes and angry stare. Although there is snow on the twisted tree and on the ground at her feet, Jacobus used patches of bright green grass to suggest a lush forest area. The sky glows bright pink near the horizon and fades from purple to dark blue, suggesting sunset.

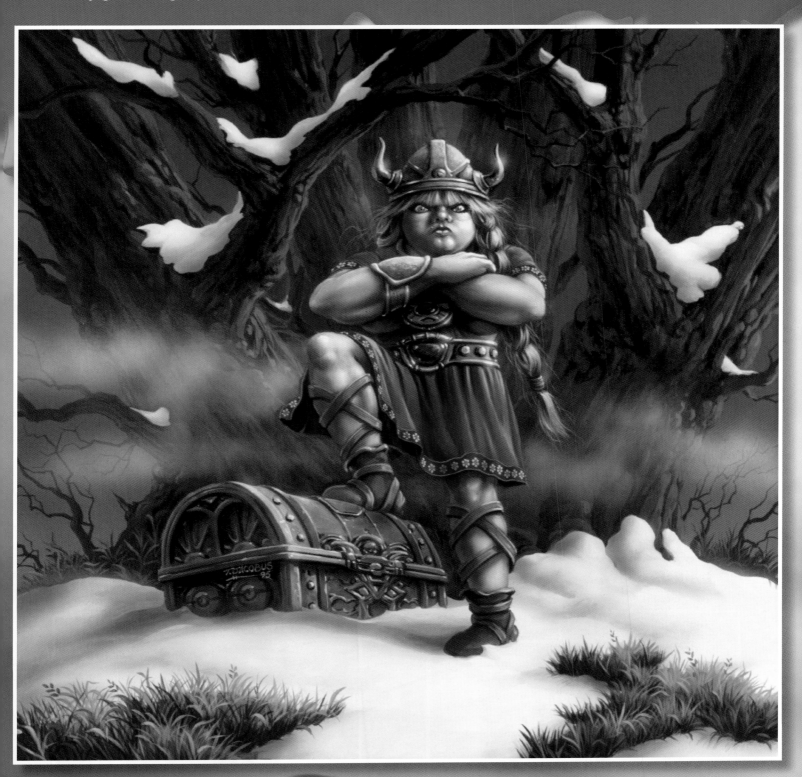

Slappy Says:

For twenty years, this was one of the few *Goosebumps* books that did not receive a reprint. It was eventually reprinted in the *Goosebumps 25th Anniversary Retro Set*.

ATTACK OF THE JACK-O'-LANTERNS

REGULAR SERIES - BOOK #48 - OCTOBER 1996

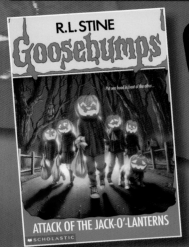

Put one head in front of the other...
"Pumpkin power! Nothing beats Halloween. It's Drew Brockman's favorite holiday. And this year will be awesome. Much better than last year. Or the year Lee and Tabby played that joke. A nasty practical joke on Drew and her best friend, Walker. Yes, this year Drew and Walker have a plan. A plan for revenge. It involves two scary pumpkin heads. But something's gone wrong. Way wrong. Because the pumpkin heads are a little too scary. A little too real. With strange hissing voices. And flames shooting out of their faces..."

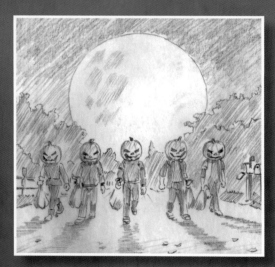

Pencil Sketch 1

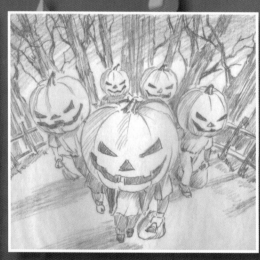

Pencil Sketch 2

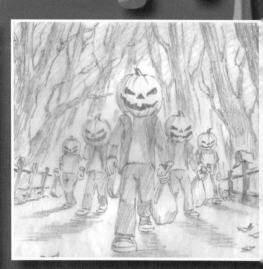

Pencil Sketch 3

Photo Shoot

Color Mockup

Once more utilizing white sacks to suggest trick-or-treating, the cover for *Attack of the Jack-O'Lanterns* is suitably creepy for a book released for Halloween. The jack-o'-lanterns on the children's (and the dog's) heads are all smiling cheerfully as they glow in the night. The use of blacks and greys for the figures' tops makes these smiles somehow sinister, as do the glaring owl and gnarled branches of the dead trees in the background. Again, we have the suggestion of light against the horizon, this time in a half-circle drawing the eye to the center figure. Note the use of white around the edges and between the legs of the kids, to suggest an immensely bright light in the background, which is subtly unsettling.

Slappy Says:

As there are shoes on the cover, it is only fitting that several of the figures are wearing Converse sneakers. Not so clear, but still possibly an Easter-egg of sorts: this is the 48th *Goosebumps* book, and the mailbox is for house 48.

VAMPIRE BREATH

REGULAR SERIES - BOOK #49 - NOVEMBER 1996

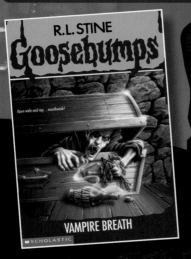

Open wide and say... mouthwash!

"He's a dentist's nightmare... Tough. That's Freddy Martinez and his friend, Cara. They're not afraid of anything. But that was before they went exploring in Freddy's basement. Before they found the secret room. Before they found the bottle of Vampire Breath. Poor Freddy and Cara. They should have never opened that bottle of Vampire Breath. Because now there's a vampire in Freddy's basement. And he's very, very thirsty...."

Pencil Sketch 1

Pencil Sketch 2

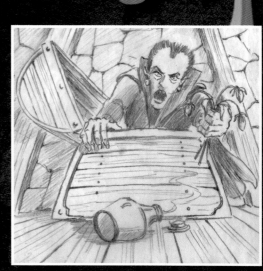

Pencil Sketch 3

Pencil Sketch 4

Photo Shoot

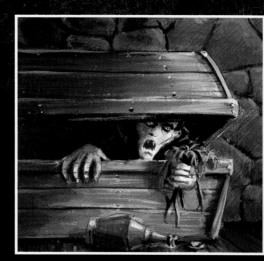

Color Mock-up

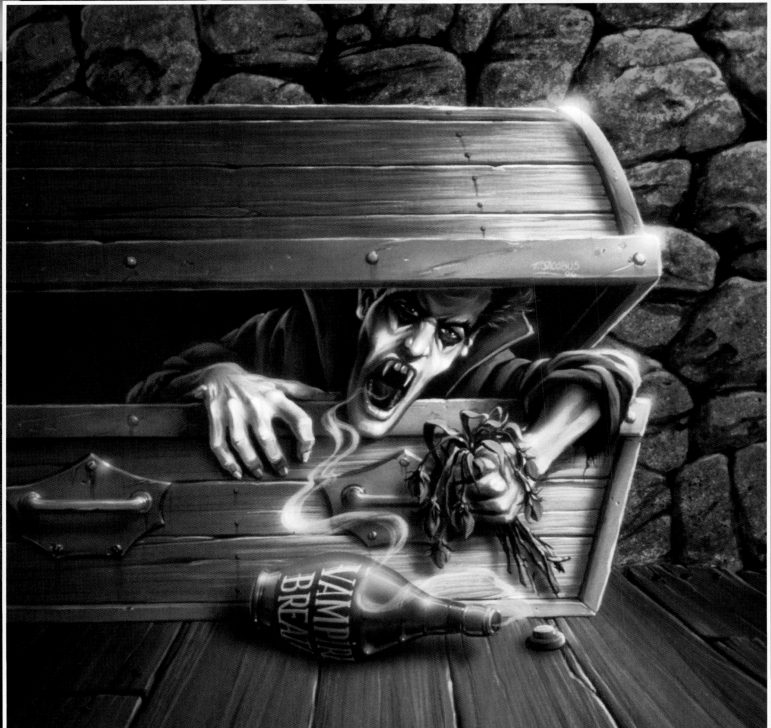

One of Jacobus' more straightforward covers, Count Nightwing is seen peering out of the coffin, holding dead flowers and with a green mist emanating either from his mouth to the bottle labelled "vampire breath" or vice versa. Jacobus uses pops of white to add a shiny cast to the iron of the casket. The count's face is suitably sinister, with dark points under the eyes highlighted by the shadows of eye bags to create the immediately recognizable visage of a vampire. Less recognizable is the fact that Count Nightwing's face was modelled after Jacobus' reference photographer, Michael.

CALLING ALL CREEPS!

REGULAR SERIES - BOOK #50 - DECEMBER 1996

Just Dial 555-C-R-E-E-P!

"Reach out and scare someone… Ricky Beamer is furious when he gets kicked off the school paper. So he decides to play a joke on Tasha, the bossy editor in chief. Just a little joke. Harmless, really. After school one day he sticks a message in the paper. If you're a creep, call Tasha after midnight, it reads. But somehow Ricky's message gets messed up. And now he's getting calls. Strange calls from kids who say they are creeps. Creeps with scaly purple skin. And long sharp fangs…"

Pencil Sketch 1

Pencil Sketch 2

Pencil Sketch 3

Color Mockup

This cover features something that is almost extinct in the United States: a telephone booth! The creeps are dressed in fashionable nineties clothes and resemble purple velociraptors. Jacobus uses his trademark pink sky, this time with blue instead of purple, to highlight the creepy trees in the background. The lines of the telephone booth and wooden fence in the background are curved to create an "off" perspective that adds to the—excuse the pun—creepiness factor.

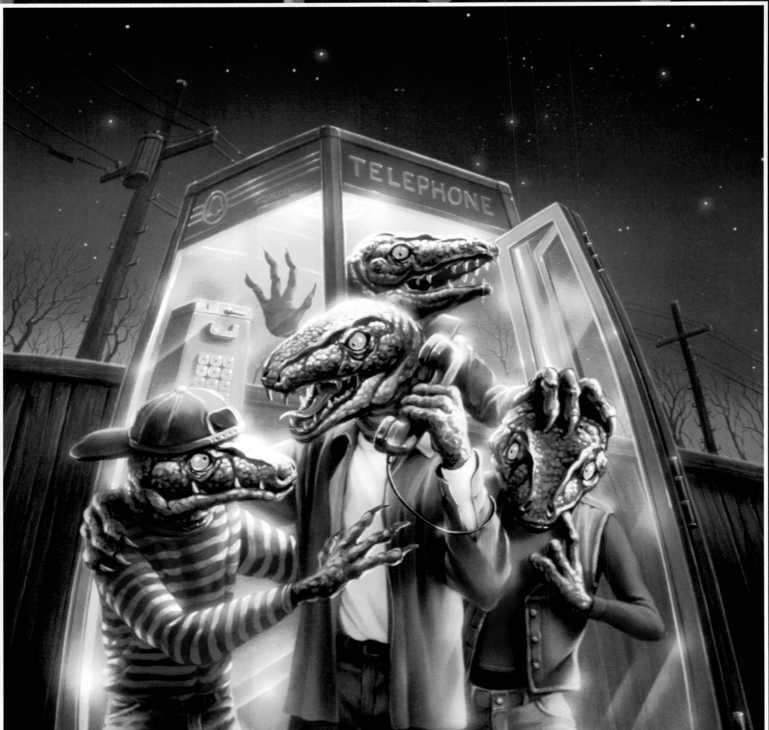

BEWARE, THE SNOWMAN

REGULAR SERIES - BOOK #51 - JANUARY 1997

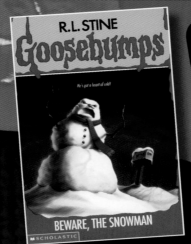

R.L. STINE
Goosebumps
He's got a heart of cold!

BEWARE, THE SNOWMAN

SCHOLASTIC

He's got a heart of cold!

"No melting allowed! Jaclyn used to live with her aunt Greta in Chicago. But not anymore. They've moved to a place called Sherpia. It's a tiny village on the edge of the Arctic Circle. Jaclyn can't believe she's stuck out in Nowheresville. No movie theaters. No malls. No nothing. Plus, there's something really odd about the village. At night there are strange howling noises. And in front of every house there's a snowman. A creepy snowman with a red scarf. A deep scar on his face. And a really evil smile…"

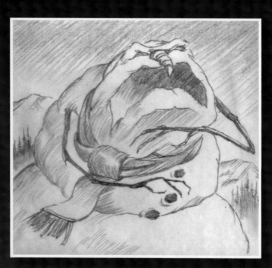

Pencil Sketch 1

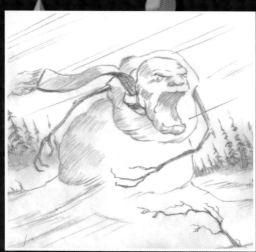

Pencil Sketch 2

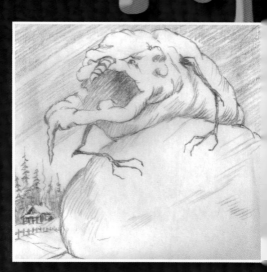

Pencil Sketch 3

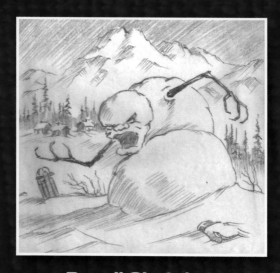

Pencil Sketch 4

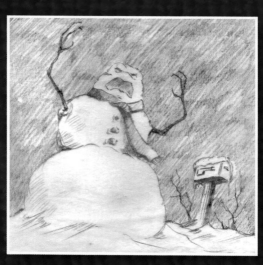

Pencil Sketch 5

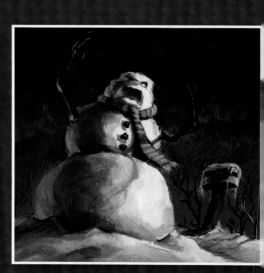

Color Mock-up

The frightening face and angry twig arms of the snowman form the center of this memorable cover. The red of the scarf is matched by the red of the mailbox tab, which is the only hint that the snowman is near society, as the snow covers everything around it except for a few dead plants. The moody, blue clouds in the background of the image help draw the eye to the bright, white figure. Note the use of dark purple near the tops of the clouds, and a greener tone of blue near the bottom of the sky, which helps to keep the dark sky "bright." Jacobus also pulls the twig arms from fading into the background by adding touches of white to the edges.

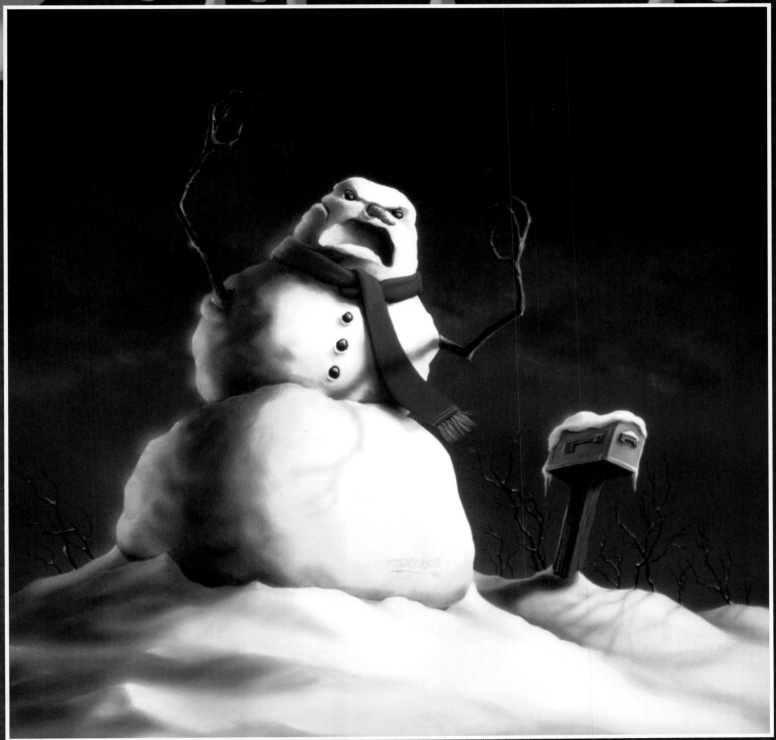

HOW I LEARNED TO FLY

REGULAR SERIES - BOOK #52 - FEBRUARY 1997

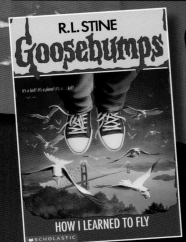

R.L. STINE
Goosebumps
It's a bird! It's a plane! It's a... kid?

HOW I LEARNED TO FLY

SCHOLASTIC

It's a bird! It's a plane! It's a... kid?

"He's got his head in the clouds. For real… Wilson Schlamme loves to make Jack Johnson feel like a total loser. And Jack's had it. That's how he ended up down at the beach. In a creepy, old abandoned house. In the dark. Trying to hide from Wilson. But everything is about to change. Because Jack just dug up the coolest book. It's called Flying Lessons. It tells how humans can learn to fly. Poor Jack. He wanted to get back at Wilson. But now that Jack's learned how to fly, things down on earth are getting really scary…"

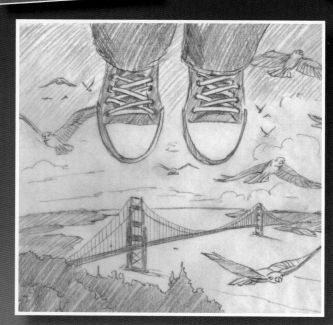

Pencil Sketch 1

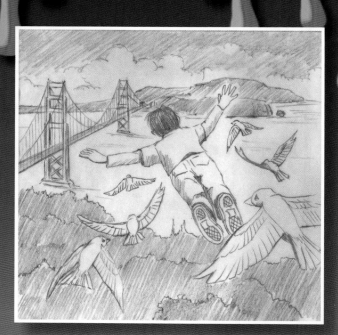

Pencil Sketch 2

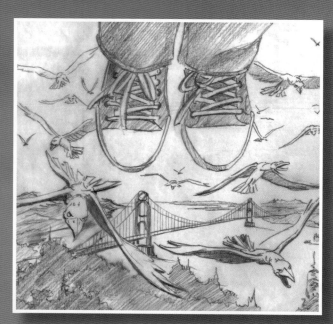

Pencil Sketch 3

Color Mockup

In what was surely an ecstatic few days on the job for Jacobus, the focus of this cover is a pair of enormous, red Converse. The red and white of the shoes are mirrored in the surrounding birds, who also sport evil, red eyes. The bridge and island below resemble the Golden Gate bridge of San Francisco. The colors of the bridge, water, and forest are all muted slightly by a light fog effect, pulling the shoes and birds dramatically into focus. Instead of the more traditional Jacobus bright, hot colors, the purples and oranges of the sky are also muted and cloudy.

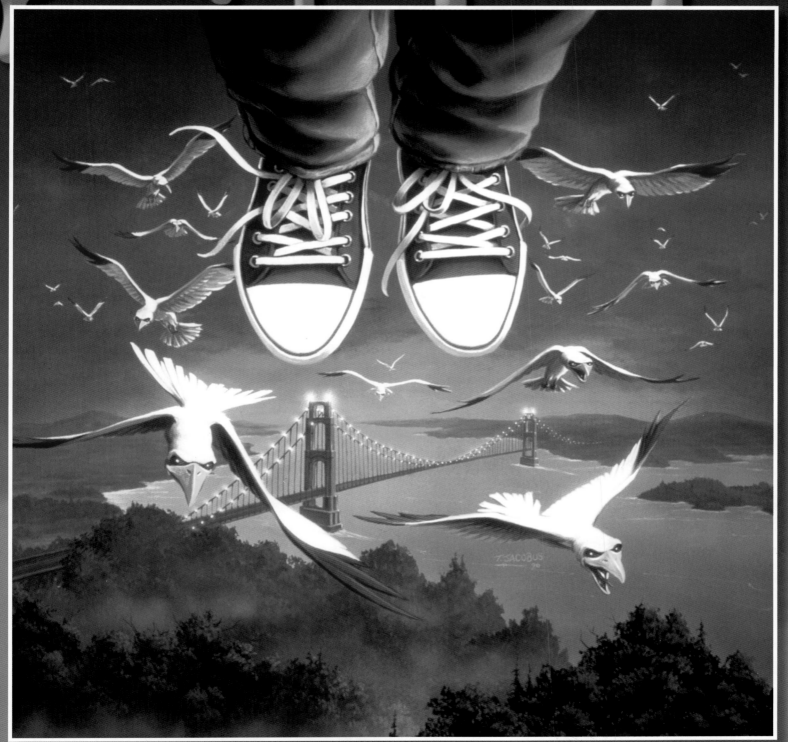

CHICKEN CHICKEN

REGULAR SERIES - BOOK #53 - MARCH 1997

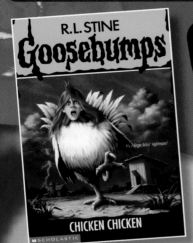

R.L. STINE
Goosebumps

CHICKEN CHICKEN

SCHOLASTIC

It's a finger lickin' nightmare!

"Don't call them chicken legs! Everyone in Goshen Falls knows about weird Vanessa. She dresses all in black. Wears black lipstick. And puts spells on people. At least, that's what they say. Crystal and her brother, Cole, know you can't believe everything you hear. But that was before they made Vanessa mad. Before she whispered that strange warning, "Chicken chicken." Because now something really weird has happened. Crystal's lips have turned as hard as a bird's beak. And Cole has started growing ugly white feathers all over his body…"

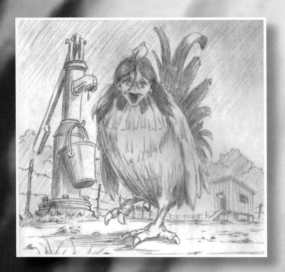

Pencil Sketch 1

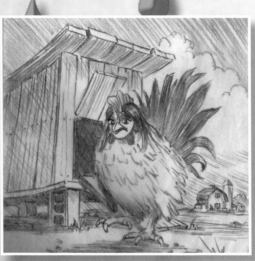

Pencil Sketch 2

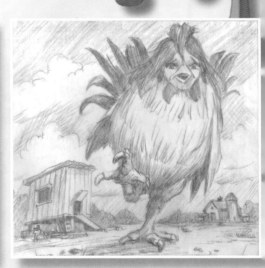

Pencil Sketch 3

Photo Shoot

Color Mockup

The horror on chickenized Crystal's face is not just conveyed via expression: the reds and shadows on her face mimic old pulp-horror comics faces. Jacobus used blue for the shading on the white feathers of the enormous chicken, keeping a few of the same shades of blue for the sky above. This time, the horizon is darker than the top of the sky, creating a moody storm background, enhanced by the lightning. Jacobus added patches of pink on the brown mud to give it texture and used that pink again on the wooden chicken house in the background.

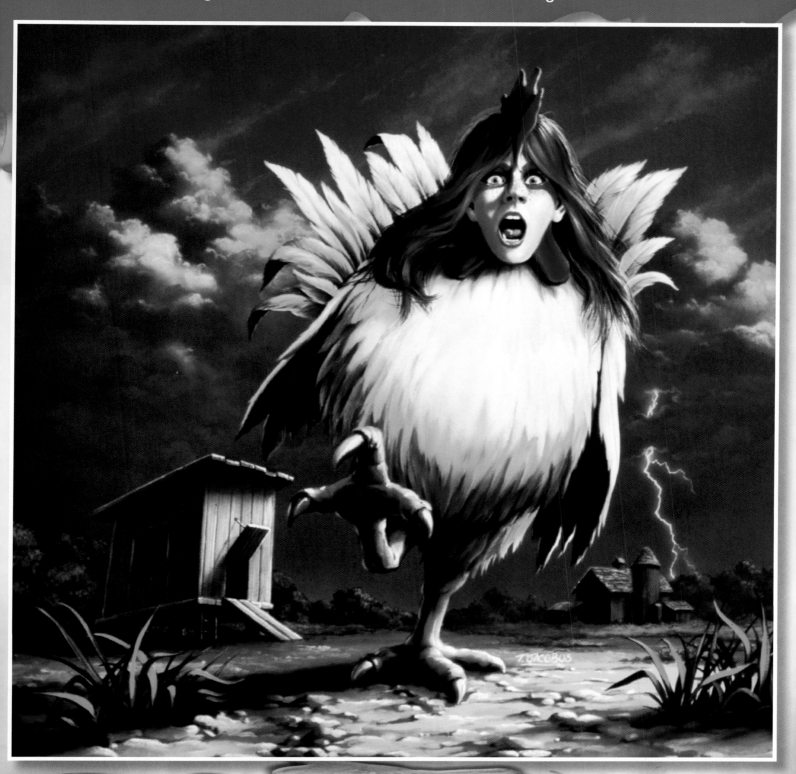

Slappy Says:

Interestingly, the art was flipped for the final cover, as evidenced by Jacobus' backwards signature on the illustration. It was restored to the original orientation for the 2007 reprint.

DON'T GO TO SLEEP!

REGULAR SERIES - BOOK #54 - APRIL 1997

Rise and shine. Forever.

"It's a no-snooze situation! Matt hates his tiny bedroom. It's so small it's practically a closet! Still, Matt's mom refuses to let him sleep in the guest room. After all, they might have guests. Some day. Or year. Then Matt does it. Late one night. When everyone's in bed. He sneaks into the guest room and falls asleep. Poor Matt. He should have listened to his mom. Because when Matt wakes up, his whole life has changed. For the worse. And every time he falls asleep, he wakes up in a new nightmare…"

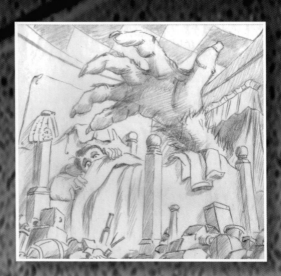

Pencil Sketch 1

Pencil Sketch 2

Pencil Sketch 3

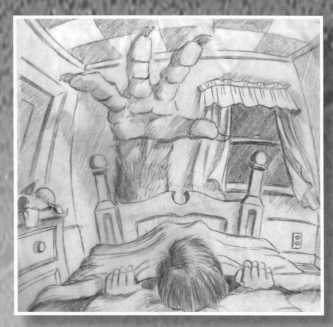

Pencil Sketch 4

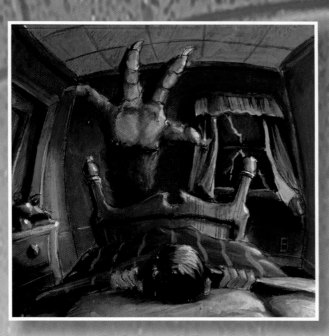

Color Mockup

When asked why this cover featured a giant monster hand when there were no monsters in the book, Jacobus explained that he generally paints the covers with very little information about the story. In fact, when he finally got the chance to read the novels years later, he was shocked by how well so many of the covers lined up with the story!

Each of the walls in the room is drawn curved and painted a different color, creating a feeling of claustrophobia and surrealism. This mood is enhanced by the terrifyingly textured monster hand rising from underneath the bed. Jacobus added small glints of white paint to create the impression of the lightning from the window illuminating part of the room. Note the interesting blue-tiled ceiling that seems to mimic a night sky.

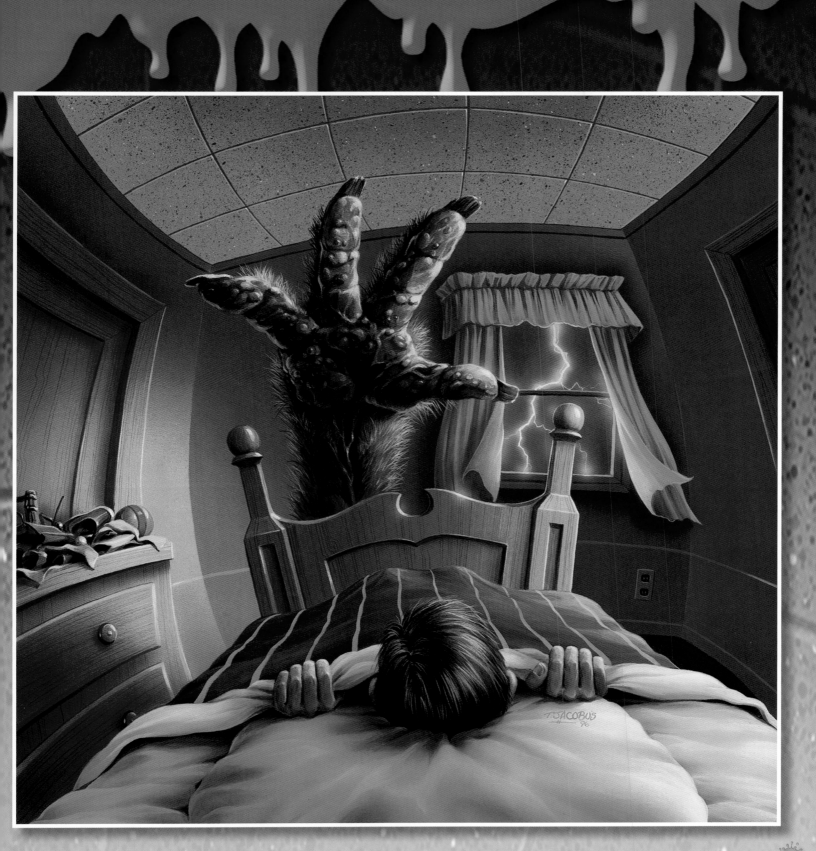

THE BLOB THAT ATE EVERYONE

REGULAR SERIES - BOOK #55 - MAY 1997

He's no picky eater!

"Read it and scream! A famous horror writer. That's what Zackie Beau-champ wants to be. He's writing a story about a giant blob monster. A pink slimy creature who eats up an entire town! Then Zackie finds the typewriter. In a burned down antique store. He takes it home and starts typing. But there's something really odd about that typewriter. Something really dangerous. Because now every scary word Zackie writes is starting to come true…"

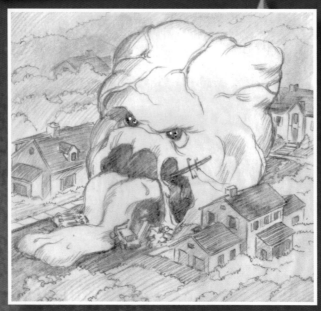

Pencil Sketch 1

Pencil Sketch 2

Pencil Sketch 3

In true *Goosebumps* fashion, this cover blends an ordinary, suburban neighborhood with the surreal: a pink, slimy, drooling monster. Bikes, cars, and mailboxes lie in a discarded pile under the enormous tongue. For once, the sky is a remarkably normal-looking color: blue with white clouds, probably to help the pink of the blob monster draw the eye.

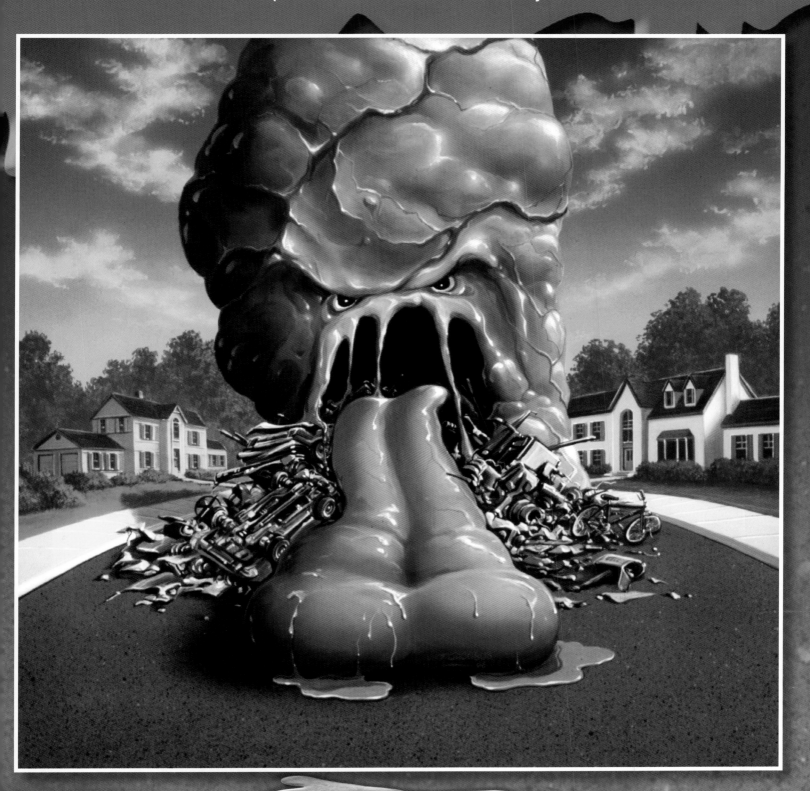

Slappy Says:

One of Jacobus' top ten, all-time favorite covers, the enormous pink blob, and the story itself, are an obvious homage to the classic horror film *The Blob*. When asked why this was one of his favorite covers, Jacobus said he wasn't sure, but he thinks it's because someone actually paid him to paint a giant tongue.

THE CURSE OF CAMP COLD LAKE

REGULAR SERIES - BOOK #56 - JUNE 1997

THE CURSE OF CAMP COLD LAKE

Last one in is a rotten...ghost!

"Sink or... sink. Camp is supposed to be fun, but Sarah hates Camp Cold Lake. The lake is gross and slimy. And she's having a little trouble with her bunkmates. They hate her. So Sarah comes up with a plan. She'll pretend to drown--then everyone will feel sorry for her. But things don't go exactly the way Sarah planned. Because down by the cold, dark lake someone is watching her. Stalking her. Someone with pale blue eyes. And a see-through body..."

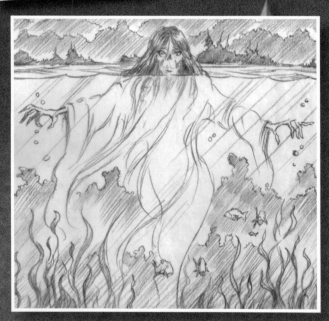

Pencil Sketch 1

Pencil Sketch 2

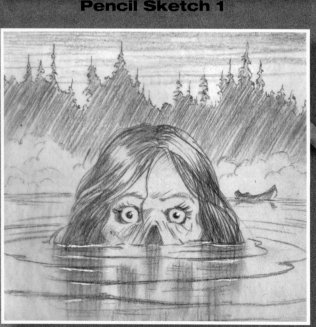

Pencil Sketch 3

Stine Says:

Another one of Jacobus' favorite covers, the frightening figure of a skeleton rising out of a lake certainly sets the mood for this camp-themed story, which I said was one of my scarier books. Jacobus was pleased with how he created the reflection of the skull in the water.

Unlike some of his scarier monsters, Jacobus uses very realistic eyeballs to up the "scare" factor in this illustration. The ripples of water are touched with white to create the impression of water shining in the light. The mist and directed, orange light in the corner suggest sunrise. The reader really gets the impression of the lake being cold, a feeling subtly influenced by the silver and white colors of the figure itself.

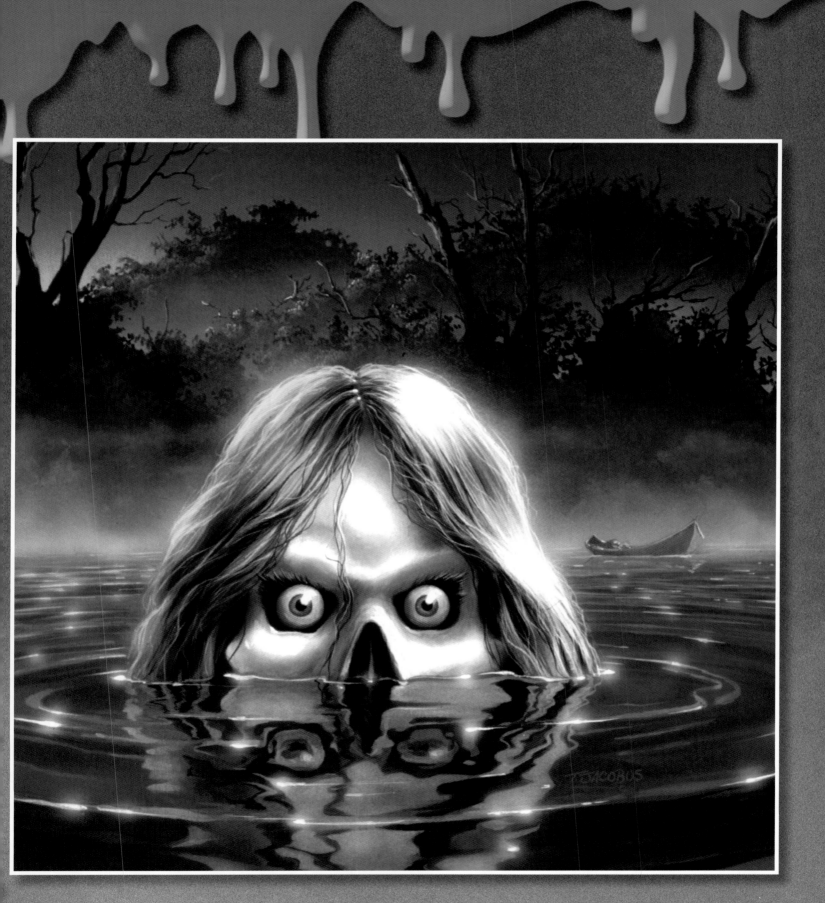

MY BEST FRIEND IS INVISIBLE

REGULAR SERIES - BOOK #57 - JULY 1997

Not seeing is believing!

"He's outta sight... for real! Sammy Jacobs is into ghosts and science fiction. Not exactly the smartest hobby--at least not if you ask Sammy's parents. They're research scientists and they only believe in real science. But now Sammy's met someone who's totally unreal. He's hanging out in Sammy's room. And eating his cereal at breakfast. Sammy's got to find a way to get rid of his new 'friend.' Only problem is...Sammy's new 'friend' is invisible!"

Pencil Sketch 1

Pencil Sketch 2

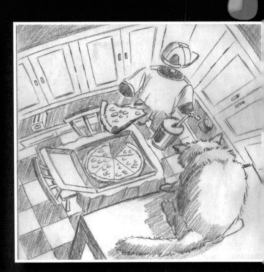

Pencil Sketch 3

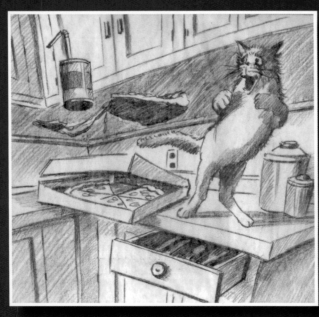

Pencil Sketch 4

Color Mockup

Perhaps the most comical of all the original *Goosebumps* covers, this illustration features Jacobus' distinct bright colors, crazy-mouthed animals, tiles, and fun perspective. It's almost the complete opposite of the previous cover's dark and morbid mood. The pizza and soda almost look hyper-realistic against the curved countertops and saturated pink, purple, and blue colors of the kitchen.

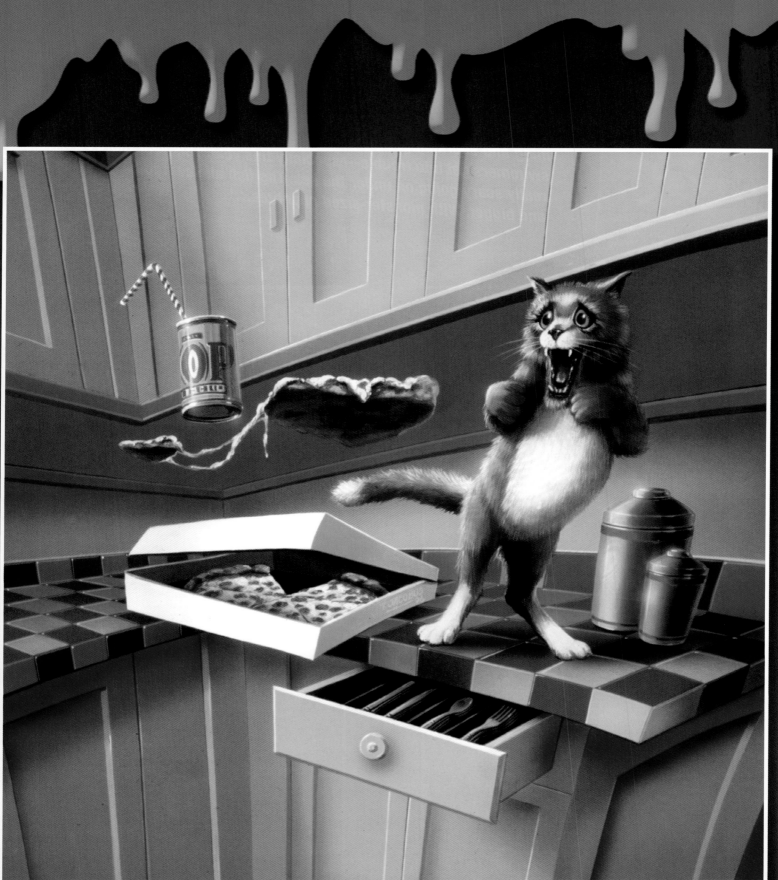

DEEP TROUBLE II

REGULAR SERIES - BOOK #58 - AUGUST 1997

Something's fishy...again!

"The fish are biting… everyone! Billy Deep and his sister Sheena are spending another summer in the Caribbean on their uncle's totally cool floating lab. The weather is beautiful. And there are lots of neat places to go swimming and snorkeling. Billy and Sheena are great swimmers. But even great swimmers get into trouble--especially this year. This year there's something really scary going on under the sea. The fish all seem to be growing. Bigger and bigger. With monster-sized appetites…"

Pencil Sketch 1

Pencil Sketch 2

Pencil Sketch 3

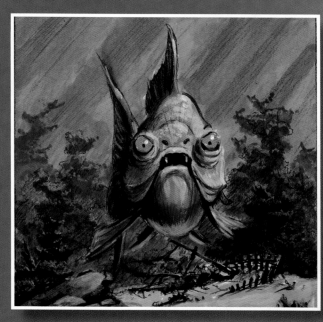

Color Mockup

The malformed fish of this cover looks more like an alien than a creature of the deep. Jacobus again uses the technique of a single-color eye with a dotted black pupil to give the creature a crazed look, but, this time, he adds a bit of lighting and shading to make the orbs pop out of the fish's face towards the reader. The light of the background is striated to represent the sunlight shining into the waters. The background reef almost looks like a forest, and the shipwreck on the seabed hints at the danger of the water.

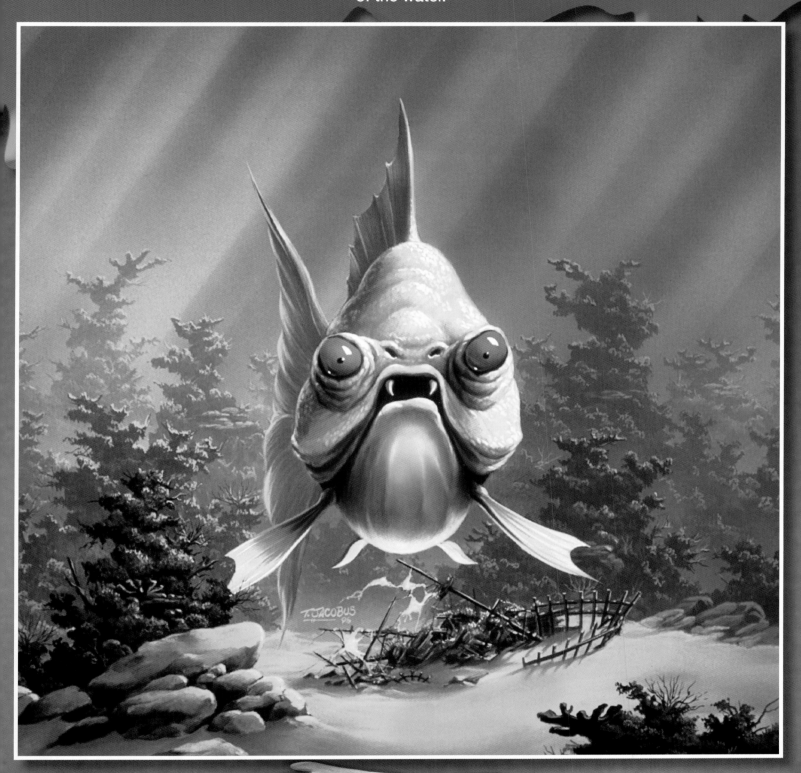

Stine Says:

This novel is one of my shortest *Goosebumps* book at about 16,000 words. It is one of three *Goosebumps* books to win a Nickelodeon Kids Choice Award, which it won in 1998.

THE HAUNTED SCHOOL

REGULAR SERIES - BOOK #59 - SEPTEMBER 1997

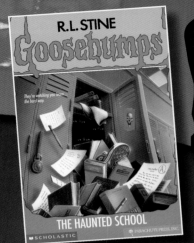

They're watching you learn… the hard way.

"He's hearing voices… from another world! Tommy Frazer's dad just got married. Now Tommy's got a new mom. And he's going to a new school -- Bell Valley Middle School. Tommy doesn't hate school. But it's hard making friends. And his new school is so big, it's easy to get lost. Which is exactly what happens. Tommy gets lost -- lost in a maze of empty classrooms. And that's when he hears the voices. Kids' voices crying for help. Voices coming from behind the classroom walls…"

Pencil Sketch 1

Pencil Sketch 2

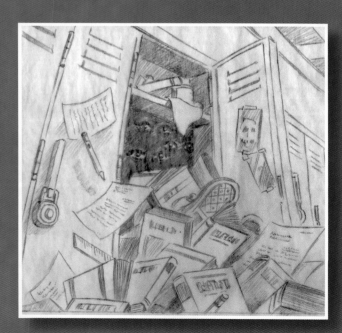

Pencil Sketch 3

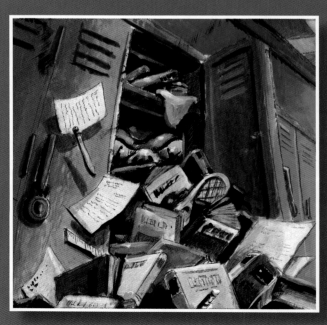

Color Mockup

Just in time for back-to-school, the cover of this book makes school appear scary. Haunted-looking faces peer out from a dark locker as gray books, tests, number two pencils, and even sneakers tumble out. The monochromatic junk is highlighted by the rainbow of colors filling the rest of the illustration, with a blue poster, green and yellow tiled ceiling, and orange and pink lockers. In addition to the bright colors, the line of the lockers is curved, playing with the reader's perspective. Jacobus' signature makes up the title of a book in the cascade.

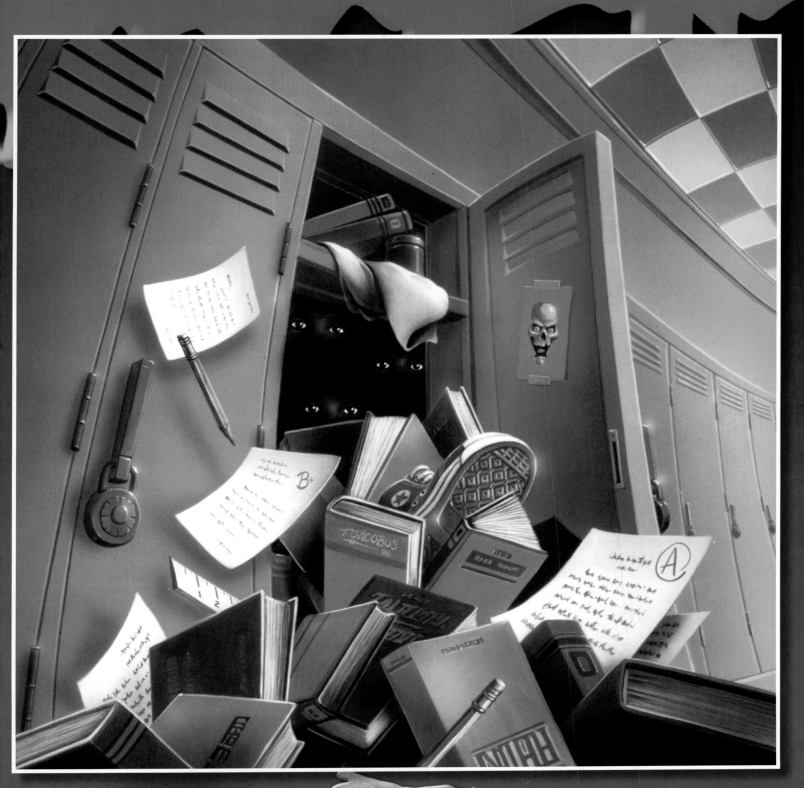

Curly Says:

Check out the inside of the locker door, it's a poster of me, the *Goosebumps* mascot.

WEREWOLF SKIN

REGULAR SERIES - BOOK #60 - OCTOBER 1997

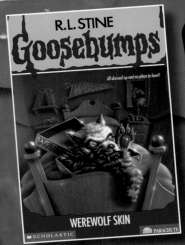

R.L. STINE
Goosebumps

All dressed up and no place to howl!

WEREWOLF SKIN

SCHOLASTIC · PARACHUTE

All dressed up and no place to howl!

"It's a full moon... do you know where your werewolf is? Picture this — Alex Hunter, photography freak, hanging out in Wolf Creek. Who lives in Wolf Creek? Alex's uncle Colin and aunt Marta. They're professional photographers. Uncle Colin and Aunt Marta are pretty cool. They only have two requests. Don't go into the woods late at night. And stay away from the creepy house next door. Poor Alex. He just wanted to take a couple of pictures. But now he's about to find out the secret of Wolf Creek. Late one night. When the moon is full..."

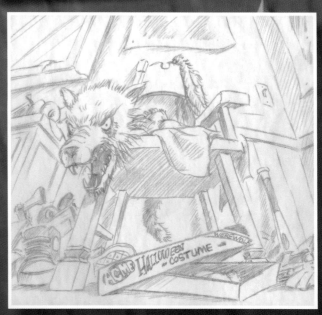

Pencil Sketch 1

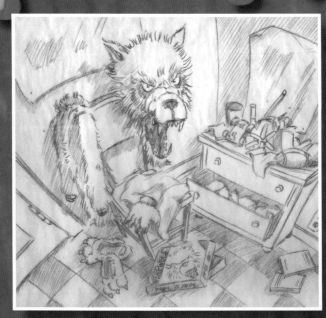

Pencil Sketch 2

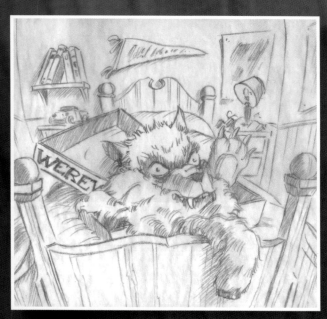

Pencil Sketch 3

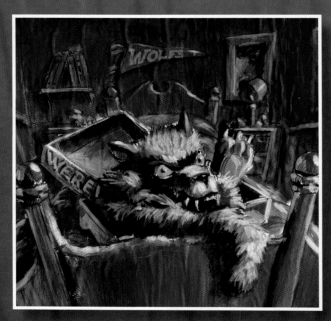

Color Mockup

The perspective, low and warped at the foot of the bed, and the close walls create a claustrophobic feel to this illustration. There are hints that the room probably belongs to a boy, including a sports banner for "wolves," appropriately enough, a toy truck, and a tiny painting of a demon-like creature. The werewolf skin is unsettling as it is, but the bloodshot green eyes bulging from the face, in addition to the saliva-ridden teeth, take the creepy factor to the next level.

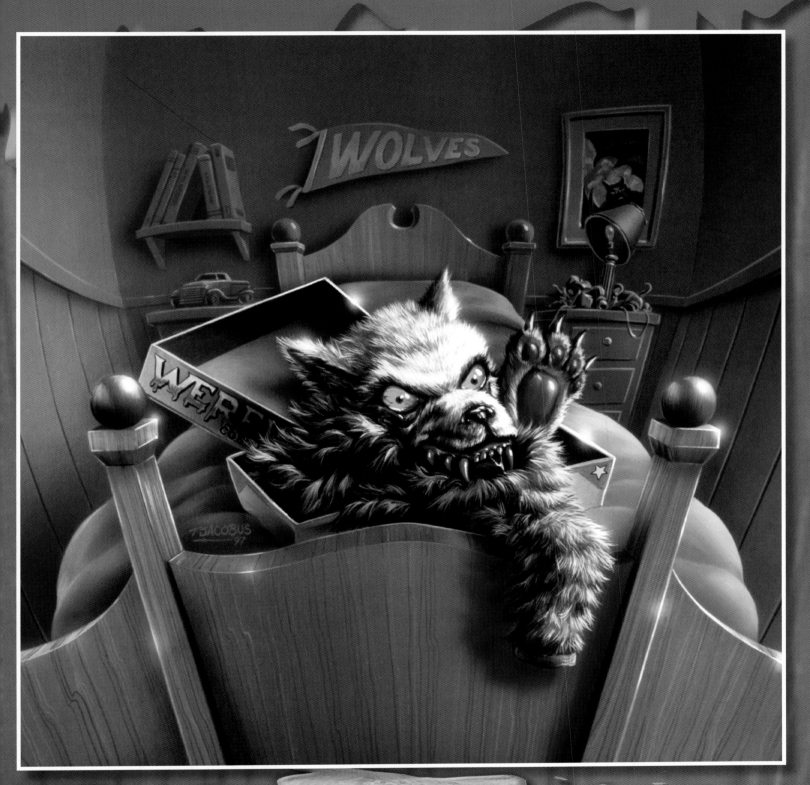

Slappy Says:

A "Howl-o-ween" mask was included in some of the first books, featuring a cut-out paper mask hof the wolf. *Werewolf Skin* is one of the few books of the original series that has not received a physical reprint, though it has been re-released digitally.

I LIVE IN YOUR BASEMENT!

REGULAR SERIES - BOOK #61 - NOVEMBER 1997

Talk about a MONSTER nightmare!

"He's got the basement blues! 'Don't do this! Watch out for that!' Marco's mom thinks the whole world is a danger zone. She won't even let Marco play softball. But Marco just wants to have fun. So he sneaks off to a game. And that's when it happens. He gets hit in the head with a baseball bat. Now things are getting really fuzzy. Really scary. Because when Marco gets home he gets the strangest call. From someone who says he lives in Marco's basement…"

Pencil Sketch 1

Pencil Sketch 2

Pencil Sketch 3

Color Mockup

Readers picking up this book in 1997 probably wouldn't guess that the monster depicted on the cover is named "Kevin." Jacobus made the texture of the monster the focus for this cover, with ripples, red veins, and the use of rounded highlights to create a gross globular effect. The purple eyes are matched by the shadows on the left side of the illustration, while sickly green at the top of the stairs and dull yellow on the floorboards are used for lighting moods.

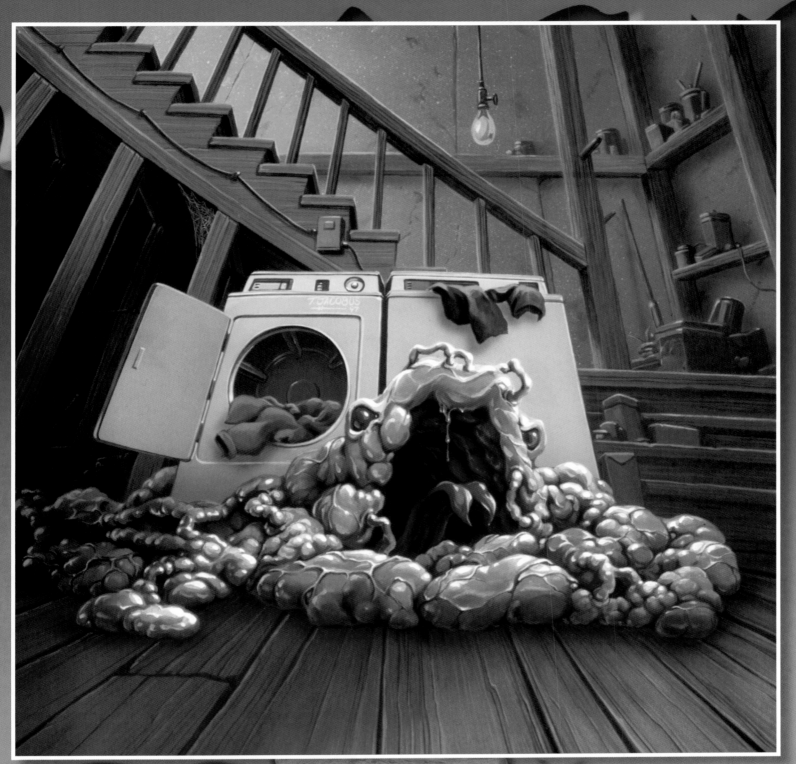

Stine Says:

The title of this book came to my mind as early as June 1996, more than a year before this novel was published. At the time, I still didn't have a story to go with the title. This novel has the lowest page count of the original series, despite not having the lowest word count, clocking in at 111 pages.

MONSTER BLOOD IV

REGULAR SERIES - BOOK #62 - DECEMBER 1997

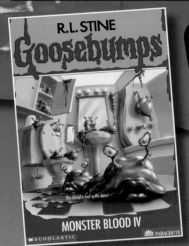

R.L. STINE
Goosebumps

This blood is bad to the bone!

MONSTER BLOOD IV

SCHOLASTIC PARACHUTE

This blood is bad to the bone!

"It's four times as evil! Evan Ross can't forget about Monster Blood -- the evil green slime that never stops growing. It can turn ordinary pets into ferocious animals and twelve-year-old kids into freakish giants. But now there's a new kind of Monster Blood in town. It comes in a can just like the others. Only difference is this slime is blue instead of green. And instead of just growing, it's multiplying -- into terrifying blue creatures with razor-sharp teeth..."

Pencil Sketch 1

Pencil Sketch 2

Pencil Sketch 3

Color Mockup

The 62nd — and very last — book of the original series received a fittingly quintessential Jacobus cover: an ordinary situation delightfully turned on its head. In this case, the ordinary place is a blue and pink bathroom, and the surreal is the disgusting slug-like monsters. Jacobus plays his greatest hits here: bright colors, warped perspective (most evidenced by the shape of the shower curtain and the ceiling), a viewpoint on the floor, and multicolored tiles. The only thing missing is a pair of Converse!

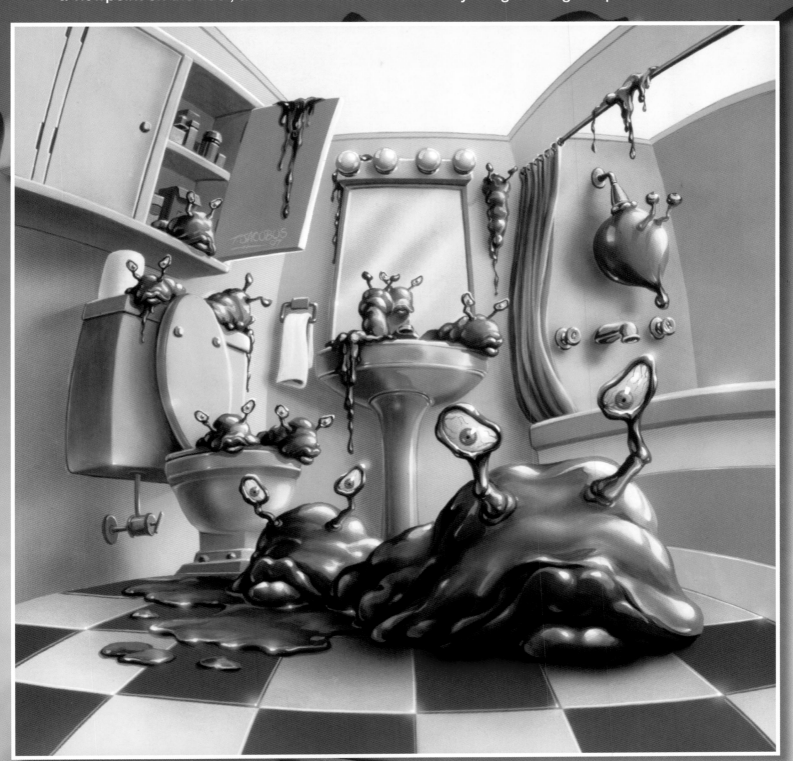

Slappy Says:

There are eleven blue monster-blood slugs on the cover, each with bulging, brown lips and bloodshot, yellow eyes with orange irises. In this case, Jacobus did not use the monochrome and single dot technique to make the monsters' eyes look flat and dead. Instead, these look just a bit too human, which is even more unsettling on the creatures' bodies.

Goosebumps

STINE

**Bride
of the
Living
Dummy**

PARACHUTE

ne deadly

OLAS

Goosebumps®

SERIES 2000
R.L. STINE

**Ghost
in the
Mirror**

GOOSEBUMPS

SERIES 2000
R.L. STINE

A mind is a terrible
thing to drink.

Brain

SCHO

Debuting in January 1998, the successor to the original *Goosebumps* series, *Goosebumps Series 2000*, was a darker, scarier upgrade for the new millennium.

Jacobus returned as the cover artist for *Goosebumps Series 2000*, but the covers were quite different from the original series. Gone was the slime-bordered logo on the front and the story synopsis on the back. The *Goosebumps* logo itself was also changed to slant upwards and the entire cover was now raised, just like the logo of the original books.

According to Jacobus, the transition to the edgier style was easy and fun. By this point, Jacobus estimated that he had done close to 100 covers in five years, which averages out to about twenty covers a year, so he enjoyed getting to try out a new style. In *Goosebumps Series 2000*, things are darker, with a less saturated, muter set of colors. The gross gore factor is ramped up, while the composition features a new level of dynamism.

Despite the new approach and scarier stories, the series was still squarely aimed at children, and there was even a *Goosebumps Series 2000* themed Count Chocula cereal released in 1998.

Goosebumps Series 2000 was originally intended to contain at least forty books, but legal issues interfered, leaving the series to abruptly come to a halt after the release of *Ghost in the Mirror*.

Despite its short run, *Goosebumps Series 2000* will be remembered as the edgier collection that introduced *Goosebumps* to a new generation of young horror fans and took things to another level of scary.

Welcome to the new millennium of fear!

Curly's Says:

The Escape from the Carnival of Horrors is the first book in the *Give Yourself Goosebumps* gamebook series. It was published in 1995. There are 25 different endings to this book but only one is correct.

CRY OF THE CAT

SERIES 2000 - BOOK #1 - JANUARY 1998

Dead cat walking...

Cry of the Cat was originally the last book of the regular series. Numbered 63, the original title was *Creep of the Cat*. Notice the regular series square layout of the painting, the *Goosebumps Series 2000* will be more rectangle in shape.

When he finally read the *Goosebumps* series that he had been illustrating so long, Jacobus cited *Cry of the Cat* as one of the most enjoyable. The first cover of the first book of the new series perfectly illustrates the updated approach.

Pencil Sketch 1

Pencil Sketch 2

Color Mockup

Curly Says:

Cry of the Cat is the only book of *Goosebumps Series 2000* to receive a trading card.

The illustration features Rip the Cat growling ferociously as saliva drips from his fangs. The muted blue background is a far cry from Jacobus' traditional bursts of color, and the cat is drawn with realistic looking eyes. The fur ripples with oranges, browns, and yellows but in very neutral tones. The pearly fangs are exaggerated and menacing. If one were to hold this cover up next to the previous book, *Monster Blood IV*, the difference would be immediately apparent.

Stine Says:

This first book was difficult and I wrote several versions before the editors were happy with it.

BRIDE OF THE LIVING DUMMY

SERIES 2000 - BOOK #2 - FEBRUARY 1998

It's a match made in horror.
The fourth book in the *Night of the Living Dummy* series, *Bride of the Living Dummy* features a happy bride and groom menacingly threatening to cut the cake. Mary-Ellen's depiction in this illustration includes classic *Bride of Frankenstein* hair, an homage to the movie that influenced the title of this story.

Curly Says:

Bride of the Living Dummy was the first of the *Goosebumps Series 2000* books to get a *Goosebumps* TV episode, which aired on Valentine's Day, of course.

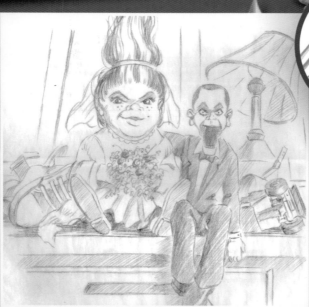

Pencil Sketch 1

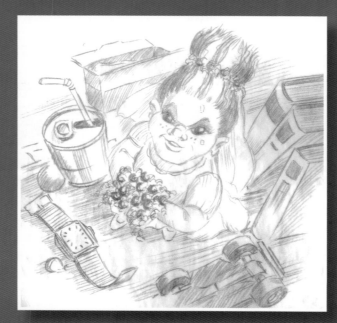

Pencil Sketch 2

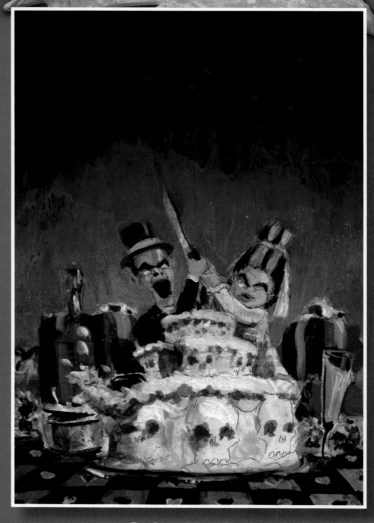

Color Mockup

Though the colors are slightly muted, this is one of the more colorful covers in the new series, with hot orange, deep purple, and glowing yellow making up the background. The wedding cake is a goth dream, featuring white-frosting skulls with red roses for eyes. The cover art is zoomed in, hiding a few details from the original illustration, which includes a checkered floor filled with hearts, a champagne flute, presents, and flowers in the background.

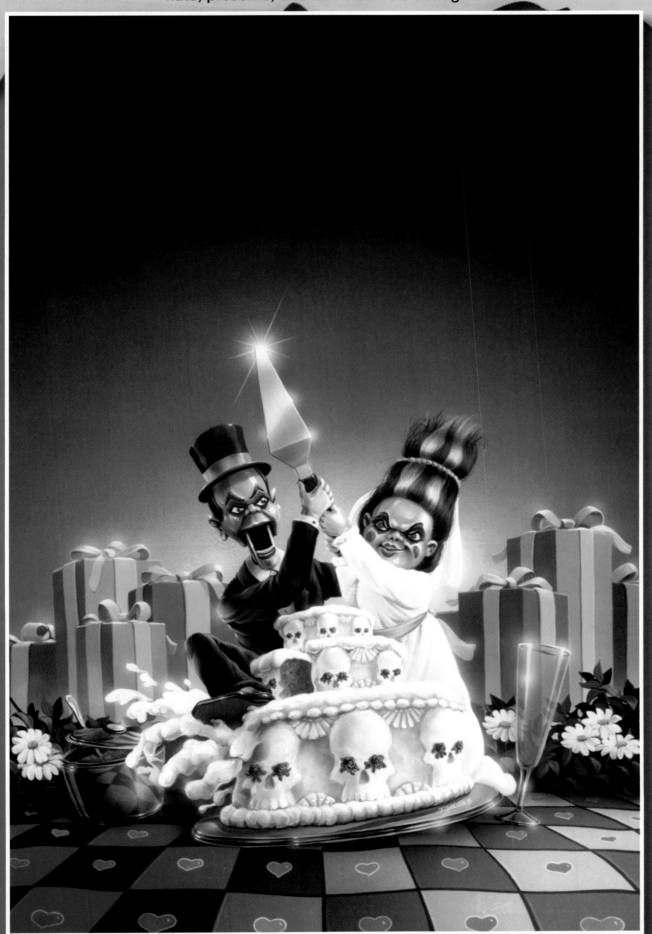

CREATURE TEACHER

SERIES 2000 - BOOK #3 - MARCH 1998

This is one killer class!

The version of Mrs. Maaargh on the cover of *Creature Teacher* is not the first depiction of the monster that Jacobus drew. As part of his artistic process, he tried a few different iterations of the irate educator. One depicted Mrs. Maaargh with a normal face but monster feet, another had her with a long braid down her back, facing the chalkboard. The editors at Scholastic ended up choosing the version seen on the cover, although they altered the final art slightly, changing the pink and purple ceiling to blue and black and scaling up Mrs. Maaargh's body and desk. They also cropped out the other classroom items, such as the bulletin board, bookcase, and the apple on the desk.

Pencil Sketch 1

Pencil Sketch 2

Pencil Sketch 3

Pencil Sketch 4

Pencil Sketch 5

Pencil Sketch 6

Pencil Sketch 7

Color Mockup 1

Color Mockup 2

Color Mockup 3

Jacobus uses a sickly-green for the chalkboard and pink for the monstrous teacher's skin so that she looks just human enough to be unsettling. The lines and shading around the eyes make the eyeballs pop out towards the reader, and the rows of teeth are certainly the last thing anyone would want to see on their teacher.

INVASION OF THE BODY SQUEEZERS: PART 1

SERIES 2000 - BOOK #4 - APRIL 1998

Talk about a tight squeeze!

Invasion of the Body Squeezers: Part 1's illustration depicts a Body Squeezer holding a human leg as a dog tries to attack the creature, which is reaching its gross hands toward the reader. Jacobus especially liked the way the neighborhood and meteors turned out, as they created a nice depth to the image. He also enjoyed creating the suction cup alien fingers that Stine described. The illustration is wonderfully sci-fi, with two moons, one enormous and one smaller, a pink and blue sky, and terrifying, red-eyed monsters that vaguely resemble green fungi.

Pencil Sketch 1

Pencil Sketch 2

Pencil Sketch 4

As the first two-parter of either *Goosebumps* or *Goosebumps Series 2000*, *Invasion of the Body Squeezers* needed a very special cover. Jacobus created a single image that would be split between the two books seamlessly.

This illustration is the only cover that Jacobus signed with just his initials, while his full signature appears on the cover of part two.

Pencil Sketch 5

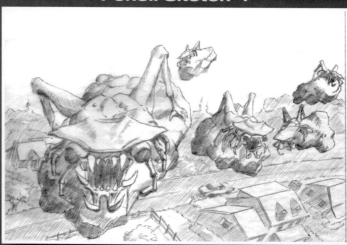

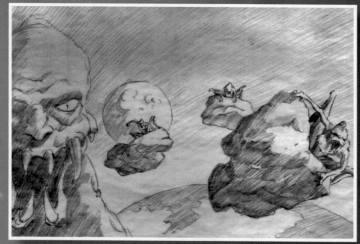

Pencil Sketch 3

Pencil Sketch 6

INVASION OF THE BODY SQUEEZERS: PART 2

SERIES 2000 - BOOK #5 - APRIL 1998

Please don't squeeze the human!

The second half of the two-part cover, the Body Squeezer here is in the midst of attacking two children. There is no perspective play or bright colors to tone down the realism of the attack. Though the scene on the cover does not appear in the book, it is fraught and dynamic, clearly depicting the stakes of an invasion. The large, salivating jaws of the lime-green monster are inches from the two kids. Once again showcasing the difference in styles from the original series, all of the colors are muted.

Even the clothes of the two boys seem drab. The cracked road and dead grass suggest chaos and death. The use of shading on the top of the monster's head gives the impression of a strange type of plant. At 128 pages, *Invasion of the Body Squeezers: Part 2* is the longest book in *Goosebumps Series 2000*.

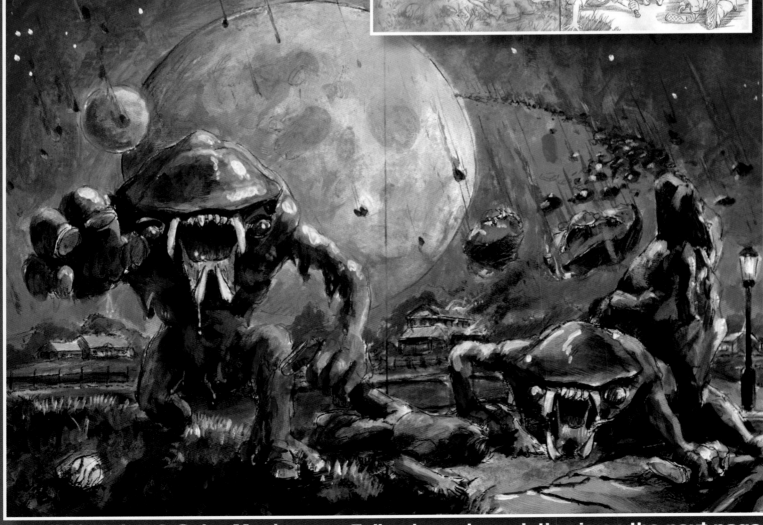

Pencil Sketch 7 & Color Mockup **Full color color painting is on the next page.**

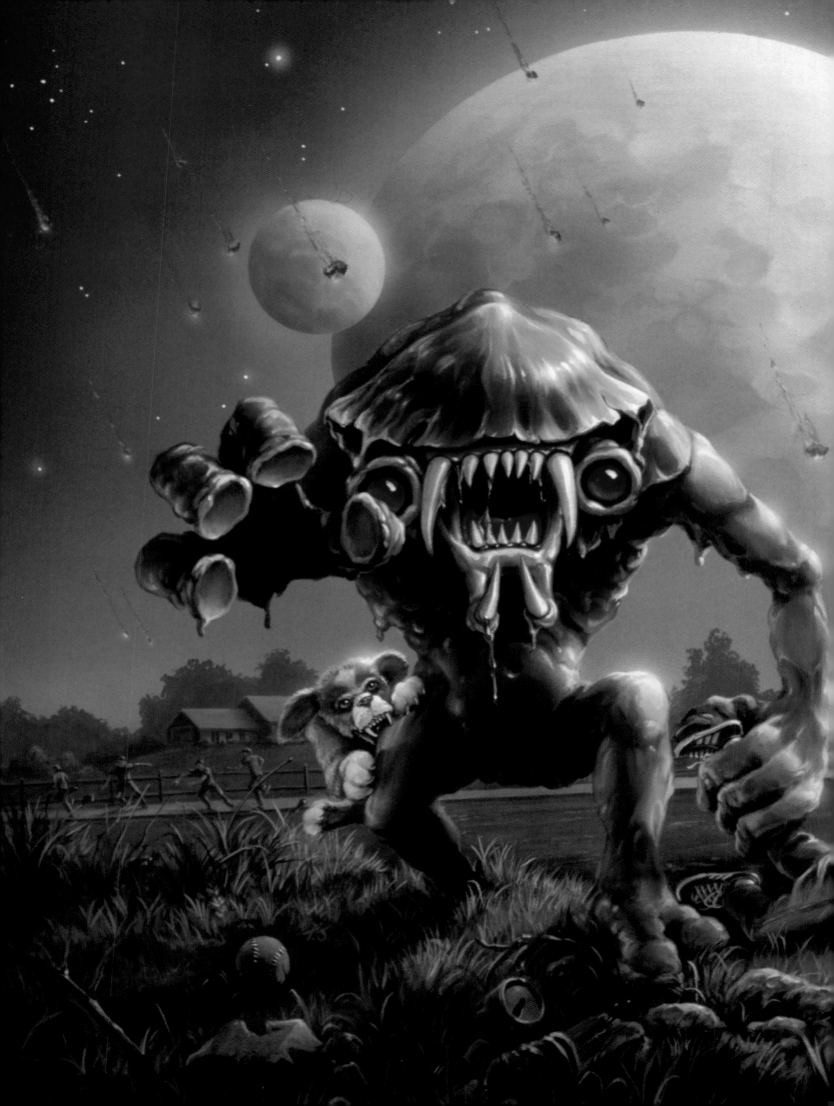

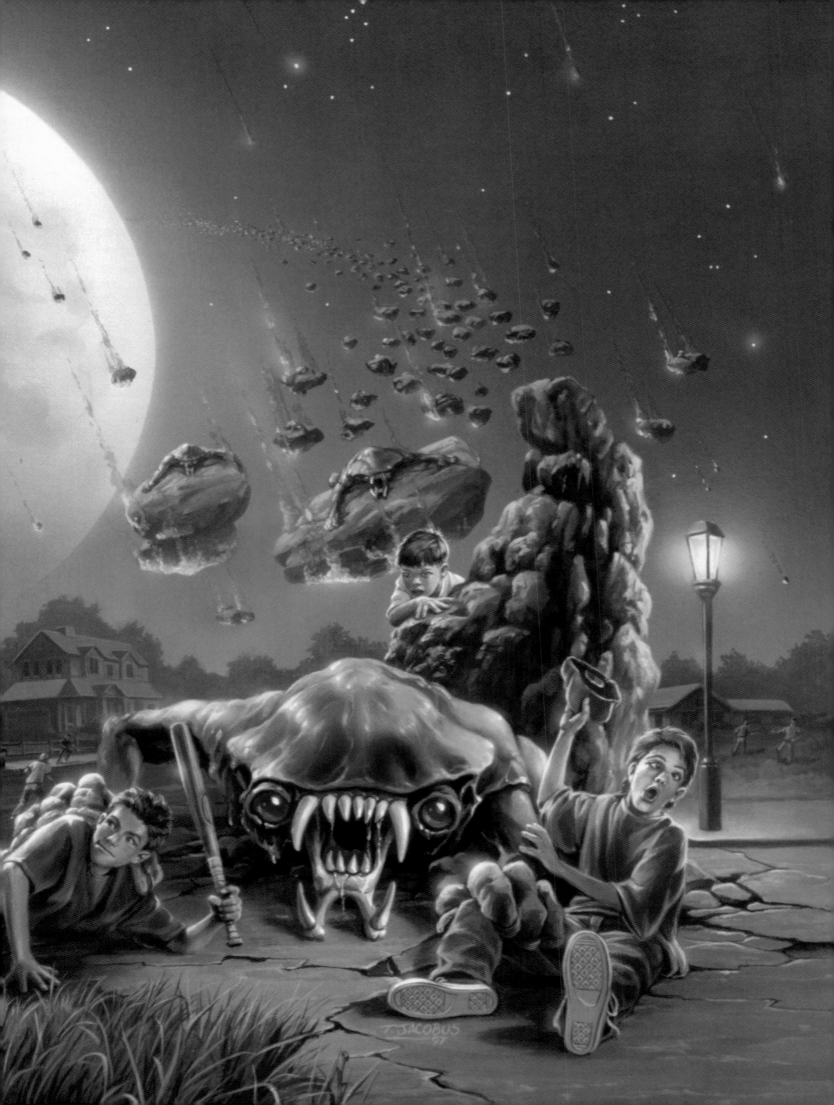

I AM YOUR EVIL TWIN

He's one deadly double!

Again, featuring a much more realistic blend of horror and the mundane, the cover of *I Am Your Evil Twin* depicts Monty in a broken mirror. On one side is a child with blue eyes and blonde hair wearing an orange shirt. On the shattered side is a child with red eyes, an enormous, exaggerated mouth, and a purple shirt. Jacobus still creates the suggestion of the *Goosebumps* feel by incorporating a slime-green background, even though the colors remain muted to indicate the new series. Small dots of white line the edges of the tear, creating the illusion of glinting glass.

Pencil Sketch 1

Pencil Sketch 2

Pencil Sketch 3

Pencil Sketch 4

Pencil Sketch 5

Color Mockup

This illustration is notably modern in comparison to depictions of children in the original *Goosebumps* series.

REVENGE R US

SERIES 2000 - BOOK #7 - JULY 1998

It's a bird's-eye view... of horror.

Although Jacobus manages to sneak a bit of purple into the color of the wings, this cover again features the deeper tones that are the hallmark of *Goosebumps Series 2000* books. The brick-red halo in the background frames the crow's head and draws the eye, while separating the darkness of the bird's feathers from the background itself.

Pencil Sketch 1

Pencil Sketch 2

Pencil Sketch 3

Pencil Sketch 4

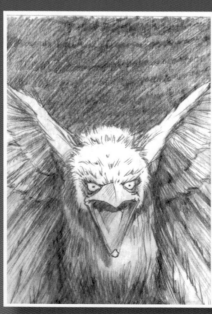

Pencil Sketch 5

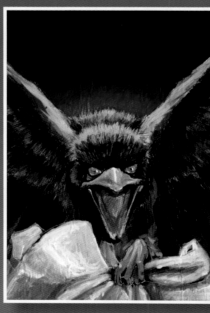

Color Mockup

The title of the book is a reference to Toys "R" Us, a toy chain, and the crow grasps a newspaper advertising *Revenge R Us*, as though it were an actual store. Jacobus uses purple highlights on the left side of the crow to show a light source and to create a dynamic effect, as if the bird is careening towards the reader.

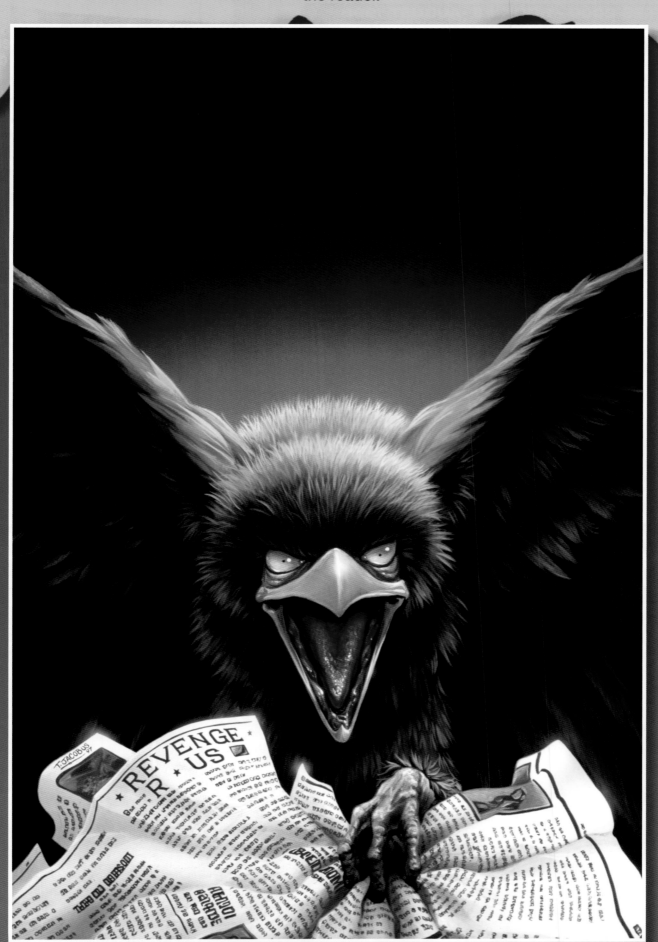

FRIGHT CAMP

Where the wild things are... out of control!

Another camp-themed book for the summer readers, *Fright Camp's* cover depicts a ravenous racoon in an overflowing trashcan filled with apple cores, bones, and slime.

Jacobus said he was inspired to illustrate the beast by his time as a lifeguard at a lake club. It was similar to a day camp and one of his duties was to pick up trash. Raccoons would get into the trashcans and frighten the camp workers unexpectedly when they took off the lid. Jacobus and the other workers took to kicking the cans before taking the lids off, saying that if they heard a growl, they would just push over the bin and run.

Pencil Sketch 1

Pencil Sketch 2

Pencil Sketch 3

Pencil Sketch 4

Pencil Sketch 5

Pencil Sketch 6

Color Mockup 1

Color Mockup 2

Curly Says:

Jacobus was first asked to illustrate a concept of a 12-year-old male camper strapped into an electric chair but the editors decided it was too shocking for young readers.

158

The startling moment stuck with him, and he recreates it within this illustration, using both his eye dot and exaggerated mouth techniques to give the animal a crazed look. Jacobus uses a glowing green in a corona around the beast to depict the gross scent of trash in the summer.

ARE YOU TERRIFIED YET?

SERIES 2000 - BOOK #9 - SEPTEMBER 1998

Along came a spider…

Look away, arachnophobes! These detailed spiders are full of life and slime. Jacobus' illustration techniques create a spider so realistic, readers might think they can feel the furry limbs of the creatures. The green saliva from the main figure's jaws are reminiscent of viscous slime. Jacobus adds bits of white to create the glinting, clear surface of the glass jar, with bits of shadow near the edges to suggest the distortion one sees through curved class. The background of the original illustration is a moody mix of yellow, orange, and red which fades up into a cloud-like purple.

Pencil Sketch 1

Pencil Sketch 2

Pencil Sketch 3

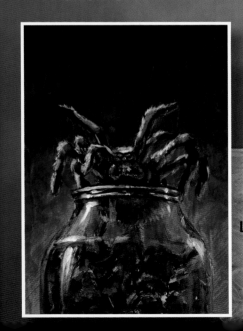

Curly Says:

Like many of the *Goosebumps Seri* *2000* covers, the image is zoomed in on the final book, showing very little of the background.

Interestingly, *Are You Terrified Yet?*, *Scream School*, and *Fright Camp* are the only *Goosebu[r]*
2000 books to be monsterless. These three books center on issues like confronting fears and b[...]
opposed to escaping a monster in your basement.

HEADLESS HALLOWEEN

SERIES 2000 - BOOK #10 - OCTOBER 1998

Talk about getting ahead!

Released for Halloween, the cover of this novel features a figure holding a disturbingly empty-looking, green head while reaching for a plump jack-o'-lantern. The enormous moon pulls the eye to the central figure, and Jacobus paints both the hand and the pumpkin bigger to create the illusion of the headless person reaching forward towards the reader. The empty, green head is glowing like toxic waste, shining its green light onto the arm of the figure. The creepy, gnarled tree in the background adds a subliminal message of loneliness to the scene. The jack-o'-lantern has no light, the mask has empty black pits for eyes, the figure has no head or face.

Pencil Sketch 1

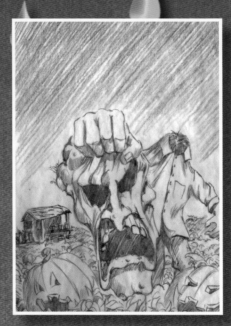

Pencil Sketch 2

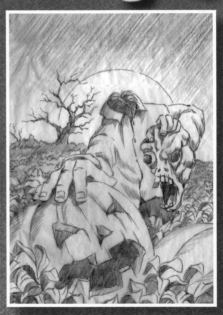

Pencil Sketch 3

Photo Shoot

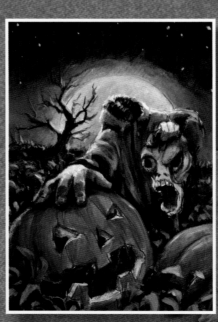

Color Mockup

Curly Says:

There is nothing "living" in the image. The illustration is quietly creepy. It's almost bone-chilling!

Headless Halloween is interesting because it is one of the few *Goosebumps* books in which the protagonist is the bully, and also wherein they die during the story, as opposed to a mysterious or suggested death at the ending.

ATTACK OF THE GRAVEYARD GHOUL

SERIES 2000 - BOOK #11 - NOVEMBER 1998

Dead but not buried...

With a cover that could easily grace the album of a heavy metal band, *Attac* *the Graveyard Ghouls* is just a touch gorier than anything that would be depic in the original *Goosebumps* series.

The titular ghouls rise up from their tombs. One has an eyeball dangling by nerve. Another has open sores and wounds on its green hands. The use of r both of these cases would have been considered too intense for previous b but not for *Goosebumps Series 2000*.

Pencil Sketch 1

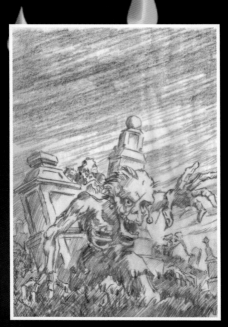

Pencil Sketch 2

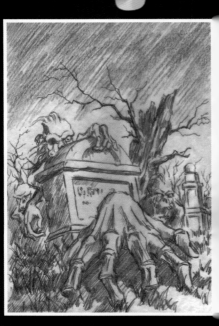

Pencil Sketch 3

Color Mockup

Curly Says:

Attack of the Graveyard Ghouls is just one of three books from *Goosebumps Series 2000* to be reprinted as a *Classic Goosebumps*. The others are *Bride of the Living Dummy* and *The Haunted Car*.

The orange and purple clouds in the background appear to be roiling in the wind, sett
ning tone. Jacobus uses forced perspective to bring the reader into the illustration, as t
hand reaches in their direction.

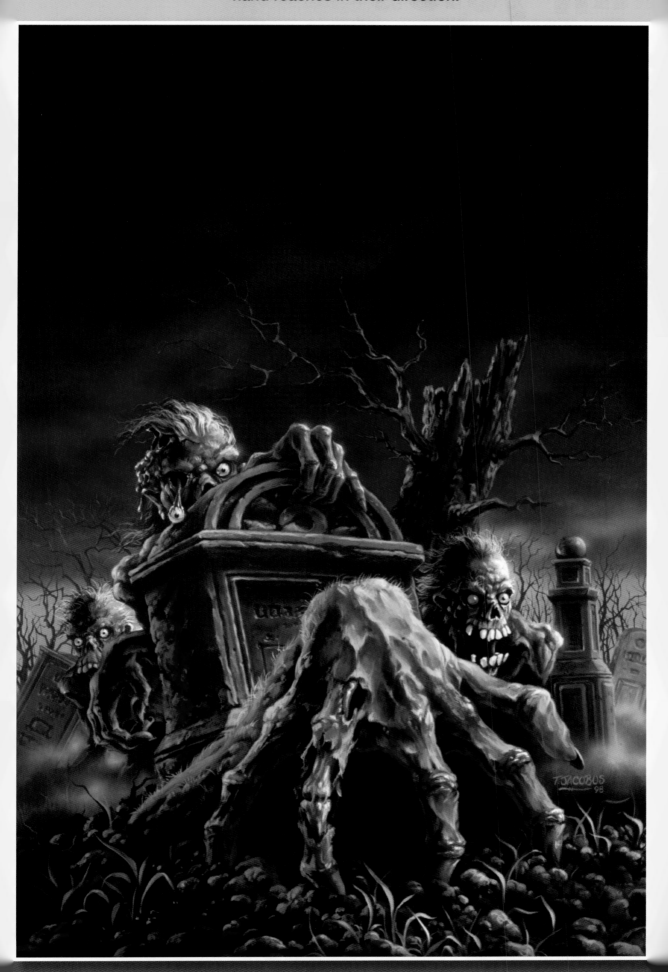

BRAIN JUICE

SERIES 2000 - BOOK #12 - DECEMBER 1998

A mind is a terrible thing to drink.

This beautifully realistic brain, complete with blue veins, the brainstem, and a myriad of folds, becomes a haunting image when combined with the vibrant, purple liquid splashing down onto it. The background is black, with no shading, texture, or gradients. The bottom left side of the brain is slightly red, suggesting a hellish light source to that side. The dripping, purple juice has white highlights to give it a truly liquid feel, and Jacobus has lovingly rendered the splash effects.

Pencil Sketch 1

Pencil Sketch 2

Pencil Sketch 3

Pencil Sketch 4

Color Mockup

Stine Says:

Brain Juice is one of my favorites in the entire series, and one that I feel is often overlooked by readers.

The Scholastic website depicted this cover with a different tagline: "This is your brain. This is your brain on juice," which is a reference to the "This is your brain on drugs" campaign by Partnership for a Drug-Free America. Considering *Goosebumps* was one of the most challenged book series at that time (as in: parents sought to have the book removed from libraries), Scholastic may have deemed it too risky to reference drugs on the cover.

RETURN TO HORRORLAND

Long time no scream!

By this thirteenth book in the *Goosebumps Series 2000*, slime-green seems to have become a common feature of many of the covers. It is featured here in the form of ice cream—or "ice scream." Jacobus uses forced perspective to give the illusion of the purple horror handing the glowing, dripping cone to the reader, pulling them right into the story.

Curly Says:

This novel seems to suggest that at least a few *Goosebumps* books share the same universe, as Evan Ross from *Monster Blood* and Amaz-O from *Bad Hare Day* both make appearances.

Pencil Sketch 1

Pencil Sketch 2

Pencil Sketch 3

Color Mockup

Jacobus uses yellow for the eyes and adds touches of yellow to the horns and face to make the eyes appear to glow. In the background is the amusement park, and behind that is a pink and black sky filled with dangerous-looking clouds.

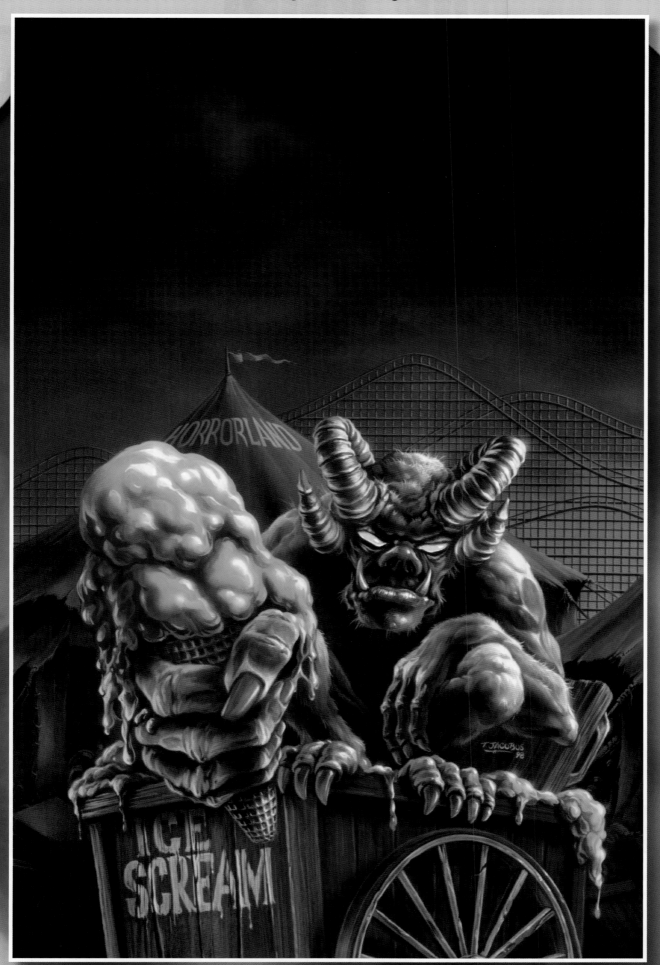

JEKYLL AND HEIDI

SERIES 2000 - BOOK #14 - FEBRUARY 1999

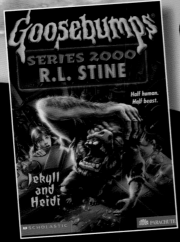

Half human. Half beast.

Jacobus considers the cover for *Jekyll and Heidi* to be one of the best in the entire *Goosebumps* series, citing the use of perspective and the horrid form of the monster. The illustration depicts Heidi Davidson looking on as a creature appears to be in pain in a laboratory. Again, we see the use of slime-green, this time in the vials and in the broken glass on the floor. Jacobus uses his single color and a dot for a pupil technique on the eye here, giving the humanoid creature a frenzied look.

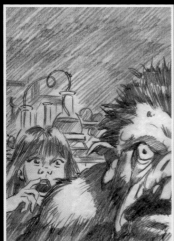

Pencil Sketch 1

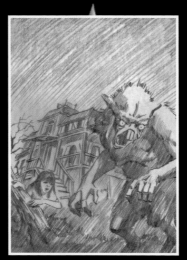

Pencil Sketch 2

Pencil Sketch 3

Pencil Sketch 4

Pencil Sketch 5

Photo Shoot

Photo Shoot

Color Mockup

Curly Says:

The creature on the cover of this book was not the creature that appears in the story. There is a scene in the book where Uncle Jekyll drinks a formula that makes his body react in a monstrous fashion, but not to the point he actually transforms into a monster.

e large, flat teeth are especially unsettling. The blues and whites create the mood of bei
at night, with the moonlight shining in on the scene. For the final cover, the overall cool
picture was warmed up, with both Heidi and the monster having more pink and red to

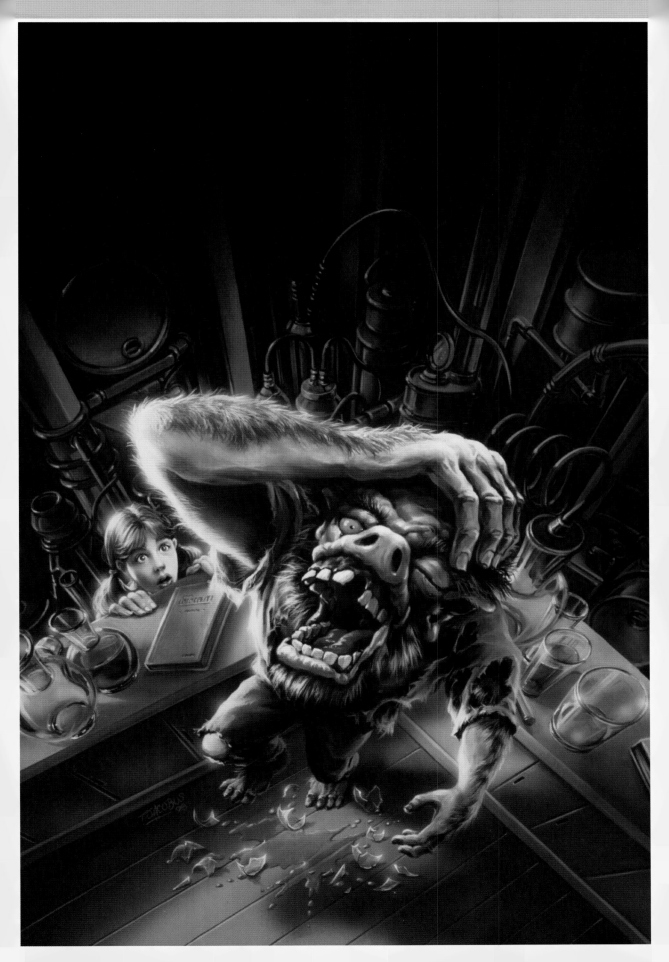

SCREAM SCHOOL

Student body stalker...
When asked who the model was for Johnny Scream, the monster featured on the cover of *Scream School*, Jacobus revealed that he modeled for this image himself. Perhaps that is why the creature is in the midst of drawing a creepy skull. The perspective on this illustration is very trippy, with the wall seeming to sink into the floor, drawing the eye fully to Johnny as he smirks over his shoulder.

Curly Says:

This is one of only three *Goosebumps Series 2000* books to be written in the third person. Along with *Fright Camp* and *Are You Terrified Yet?*, this is one of the few *Goosebumps Series 2000* books where nothing supernatural happens.

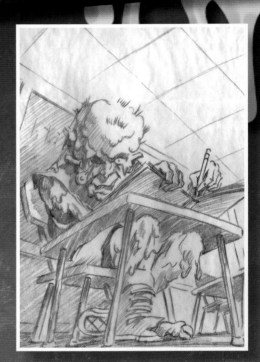

Pencil Sketch 1

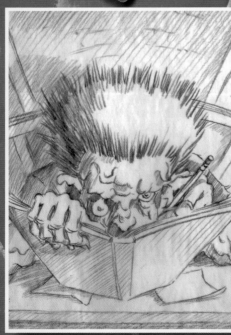

Pencil Sketch 2

Pencil Sketch 3

Color Mockup

The texture of the skin is especially grotesque. The hint of green in this image comes from the light source and can be seen on the figure's back and bright-red hair. The classroom is actually purple, but an extremely muted tone of the color.

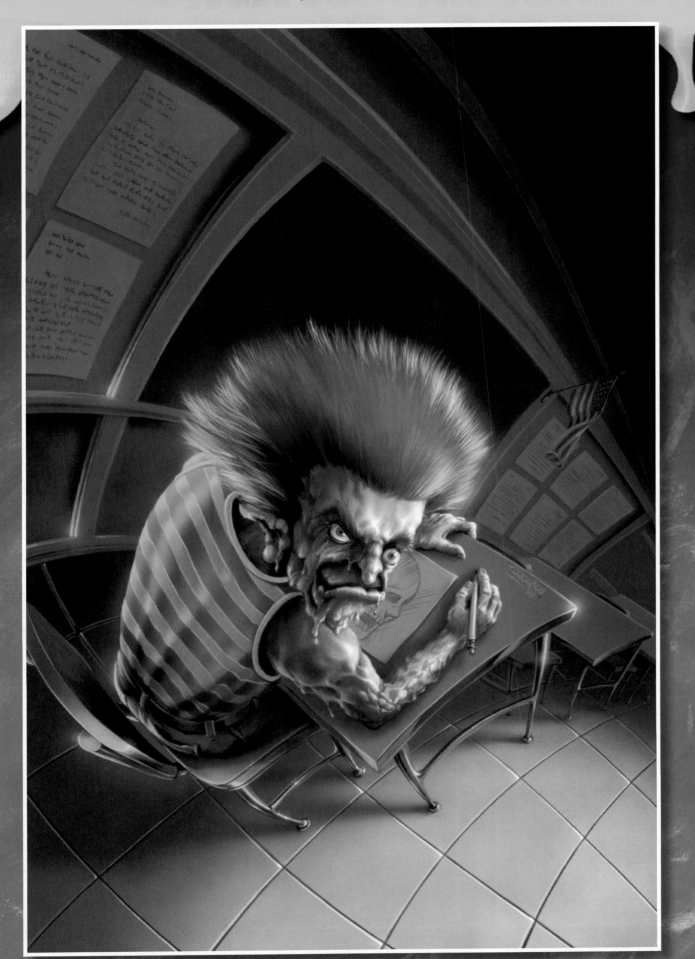

HE MUMMY WALKS

SERIES 2000 - BOOK #16 - APRIL 1999

One small step for mummy…

The third mummy cover illustration in the *Goosebumps* series, Emperor Pukra depicted in very traditional fashion, with desiccated, gray limbs peeking thro white bandages. The perspective is shifted down, so that the mummy app to be stepping towards the reader as if they are on the ground. The cave which the figure is emerging glows red, lighting the back of the mummy's and arms. The stones making up the cave are a mix of grays, blues, and gr

Pencil Sketch 1

Pencil Sketch 2

Pencil Sketch 3

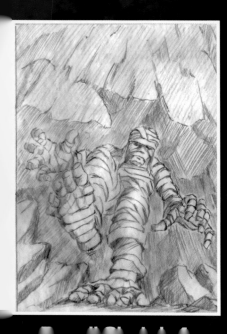

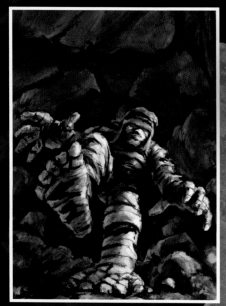

Stin Says

This story was inspired by something I witnessed at the Angeles International Airport. T I saw two parents hand their so envelope before the son boar the flight alone. I imagined ins the envelope there was a note read: "We are not your parent then turned this into the begin

This is one of the few *Goosebumps* books to not feature supernatural elements throughout most of the plot. The book's manuscript appears on Stine's bookshelf in the *Goosebumps* film.

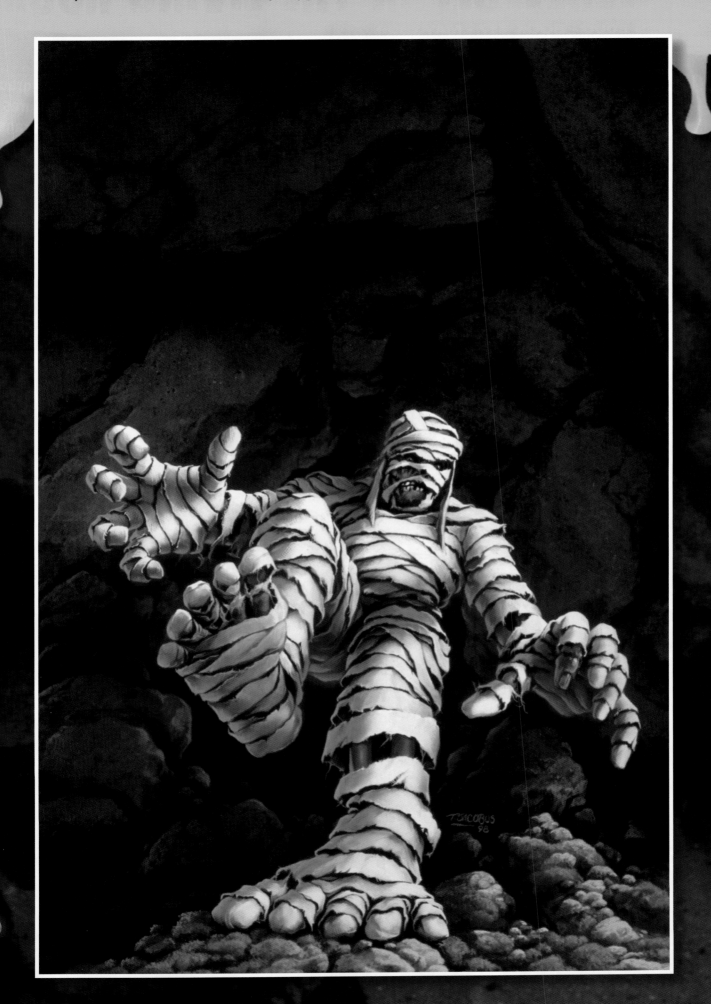

THE WEREWOLF IN THE LIVING ROOM

SERIES 2000 - BOOK #17 - MAY 1999

Home sweet horror

Another example of a much more intense illustration than could ever grace the cover of the original series, *The Werewolf in the Living Room* features a creature with disgusting, red wounds. However, not only was it encouraged for *Goosebumps Series 2000*, but the red was even amped up a bit for the final cover.

Pencil Sketch 1

Pencil Sketch 2

Pencil Sketch 3

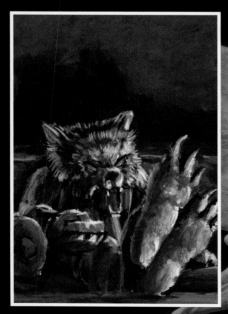

Color Mockup

Curly Says:

Despite the more grotesque elements, this image features a few techniques commonly found in the original series. First by taking a mundane setting and placing something highly unusual in the scene is always a good twist. Such as sitting on the couch, watching television and that somebody is a monstrous werewolf holding the remote. Second, the character has single colored eyes and dotted-pupils, a technique that Jacobus uses to add an insane look to his painted creatures. Last is the "Goosebumps" slime-green color that makes its appearance as the hue of the plush couch beneath the monster with the reflective light of the television shining on the hairy monster.

Tim Jacobus believed that the werewolf's skin, as it appears on the cover of this book — would have been too grotesque an element to include on a cover in the original *Goosebumps* series.

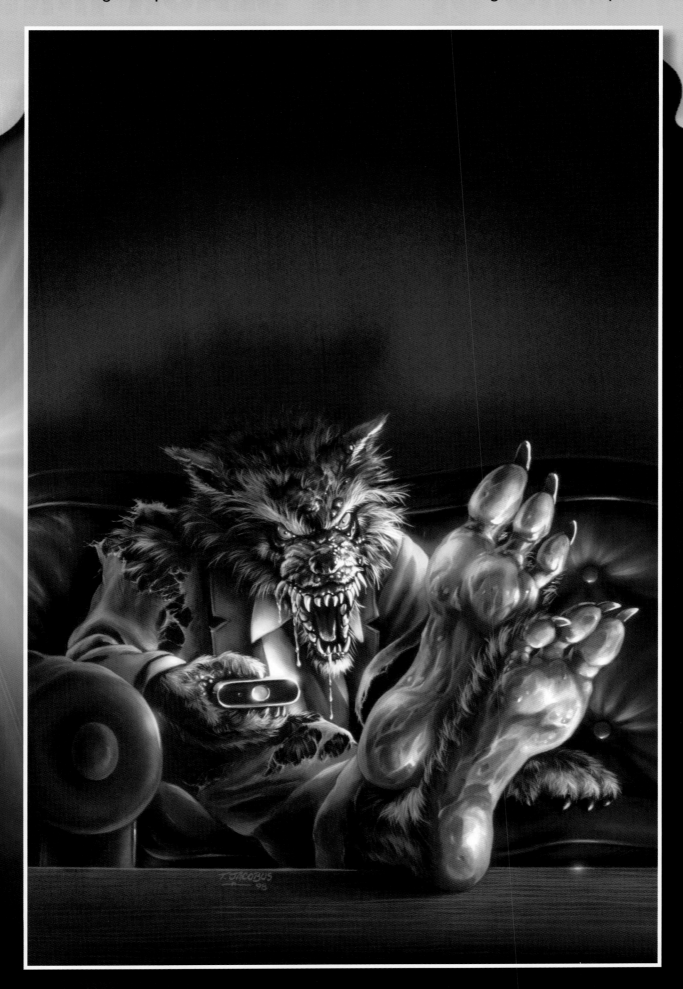

HORRORS OF THE BLACK RING

SERIES 2000 - BOOK #18 - JUNE 1999

Ring around the creature!

Muted grays and golds dominate this cover, as the titular ring sits in the midst of a pile of jewelry. The face inside the jewel is disgusting, missing a nose, and featuring strange, textured skin. The eyes appear to be made of one white and one black pearl. The mouth is bloody red and sharp-fanged. Jacobus uses white to simulate glints on the ring, creating the illusion of a monster trapped in a glass filled with mist. The gold decorations on the ring mimic the shape of the monster's mouth.

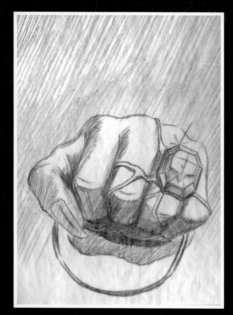

Pencil Sketch 1

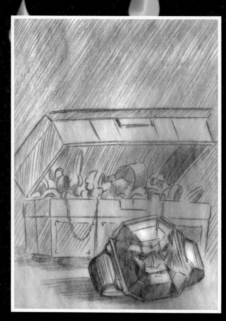

Pencil Sketch 2

Pencil Sketch 3

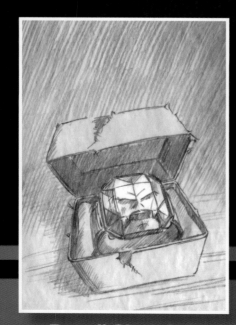

Pencil Sketch 4

Pencil Sketch 5

Color Mockup

Horrors of the Black Ring has the lowest page count of any novel within both *Goosebumps Series 2000* and the original *Goosebumps* series, coming in at only 108 pages. While this book was in preproduction its tentative title was *The Evil Ring*.

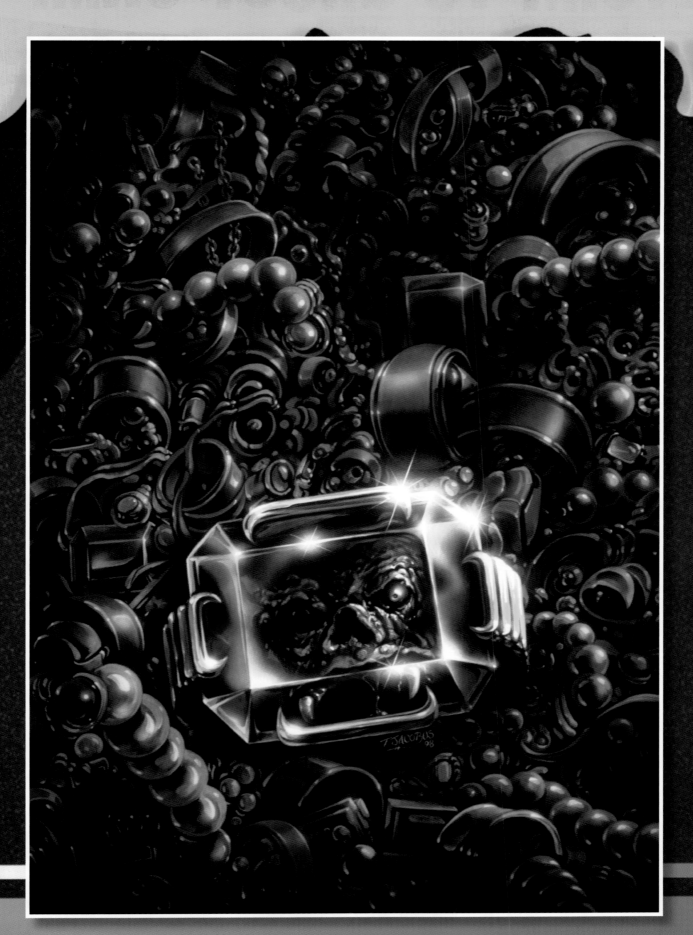

RETURN TO GHOST CAMP

SERIES 2000 - BOOK #19 - JULY 1999

Another summer. Another spirit.
Jacobus believes the demonic smoke ghost of this cover is the best ghost in the *Goosebumps* series, noting the especially grotesque mouth. The large, flat teeth and red gums are certainly disturbing. The ghost is skeletal and Jacobus uses highlights and shadows within the white figure to suggest a goopy texture surrounded by a smoky mist. The ghost rises straight towards the reader, and the campfire and buildings are tiny in comparison, giving the illusion of the monster floating high into the night sky. The trees are lit by the orange of the fire, which casts long shadows that hint at the occult.

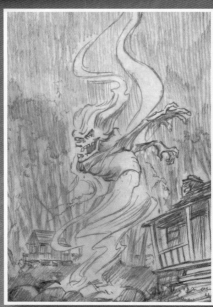

Pencil Sketch 1

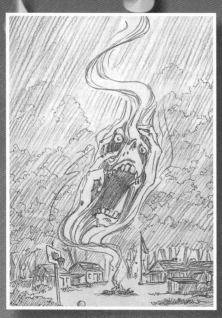

Pencil Sketch 2

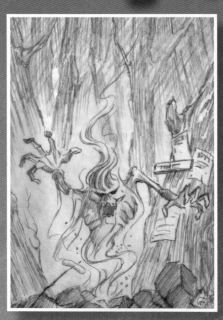

Pencil Sketch 3

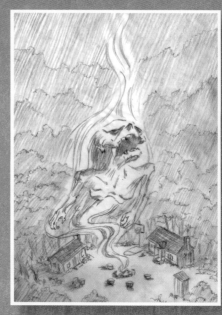

Pencil Sketch 4

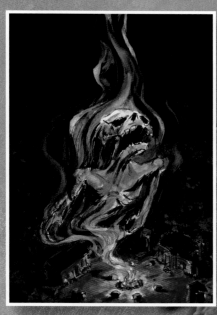

Color Mockup

Curly Says:

Jacobus feels that some of the covers in the *Goosebumps 2000* series are some of his best work in the *Goosebumps* franchise.

Though this novel is the spiritual successor to the original *Goosebumps* series novel, *Ghost Camp*, none of the characters of the original book return in this sequel. In fact, it takes place in a different location as well, meaning readers do not actually return to *Ghost Camp*.

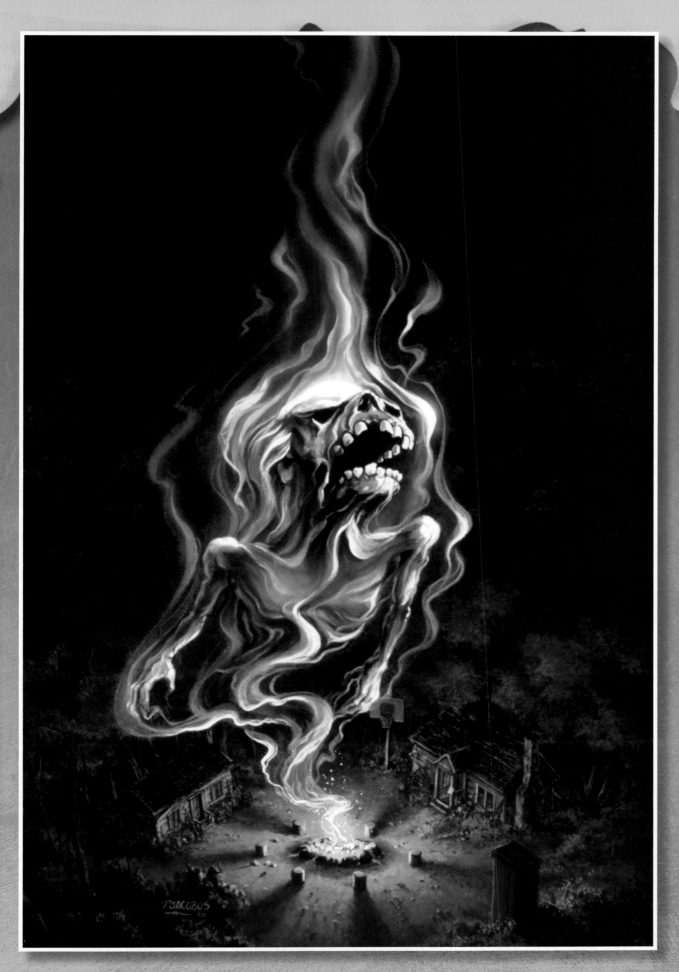

AFRAID - BE VERY AFRAID

ES 2000 - BOOK #20 - AUGUST 1999

There's a new beast on the block…

Much of the dragon and the background are shades of purple, with the brigh[t] being the inner wings of the dragon and the darkest shadowing the clouds i[n] sky and the windows of the houses. The pebbly skin is a brownish gray, dap[pled] in white to give the illusion of shimmering scales. The eyes, nostrils, and m[outh] of the dragon suggest that the monster's head is just a cavern filled with The glow is created by adding yellow to the insides of the teeth, and the to[ngue] itself looks like a tongue of fire. The effect is gorgeous and terrifying. Ja[ck] uses a low perspective here to have the monster looming over the reader.

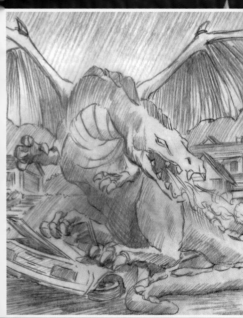

Pencil Sketch 1

Curly Says:

The final cover crops the image in close and tones out some of the purple, resulting in a grayer backgrou[nd] It also removes some of the shine fr[om] the dragon scales, creating a mor[e] dull-looking creature.

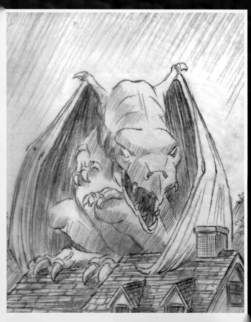

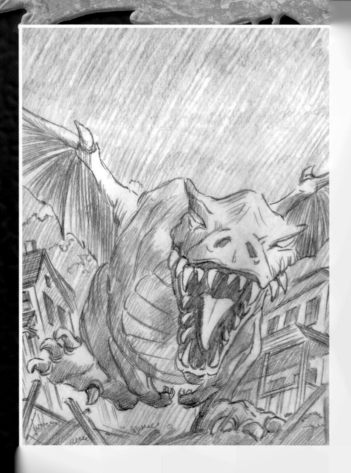

In the illustration for *Be Afraid — Be Very Afraid!* Jacobus demonstrates how colors no[t] considered a bit garish, in this case purple and orange, can be used in a muted fashion to [create a] horror image worthy of a t-shirt.

THE HAUNTED CAR

SERIES 2000 - BOOK #21 - SEPTEMBER 1999

Ghosts, start your engines!

The titular car resembles an unholy mix between a snake, a BMW, a Corvette, and a Camaro. Part muscle car, part monster car, the headlights gleam with slitted eyes. Jacobus adds red veins to the corners of the lights to enhance the illusion of eyes. The front and grill of the car look like nostrils and enormous fangs. Jacobus uses transparent white to create the headlights shining out and onto the road, and he also uses white in a lens-flare style to add a new-car shim- mer to the vehicle. The background of trees is lit by a hellish red-orange light which fades up into gray clouds. Jacobus pulls this orange down to highlight parts of the trees, and the orange helps the blue of the car to pop even more fo the reader.

Pencil Sketch 1

Pencil Sketch 2

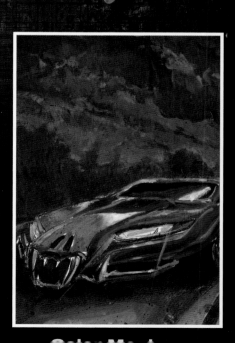

Slappy Says:

I used the haunted car as my preferred mode of transportation in the *Goosebumps* movie.

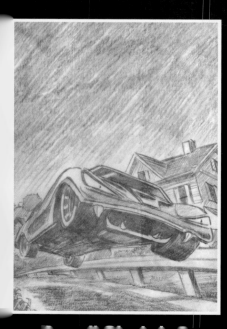

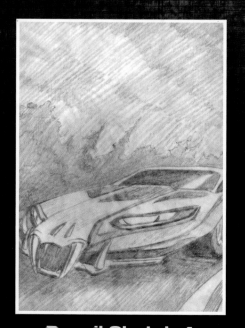

The cover concept instructions given to Jacobus were to paint a "close up of a sleek, dark sportscar with all the essentials - cruise control, anti lock brakes, power steering, and... a ghost! The headlights should look like eyes, front fender bent in as a cruel grin and grill-like teeth."

FULL MOON FEVER

SERIES 2000 - BOOK #22 - OCTOBER 1999

Hairy Halloween!

Full Moon Fever is one of the few Halloween-themed covers not to feature a traditional Halloween image, such as a mask or jack-o'-lantern. Instead, the enormous full moon dominates this illustration, lighting the beast in the foreground with a silvery glow to its fur. The moon has a soft aura of purple against the darkness of the night sky. The slime-green is brought in via the moss-like vegetation at the bottom of the illustration. The mist and silent forest in the background give a somber mood to the illustration, even as the exaggerated mouth, red gums, and lifeless, yellow eyes of the monster bring the horror element.

Pencil Sketch 1

Pencil Sketch 2

Pencil Sketch 3

Pencil Sketch 4

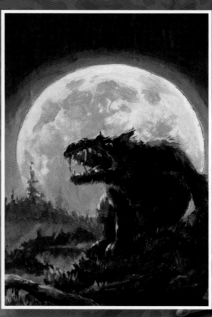

Color Mockup

Curly Says:

This book references Zorro, Hershey Bars, Milky Ways, and Teletubbies. After working on *Goosebump* covers Jacobus illustrated Teletubbies books

Jacobus was given instructions to illustrate a "ferocious, black, furry monster from the middle of the woods, illuminated by a larger than large, round, glowing moon."

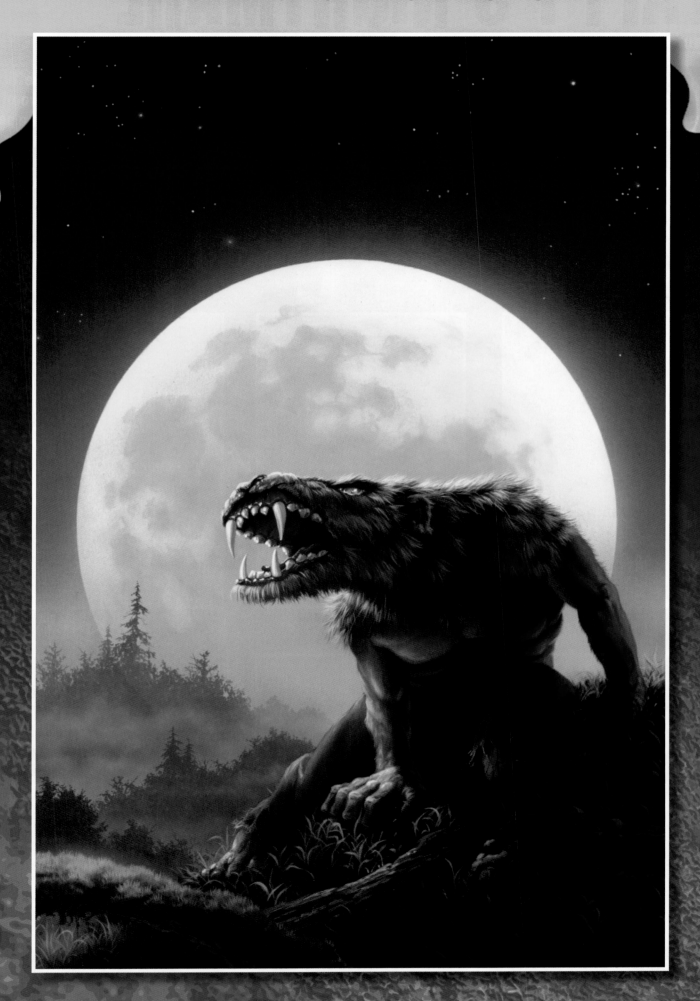

SLAPPY'S NIGHTMARE

SERIES 2000 - BOOK #23 - NOVEMBER 1999

Sweet Screams!

The fifth entry in the Living Dummy series, *Slappy's Nightmare* is the Goosebumps book featuring a villain who has returned as the anti-hero story. It is also the first time in the series a book was not written from the spective of a child protagonist. The cover illustration depicts Slappy lyi bed screaming, his blue eyes lifelike and bloodshot. His pillows are purpl covered in adorable pink sheep. His trademark white gloves pull the cove closer to his face. The horror in his expression and the perspective of lot down could suggest that something is looming over the dummy.

Pencil Sketch 1

Pencil Sketch 2

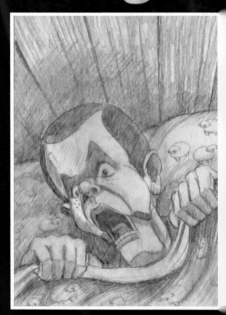

Pencil Sketch 3

Photo Shoot - Jacobus

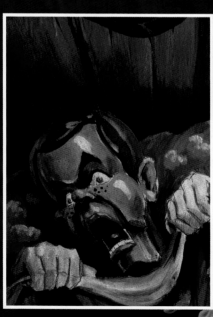

Color Mockup

Slappy Says:

This is the first book to featu me as the main character th doesn't have "of the Living Dummy" in the book title.

acobus uses large, white highlights all over Slappy's face to give the impression of shir ad of flesh. On the left side of the doll's head, a light haze of red that encompasses a s low beneath him hints at another light source. The green used in this illustration is bar in the final cover, as it is on the wooden backboard of the bed.

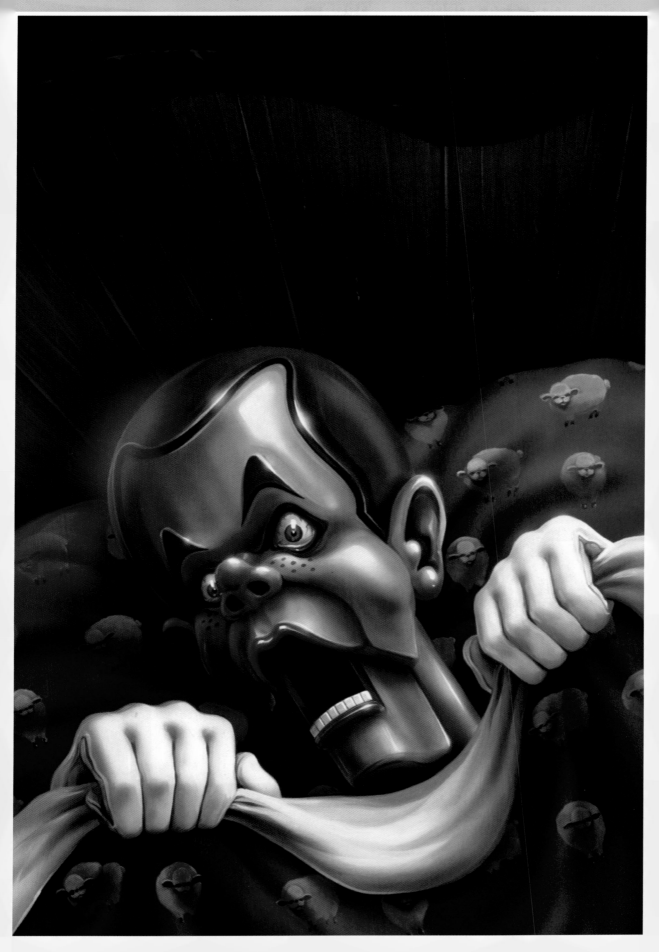

EARTH GEEKS MUST GO!

SERIES 2000 - BOOK #24 - DECEMBER 1999

Warning: Alien on Board

Outlined against the star-filled blackness of space, Jacobus' spaceship appears to be careening towards Earth. The blue planet can be seen reflected in the window of the spacecraft, and a red aura surrounds the back and side of the ship as if it is entering the atmosphere. The orange glow of the thrusters is ominous, as is the astronaut in the driver's seat, who is depicted in a red spacesuit with orange, red-rimmed eyes. The reflection of planet Earth is beautifully done, with Jacobus adding white and gray lines over the image to create the reflective look. The entire ship has a metallic shine due to a similar effect. The trademark *Goosebumps Series 2000* green is found on the highlights of the otherwise blue ship.

Pencil Sketch 1

Pencil Sketch 2

Pencil Sketch 3

Pencil Sketch 4

Pencil Sketch 5

Pencil Sketch 6

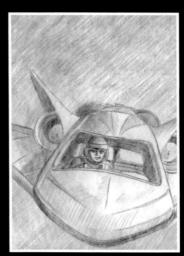

Pencil Sketch 7

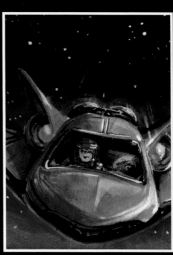

Color Mockup 1

Curly Says:

Other titles for this book were rumored to be
Earth Geeks Must Die!, *Space Geeks Must Die!*,
and *Escape from the Armpit Planet*.

erestingly, this gorgeous space travel themed cover and tagline do not really match t[...]
[...]thin the pages of the book. *Earth Geeks Must Go!* is the only *Goosebumps* book wri[...]
present tense, with the exception of the novels in the *Give Yourself Goosebumps* ser[...]

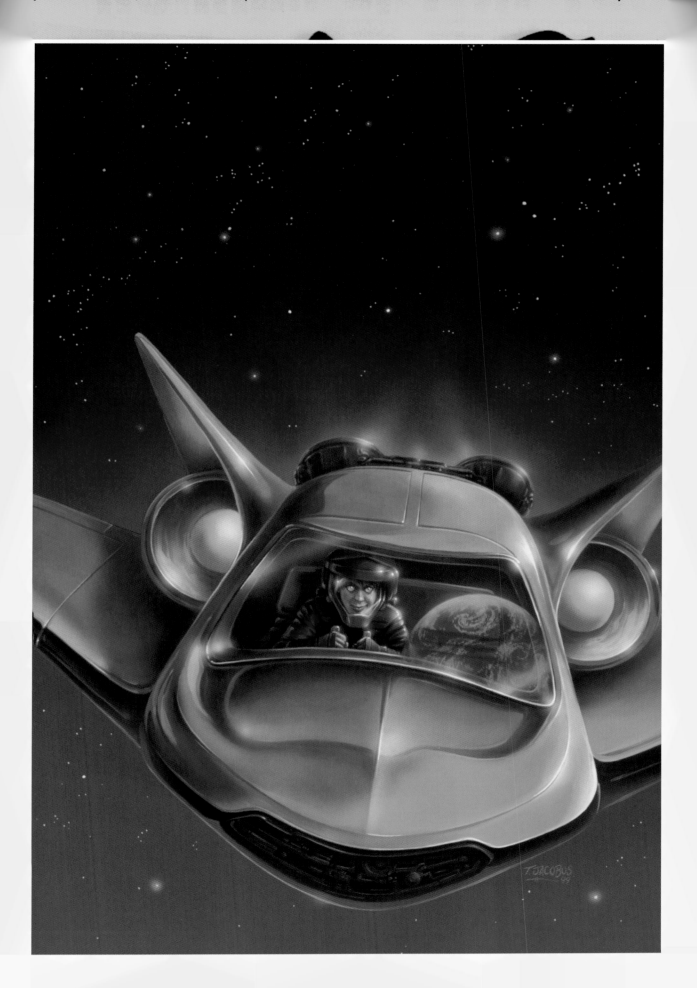

GHOST IN THE MIRROR

SERIES 2000 - BOOK #25 - JANUARY 2000

Look but don't scream!
This creepy cover features a monstrous hand reaching out from a blue mirror. The surface of the mirror has ripples created with light and shadowing, and the arm itself is slightly transparent, becoming more tangible as it reaches the clawed hand. Jacobus brings in the green as a sort of murky light shining throughout the room. A half-visible poster of a skeleton, a repeating motif in Jacobus' work, appears on the right side of the messy room—which includes the final pair of Converse on a released *Goosebumps* cover.

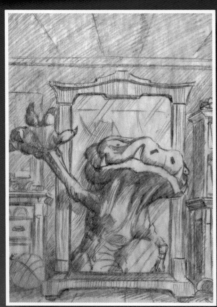

Pencil Sketch 1

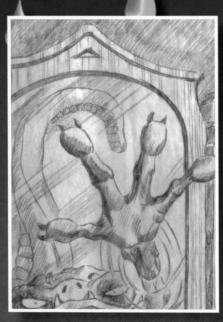

Pencil Sketch 2

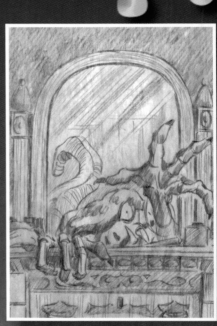

Pencil Sketch 3

Pencil Sketch 4

Pencil Sketch 5

Color Mockup

Jacobus uses subtle clues within the mirror design to create the full, creepy effect, such as the horns at the top, the feet looking a bit too much like an animal's legs, and the suggestion of faces in the attached drawers. He uses splashes of white to show that the mirror is glowing, casting a light into the green-tinged room. The only book of *Goosebumps Series 2000* to be published in the year 2000, *Ghost in the Mirror* would be the final book of the series.

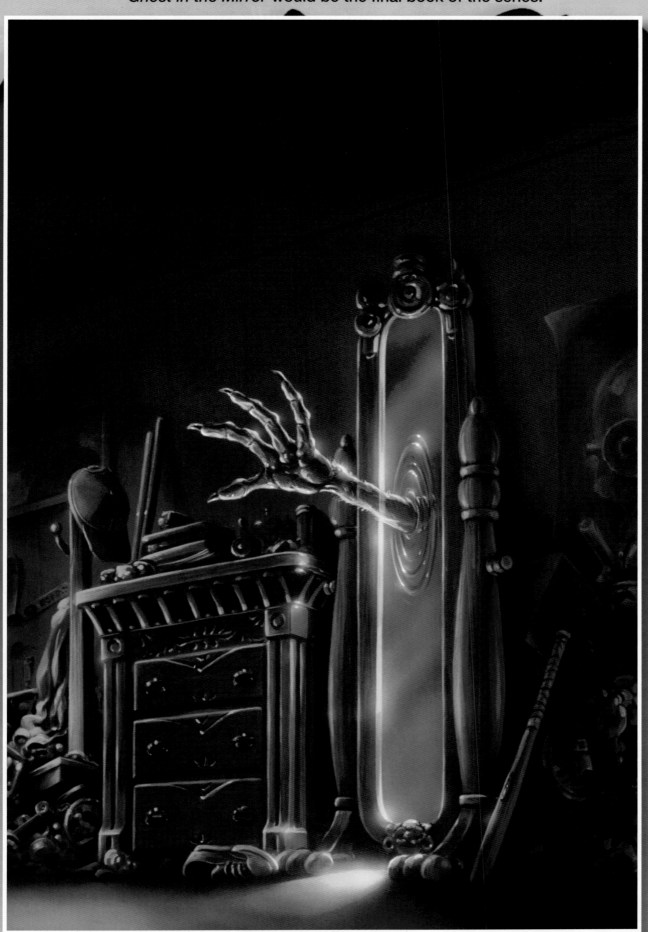

THE INCREDIBLE SHRINKING FIFTH GRADER

SERIES 2000 - BOOK #26 - UNPUBLISHED

Don't call him short stuff!

The Incredible Shrinking Fifth Grader was going to be the twenty-sixth book in the *Goosebumps Series 2000* series. It was never released due to R. L. Stine's contract with Scholastic expiring, but not before Jacobus finished the cover. The description of the story dealt with a boy who stepped in front of a film projector and now he can't seem to stop shrinking! The original animal in the story was supposed to a bunny glaring at the student, but was later changed to a rat.

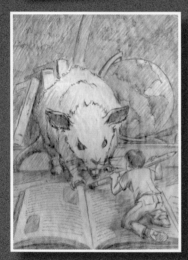

Pencil Sketch 1

Pencil Sketch 2

Pencil Sketch 3

Pencil Sketch 4

Color Mockup

Pencil Sketch 1

Pencil Sketch 2

The Adventures of Shrinkman

Curly Says:

There was going to be another *Goosebumps Series 2000* book numbered 27, titled *When The Snake Bites*. It's release date was scheduled for March 2000. No artwork or story was created.

In the year 2000, R.L. Stine published a one-off book titled *The Adventures of Shrinkman*. The book was the first of six stand-alone novellas that Stine would publish between 2000 and 2001. On November 14, 2017, R.L. Stine confirmed on Twitter that the plot for *The Adventures of Shrinkman* had evolved from *The Incredible Shrinking Fifth Grader*.

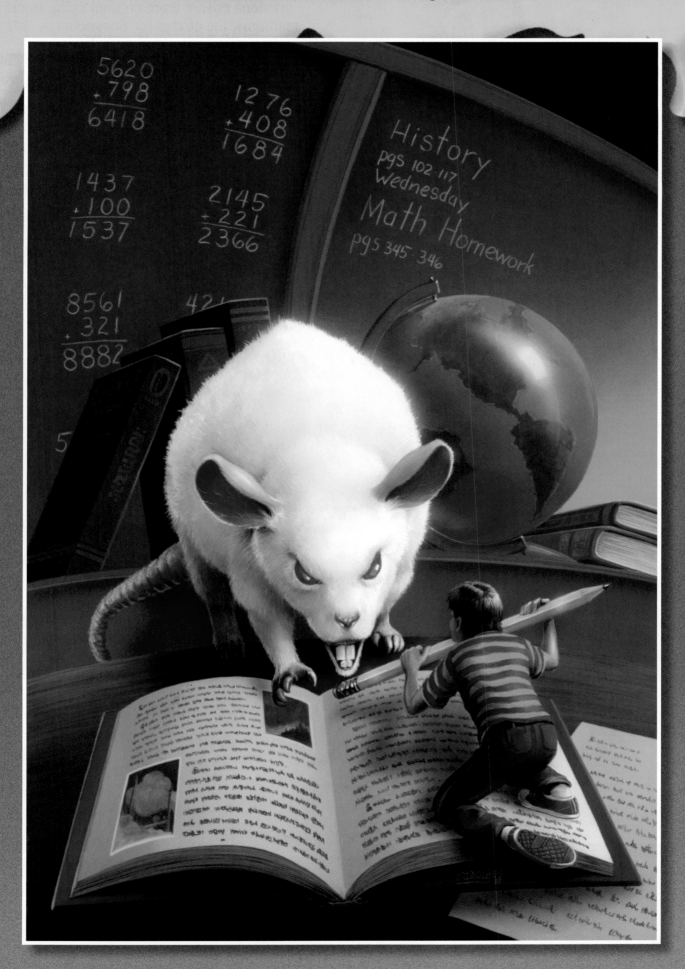

GOOSEBUMPS GOLD

Around six months after he completed his work on *Goosebumps Series 2000*, Jacobus was contracted to create the cover art for a new series, *Goosebumps Gold*. Although all of his previous covers were created using traditional mediums, the covers for *Goosebumps Gold* were created digitally.

R.L. STINE
GOOSEBUMPS GOLD

THE HAUNTED MASK LIVES!

A return to the saturated colors of the original series, the cover illustration for *The Haunted Mask Lives!* features a girl screaming as she rips off a mask. The fuchsia in the background is textured in a way that calls to mind the beginnings of the digital age, as does the texture of the mask, which resembles green goo. The outside of the left side of the figure is touched with blue light, suggesting a light source, while the inside glows orange and red like a demonic fire. The flower ring on the child's finger was highly fashionable at the time of the book's creation. For the final cover design, mist was added to the mask, as was a flower motif to the collar of the girl's shirt.

Pencil Sketch 1

Pencil Sketch 2

Pencil Sketch 3

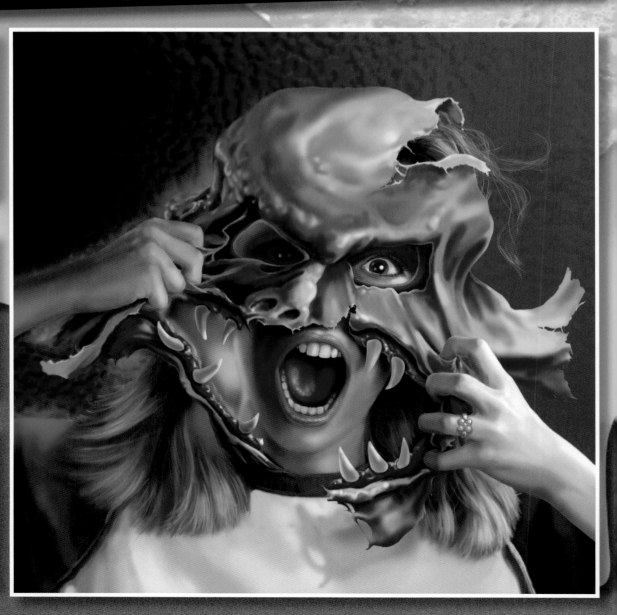

THE HAUNTED MASK LIVES!

Jacobus completed and sent in the artwork for *The Haunted Mask Lives!* and *Happy Holidays from Dead House* in January 2001.

The covers for the two books were similar to the template for the original series, with the new logo, created by Jacobus, at the top of the page and the title of the book at the bottom. However, instead of a slime theme, the template appears much more digital and pixelated, like an old computer Paint program. The colors for the border, logo, and title were different for the two books, but the word "Gold" was left in gold for both covers.

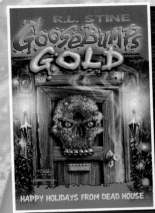

The Happy Holidays from Dead House cover appears at first glance to be a beautiful Christmas scene, complete with cheerful lights, a door wreath, and warm candles. However, a closer inspection reveals the wreath is in the shape of a skull, with red-ornament eyes and bells for teeth. Vines grow all around the wooden door, which is streaked with a myriad of beautiful colors including pinks, blues, orange, yellow, and red. The door opens into an ominous, orange mist, which seems to creep out of the door towards readers. This book also had mist added to the final cover design. Unfortunately, the *Goosebumps Gold* series was cancelled before Stine ever wrote a single book.

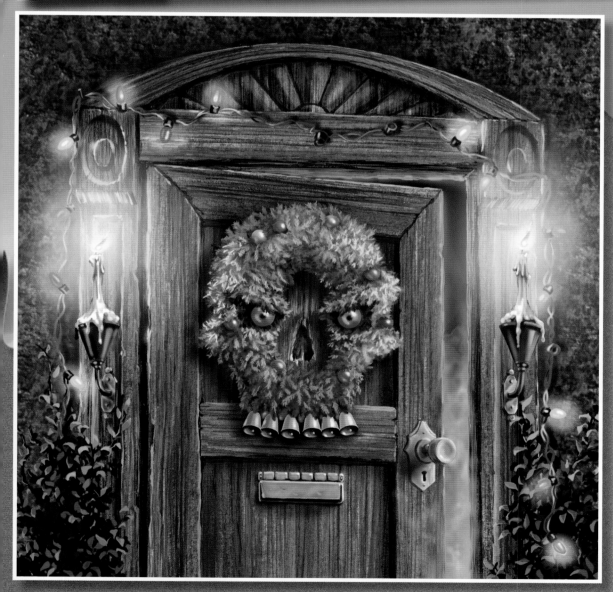

Pencil Sketch 1

Pencil Sketch 2

Pencil Sketch 3

HAPPY HOLIDAYS FROM DEAD HOUSE

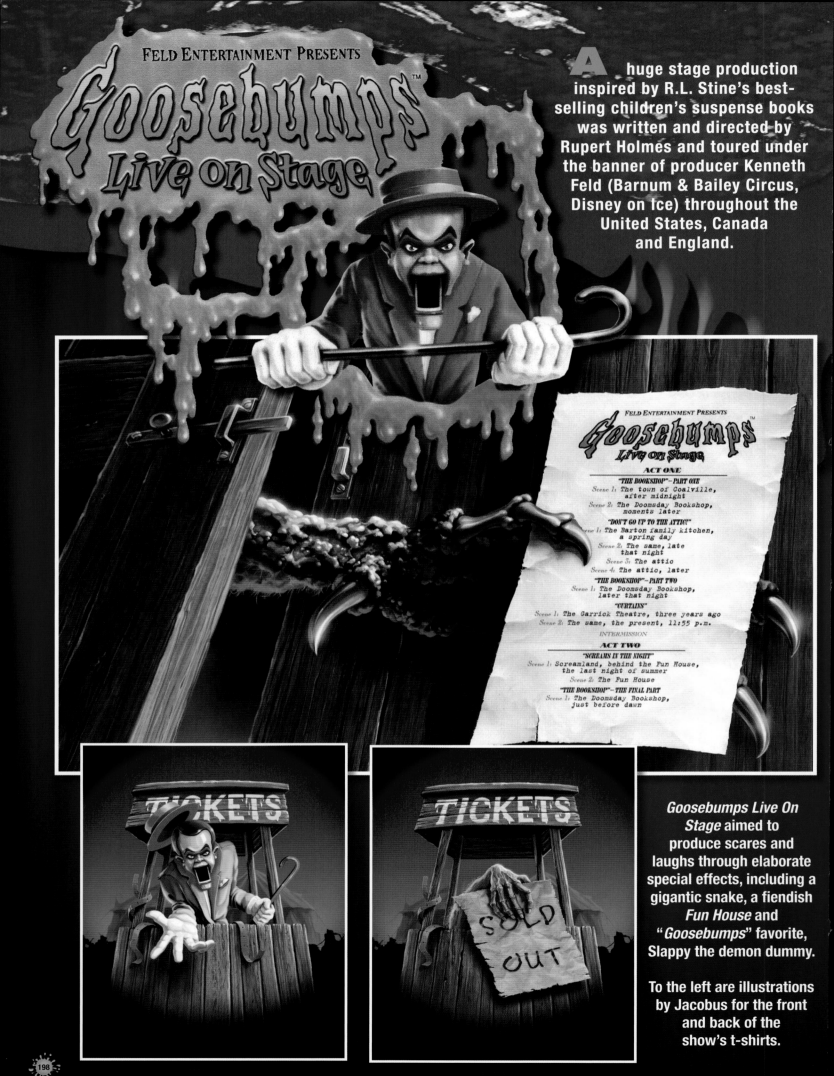

FELD ENTERTAINMENT PRESENTS

Goosebumps™
Live on Stage

A huge stage production inspired by R.L. Stine's best-selling children's suspense books was written and directed by Rupert Holmes and toured under the banner of producer Kenneth Feld (Barnum & Bailey Circus, Disney on Ice) throughout the United States, Canada and England.

FELD ENTERTAINMENT PRESENTS

Goosebumps™
Live on Stage

ACT ONE

"THE BOOKSHOP"—PART ONE
Scene 1: The town of Coalville, after midnight
Scene 2: The Doomsday Bookshop, moments later

"DON'T GO UP TO THE ATTIC!"
Scene 1: The Barton family kitchen, a spring day
Scene 2: The same, late that night
Scene 3: The attic
Scene 4: The attic, later

"THE BOOKSHOP"—PART TWO
Scene 1: The Doomsday Bookshop, later that night

"CURTAINS"
Scene 1: The Garrick Theatre, three years ago
Scene 2: The same, the present, 11:55 p.m.

INTERMISSION

ACT TWO

"SCREAMS IN THE NIGHT"
Scene 1: Screamland, behind the Fun House, the last night of summer
Scene 2: The Fun House

"THE BOOKSHOP"—THE FINAL PART
Scene 1: The Doomsday Bookshop, just before dawn

Goosebumps Live On Stage aimed to produce scares and laughs through elaborate special effects, including a gigantic snake, a fiendish *Fun House* and "*Goosebumps*" favorite, Slappy the demon dummy.

To the left are illustrations by Jacobus for the front and back of the show's t-shirts.

FELD ENTERTAINMENT PRESENTS

Goosebumps Live on Stage™

Exclusive Interview R.L. Stine

Pictured below is the cover to *Screams in the Night* which features a cobra that has eaten Monster Blood. Published in 1998, this short book was given to viewers of the stage show *Goosebumps Live on Stage*.

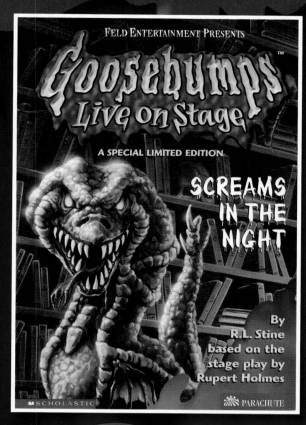

FELD ENTERTAINMENT PRESENTS

Goosebumps Live on Stage™

A SPECIAL LIMITED EDITION

SCREAMS IN THE NIGHT

By R.L. Stine based on the stage play by Rupert Holmes

SCHOLASTIC PARACHUTE

The plot of the live show was simple — four kids find themselves in the mysterious Doomsday Bookstore, where the proprietor introduces them to three separate scary stories, all of which they become personally involved in.

Curly Says:

Goosebumps ALIVE

T. JACOBUS

On May 14, 2016, Goosebumps ALIVE opened its doors to the public in London. Goosebumps ALIVE is an interactive show in the Vaults underneath Waterloo Station that sought to create an immersive theatrical performance based on the Goosebumps universe.
The show featured special artwork created by Jacobus and had two tracks: one for younger children and one for everyone else.
Characters and moments from several books were a part of the installment, including *Say Cheese, And Die!, The Blob That Ate Everyone, The Haunted Mask, Stay Out Of The Basement, One Day In Horrorland,* and, of course, *Night Of The Living Dummy.*

Goosebumps
MOVIE & SOUNDTRACK

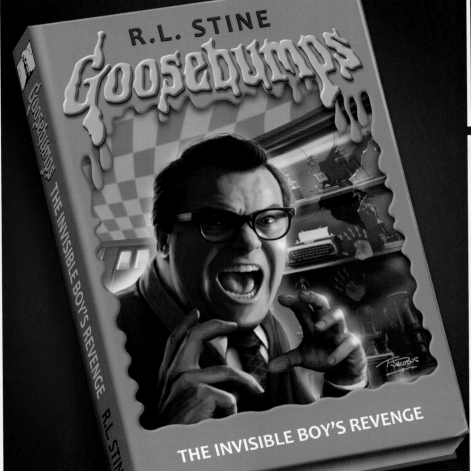

Pictured above clockwise: Jack Black as pictured on the cover of *The Invisible Boy's Revenge*, cover art to the *Goosebumps (Original Motion Picture Soundtrack)*, and artwork for the *Goosebumps: Slappy Sweepstakes*.

At the height of *Goosebumps'* popularity in the '90s, there were fan clubs, web pages, a television series, and even a cereal. So it comes as no surprise that a movie deal was brought up.

What may be a bit more surprising is that it took about twenty years before the film saw its first scripts. In 1998, Tim Burton was attached to direct the movie, but no one could decide which book to adapt. Finally, in early 2008, Columbia Pictures acquired the rights to create a *Goosebumps* film, and the project was back in business, with Rob Letterman directing.

On October 16, 2015, *Goosebumps* was released in the United States to commercial success and critical praise. Instead of following the plot of one book, the movie created a new plot, and filled it with characters from the *Goosebumps* world, while keeping the trademark humor and scares the books were known for.

The plot follows Zach Cooper, played by Dylan Minnette, a teenager who must team up with R.L. Stine, played by comedic actor Jack Black, to save his town from an attack as the monsters from the *Goosebumps* series escape the books and come to life.

The movie features beloved characters such as Slappy, the Abominable Snowman of Pasadena, the lawn gnomes, graveyard ghouls, the invisible Brent Green, and Will Blake, the werewolf in Converse sneakers.

As an homage to the *Goosebumps* cover art that influenced a generation of kids to pick up their first *Goosebumps* book, the end credits feature Jacobus' artwork. Jacobus was also brought on to illustrate the cover for *The Invisible Boy's Revenge*, a book within the movie, as well as the vinyl release of the *Goosebumps (Original Motion Picture Soundtrack)*.

A sequel, *Goosebumps 2: Haunted Halloween*, was released on October 12, 2018.

> ## It was always fun, and I enjoyed the last one as much as the first.
> Tim Jacobus speaking about his *Goosebump* covers • September 13th, 2015

THE ART OF GOOSEBUMPS®

WRITERS

Sarah Rodriguez
Rachel Deering
Mark McNabb

DESIGNER

Mark McNabb

EDITORS

Kevin Ketner
Hannah Elder

ASSISTANT EDITORS

Amy Jackson

SPECIAL THANKS TO SCHOLASTIC

Lynne Karppi
Anthony Kosiewska

COVER & INTERIOR ART

Tim Jacobus

DYNAMITE®

www.DYNAMITE.com | Facebook /Dynamitecomics
Instagram /Dynamitecomics | Twitter @dynamitecomics

Regular Hardcover ISBN-10:
Paperback ISBN:

First American Edition 2021 • Printed in China

Nick Barrucci: CEO / Publisher
Juan Collado: President / COO
Brandon Dante Primavera: V.P. of IT and Operations

Joe Rybandt: Executive Editor
Matt Idelson: Senior Editor

Alexis Persson: Creative Director
Rachel Kilbury: Digital Multimedia Associate
Katie Hidalgo: Graphic Designer
Nick Pentz: Graphic Designer

Alan Payne: V.P. of Sales and Marketing
Vincent Faust: Marketing Coordinator

Jim Kuhoric: Vice President of Product Development
Jay Spence: Director of Product Development
Mariano Nicieza: Director of Research & Development

Amy Jackson: Administrative Coordinator

THE ART OF Goosebumps®

TABLE OF CONTENTS

In the summer of 1992, Scholastic tasked two terrifyingly talented artists with creating the cover paintings for the books that would premiere the *Goosebumps* series. At that time, four books in the line were being market-tested by the publisher to see how young readers would react to R.L. Stine's particular brand of humor-tinged horror. One element that was sure to catch the attention of little eyes everywhere was striking cover art, but Scholastic wasn't sure who might be the right man for the job.

Tim Jacobus was an eager, young New Jersey artist who had dreamed of painting album covers for progressive rock bands from an early age, having been inspired by his childhood hero, Roger Dean of Yes, Asia, and Uriah Heep fame. Rather than diving straight into the world of album cover paintings, though, Tim set his sights on an industry that would guarantee him a high level of work and thus a great amount of practice. That industry was paperback book publishing.

His first paid work came in 1985 from a science fiction publisher called DAW, for

which he produced the covers for *Fugitive in Transit* by Edward Llewellyn and *Brainz*, Inc. by Ron Goulart. He went on to paint three more covers for the publisher that year before the paying gigs dried up and he faced a tough few years without notable work. In 1988, he caught a break that would finally get the ball rolling for his career with a cover painting for a release of *The Invisible Man* by H.G. Wells. The popularity of that paperback earned Jacobus well-deserved attention and consistent work from more major publishers, and by 1991, Scholastic had their eye on him. They commissioned him to paint the iconic purple and blue facade that would grace the cover for the very first Goosebumps book, *Welcome to Dead House*.

The second book in the series, *Stay Out of the Basement*, featured cover art by the skilled hand of Jim Thiesen. Before slinging paint on the putrid, plant-infested hand creeping around the basement door, Thiesen illustrated a short three-page comic for the adult-themed *Heavy Metal* magazine. From that brief stint in comics, he made the leap to creating package art for the companies HG Toys and CBS Toys as well as assisting them in designing and developing new toy lines.

Some four years later, the adult world came to reclaim Jim and he found himself gaining popularity as a cover artist for novels. Being a fan of fantastical creatures and horrors alike, he was typecast as the "Horror Guy" in the eyes of his peers and clients. With early assignments for macabre pulp fiction pieces, he was afforded a great deal of flexibility and so he created not only illustrations and paintings, but also a number of gruesome three-dimensional sculptures for publisher Zebra Books. The apex of this vile vocation was a set of commissions from Doubleday for reissues of four novels by the legendary author Stephen King as well as the Tor Books cover for the seminal horror/ sci-fi story *I Am Legend* by *The Twilight Zone* screenwriter Richard Matheson.

In the end, Scholastic found Tim Jacobus' use of vivid, saturated color, and odd perspectives to be a better fit for the intended tone of the series, a style that would soften the harsh edges of the seemingly horrific themes and make it more palatable for their audience. This hard-won victory earned him a full-time job as the official *Goosebumps* artist, painting sixty of the sixty-two covers for the original lineup and more than one-hundred covers over the life of the series.

INTRODUCTION
by R.L. Stine

People ask me what my favorite *Goosebumps* cover is, and I never have an answer. After all, there are more than 130 *Goosebumps* books now, and dozens and dozens of funny, frightening covers that could all go on my favorites list.

In cover after cover, Tim has captured that combination of humor and horror that I strive for in each book. Just scary enough. Just funny enough to make you look twice.

Some of my favorites? Let me think…

SLAPPY:

I'd choose Tim's painting for the original Slappy book, *Night of the Living Dummy*. It's the first portrait ever of Slappy, and he's truly maniacal with bulging, icy-blue eyes and a terrifying grin. And there's a perfect cover-line: *"He walks… He stalks…"*

DOGS:

To be frank, I'm a dog person. I think cats are a lot scarier than dogs. But the cover painting Tim did for the book entitled *The Barking Ghost* — the close-up of the ferocious, roaring dog — is bold and frightening and actually made me shiver.

THE HAUNTED MASK:

Tim's original cover painting for *The Haunted Mask* perfectly captures the feel of Halloween and the terror of this most evil mask. This is one of my favorite books and all-time favorite covers.

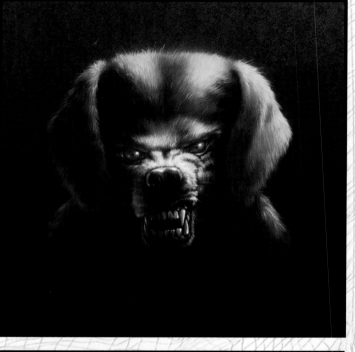

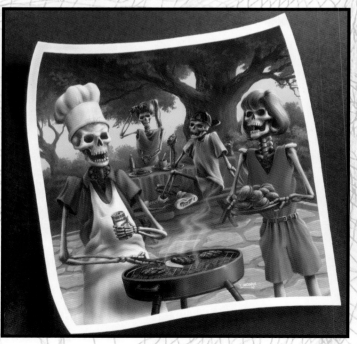

So many memorable covers. But one thing I remember most are the problem covers. The problems are usually created because the cover paintings must be done before the book manuscript is finished. Here's an example…

Say Cheese and Die is a story about kids who find an evil camera that takes photos of bad things that will happen in the future. But when Tim's cover painting came in, we were surprised to see that it had a scene of skeletons barbecuing.

That scene didn't exactly fit the story, did it? But everyone loved Tim's painting. They didn't want it changed.

And so, my editors called me and said, "Bob, you have to add a scene in the book of skeletons barbecuing."

What did I do to make the cover work? I added a *dream sequence* in which the boy dreamed of skeletons barbecuing.

Clever?

I'm a *huge* admirer of Tim and the other *Goosebumps* artists.

Goosebumps wouldn't be *Goosebumps* without them!

Opposite Page Above:
Goosebumps Tripleheader 1
Opposite Page Below:
Welcome To The Dead House

Above Left:
Goosebumps Tripleheader 3
Left:
The Barking Ghost
Bottom Left:
Say Cheese And Die

You developed an early fondness for the classic horror comics of the '50s and '60s. Did your love of those four-color tales of terror influence your approach to writing *Goosebumps*? Also, do you have any favorite stories from those musty, old mags?

Such comics as *Tales from the Crypt* and the *Vault of Horror* were incredibly influential on me. They were horror and humor combined—and they all had funny twist endings. Exactly what I do in *Goosebumps* books.

Several scenes stand out from those comic stories. One that lingers in my mind is about a butcher who runs out of meat, so he puts people through the meat grinder. Sweet.

You grew up in a quiet suburb of Columbus, Ohio. How did that small-town upbringing impact the characters and settings you went on to create as a writer?

Most *Goosebumps* books take place in a neighborhood much like mine in Ohio. I want the scares to come in a typical quiet suburban setting, so I think back to where I grew up. I think everything is scarier if it happens in your own back yard.

What, to you, are the essential elements to creating a great horror story for young readers?

Surprises and twists. You have to keep the reader

Interview with
R.L. Stine
by Rachel Deering

Above:
It Came From Ohio!
Opposite Left
The Haunted Mask
Opposite Right:
Night Of The Living Dummy

off-balance, unsure of what is really happening and what will happen next.

Was there ever a *Goosebumps* story that didn't make it to print because it was too scary or maybe too mature?

Never. I'm always immature.

One of the things that struck me most back in my book fair days was that both boys and girls loved to read *Goosebumps*! There was no gender divide there like there was for so many other properties and your work seemed to unite the playground, if only for a little while. Was that something you set out to achieve or is it a lucky coincidence?

It came as a surprise. We thought we were writing for girls because girls like to read and boys don't. But then half the mail was from boys. *Goosebumps* was the first series to attract both equally.

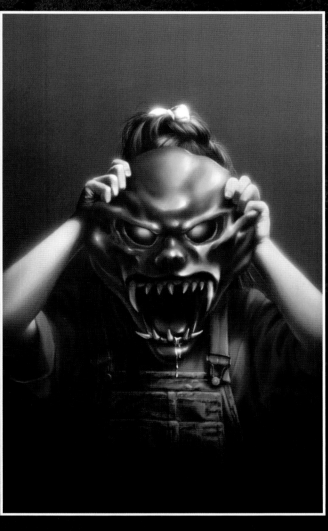

The generation that launched *Goosebumps* to its success is now grown. Do you find that many of those readers have gone on to support your work in adult fiction?

No. No one supports my work in adult fiction. Just check the sales numbers!

Humor was your primary focus for a number of years early in your career. How do you think your approach to horror might differ from another writer who doesn't have a knack for comedy?

I don't get scared at scary movies or books. Horror always makes me laugh. In writing for kids, it's important to use humor to lighten the intensity of the horror.

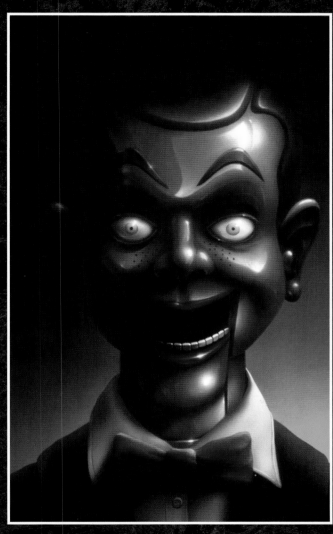

What is your routine like as a writer? Do you listen to music while you work? Walk us through a typical workday in the life of Bob Stine!

No. No music. But I'm pretty much a machine. I sit down at my laptop at 9:30 or 10 every morning, and I write 2,000 words. Maybe six days a week. When I hit word 2,000, I quit no matter where I am.

Finally, could you please leave us with your all-time favorite monster joke?

Q: What do you call a 4th-grade monster who eats all the books, smashes the chalkboard, and sets fire to the desks?

A: Teacher's pet.

Above:
A Night In Terror Tower
Opposite Page:
The Blob That Ate Everyone

How were you approached to become the cover artist for *Goosebumps* and what was your initial impression of the series concept? Did you think it would go as far as it did?

I had worked with Scholastic for a few years on other book projects and hadn't screwed anything up! When the *Goosebumps* series came along, it came down to being in the right place at the right time. I'm embarrassed to say that I didn't know who R.L. Stine was. He was already famous, but I'd never heard of him. And I'm sure he never heard of me, either!

I was told R.L. was writing a series of scary books for middle school kids with a touch of humor thrown in. I was told it would be a few books…maybe 6. After reading the first story excerpt, it just seemed like fun.

The folks at Scholastic were very unsure about how that age group would respond to the series—which didn't take off right away and early sales weren't great. But then something just happened, and it took off! I didn't have kids at the time, so I may have been the last to know the series was a hit. I'm still amazed and humbled by the fact that the series remains popular and is still so fondly remembered.

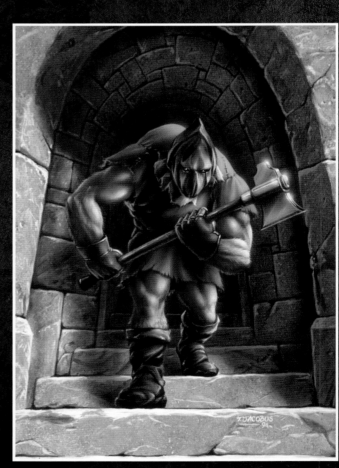

Of all the classic *Goosebumps* covers, which was the most labor intensive? Which of your creations took the most out of you?

A Night in Terror Tower was a tough one. Each *Goosebumps* cover typically took a week to complete from start to finish. I had taken on a lot of covers that month

along with *Terror Tower*. When it came time to do the cover art, I had to squeeze the full week's worth of work into thirty straight hours — a very long stretch of nonstop painting. But it got done, I drove it into NYC and delivered it on time. There are couple of things I would have done differently if I had the extra time. After so many years, I don't remember doing many of those illustrations, but I remember *Terror Tower* vividly!

Are there any covers you wish you could go back and rework, or repaint completely?

I have a thing about all of my paintings — I always want to go back and tweak them. It's a little of my obsessive-compulsive behavior, but overall, I like all the *Goosebumps* covers as they are. There aren't any I would want to redo from scratch… but I would like to touch up ALL of them.

Do you listen to anything while you paint?

The voices in my head.

Actually, there is always music playing when I'm working. I like prog rock, but I listen to more than that. I like the longer "jam" style of playing which comes in many forms—Yes, The Grateful Dead, The Allman Brothers, Santana, Moe, Marillion, or Porcupine Tree. Any band that's got a twenty-minute song, I'm in for the ride.

Who were some of the early influences on your craft?

I was and am a huge fan of Roger Dean. I became familiar with his work, specifically his album art for the band Yes, when I was in high school. I loved his alternate worlds and use of imagination. I spent my teen years trying and failing to recreate his paintings.

For those of you who are not familiar with Roger's album art, check out the movie *Avatar*. His art was a huge influence on that movie, even though no one from the movie studio was willing to admit it.

Is there a creature you never got the chance to paint that you would like to take a shot at some day?

The new *Goosebumps* movies brought many of the characters together in one place at the same time. I never got to do any character combos, but I'd like to do an image or two where a few of the *Goosebumps* characters are in an iconic location — like Slappy, Curly, the mummy, and a lawn gnome walking across Abbey Road, like the Beatles album cover.

Did you ever worry about striking a balance between being scary while still being kid-friendly?

My style is a bit cartoonish and not ultra-realistic. That takes the "edge" off right from the start. The saturated colors were another way I kept the images from being too horrific—and never any red blood. There was a lot of

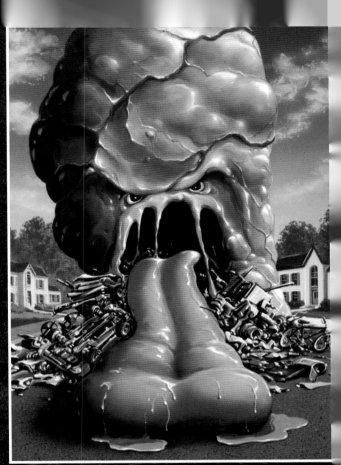

How did you choose which elements you would include on the cover without spoiling the story?

R.L. was writing the story at the same time I was doing the cover. He would give me a short description — a few sentences or a paragraph describing a scene. I finished nearly every *Goosebumps* cover without ever knowing how the story ended! There are a few I STILL don't know what happened.

Have you been labeled as the "Goosebumps Guy" and has that affected how others view your non-*Goosebumps* art?

I have been labeled as "that guy." It was only a problem during one time period. In the early 2000's, *Goosebumps* took a break and I needed to find new work. No one wanted me because they were looking for something new and different and felt that my *Goosebumps* style was played out. I felt like I was in an '80s hair band in the grunge rock world!

I dove into digital technology and discovered a new world to be creative in. Eventually, the classic *Goosebumps* art came back into style because of nostalgia and I couldn't be happier. I'm proud to be known as the original "Goosebumps Guy." Lord knows I've been called way worse things!

Were you responsible for the iconic Goosebumps slimy logo?

I can't take any credit for the *Goosebumps* logo. That was developed by one of the art directors at Scholastic

In July 1992, Goosebumps debuted with three books, *Welcome to Dead House, Stay Out of the Basement,* and *Monster Blood.* As the series launched and demand began to rise, a distinct artistic look, now recognized as a zeitgeist of the '90s, took shape over the course of the first twenty-two books.

Evidence of the evolution of the initial wave can be found on the spines of the earliest books of the series. Because Scholastic initially anticipated a run of about six books, the first five *Goosebumps* novels did not have numbering on the spines. Another notable difference is that the spines of the first nineteen books feature the *Goosebumps* title in plain font. *The Scarecrow Walks at Midnight* was the first book to replace that font with the beloved slime logo.

Welcome to Camp Nightmare, the ninth book in the series, was the start of a monthly publishing schedule, a schedule which R.L. Stine was able to maintain due to his ability to write a single *Goosebumps* novel in under ten days. Within just a few years, *Goosebumps* became the best-selling children's book series of all time, and currently it is second only to the

Harry Potter series as the best-selling book series, with more than 400 million sales.

Tim Jacobus cemented the classic *Goosebumps* style during this first wave. That style included viewpoints near the floor, warped perspectives, curved lines and bright, deliberate colors. He was also careful not to repeat color schemes, attempting to ensure that each *Goosebumps* book had its own set of colors used in different variations.

Each cover was created as an acrylic-based 20-inch by 20-inch painting using brush and airbrush together. Jacobus used #80 illustration board and would usually spend about four to five days creating the art, first filling in the background using a frisket and airbrush, then filling in the details with a paintbrush. When the painting was sent to Scholastic, there would sometimes be retouches, and then the cover, complete with the slime logo, was complete.

The importance of these bright, gross, scary, interesting, often Escher-like covers cannot be overstated, as many young people picked up their first *Goosebumps* book after seeing an intriguing design.

WELCOME TO DEAD HOUSE

REGULAR SERIES - BOOK #1 - JULY 1992

It will just kill you.

"Look Alive! Amanda and Josh think the old house they have just moved into is weird. Spooky. Possibly haunted. And the town of Dark Falls is pretty strange, too. But their parents don't believe them. You'll get used to it, they say. Go out and make some new friends. So Amanda and Josh do. But these new friends are not exactly what their parents had in mind. Because they want to be friends...

...forever."

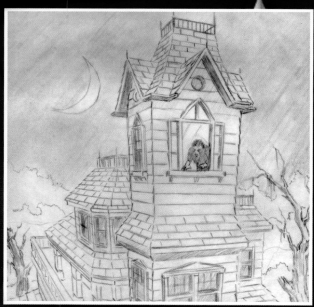

Pencil Sketch 1

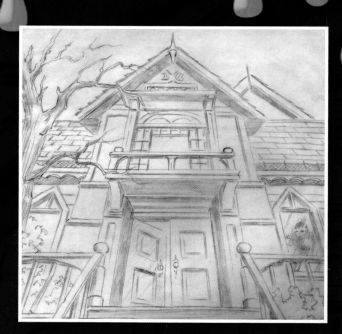

Pencil Sketch 2

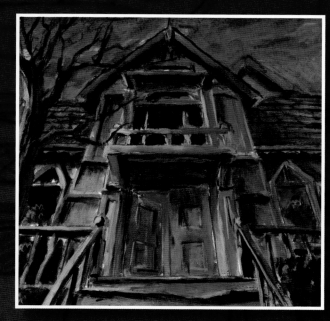

Color Mockup

The first cover in the Goosebumps series certainly lives up to the name. The low angle, looking up broken-down stairs to the open door gives the appearance of the house looming over the reader. The orange glow coming from the door and window are as ominous as the unsettling figure barely visible in the right window. There's no mistaking it: this is a horror book. Dare the reader enter?

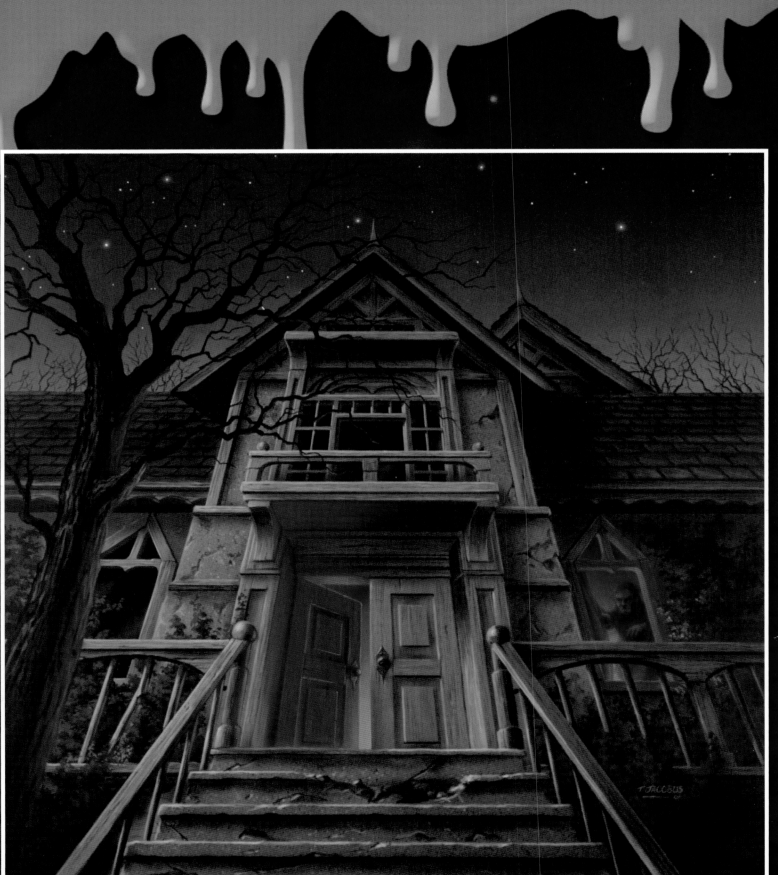

STAY OUT OF THE BASEMENT

REGULAR SERIES - BOOK #2 - JULY 1992

Something's waiting in the dark...

"Live Plants...Dead People? Dr. Brewer is doing a little plant-testing in his basement. Nothing to worry about. Harmless, really. But Margaret and Casey Brewer are worried about their father. Especially when they...meet...some of the plants he is growing down there. Then they notice that their father is developing plantlike tendencies. In fact, he is becoming distinctly weedy—and seedy. Is it just part of their father's 'harmless' experiment? Or has the basement turned into another little shop of horrors?"

Stine Says:

One of my favorite books from the series, features cover art by Jim Thiesen. With more realistic rendering and perspectives, Thiesen's style was a bit more adult and realistic than the ultra-saturated and cartoonish scenes painted by Jacobus. It's no surprise Jim went on to work for major players in the field of horror literature.

Original Cover by Jim Thiesen